Translated from the Hungarian by Peter Laki *and* Barna Kantor

English-language edition sponsored by
The Museum of Fine Arts, Houston

THE UNIVERSITY OF CHICAGO PRESS

CHICAGO AND LONDON

The University of Chicago Press, Chicago 60637
The University of Chicago Press Ltd., London
Text and photographs by Brassaï © 1997 by Gilberte Brassaï
Foreword © 1997 by Gilberte Brassaï
"Hallway to Parnassus" and Editorial Note © 1980 by Andor Horváth
"Education of a Young Artist" © 1997 by The Museum of Fine Arts, Houston
All rights reserved. Published 1997
Printed in the United States of America
05 04 03 02 01 00 99 98 97 1 2 3 4 5

Library of Congress Cataloging-in-Publication Data

Brassaï, 1899–1984
 [Előhívás. English]
 Brassaï : letters to my parents / translated from the Hungarian by Peter Laki and
Barna Kantor.
 p. cm.
 Includes bibliographical references and index.
 "English-language edition sponsored by the Museum of Fine Arts, Houston."
 ISBN 0-226-07146-4 (cloth : alk. paper)
 1. Brassaï, 1899–1984—Correspondence. 2. Photographers—France—
Correspondence. I. Museum of Fine Arts, Houston. II. Title.
TR140.B75A413 1997
770'.92—dc21
 [B] 97-10099
 CIP

This book is printed on acid-free paper.

CONTENTS

Illustrations follow pages 106 and 202

For twenty years, from 1920 to 1940, Brassaï and his parents maintained a regular correspondence that never failed to reveal the deeply affectionate ties binding him to his family. After a period in Berlin from 1920 to 1922, he spent the rest of his life in France, from 1924 until his death in 1984. Brassaï never returned to his native Transylvania, but always savored the memory of it. He would decline insistent appeals and invitations both flattering and official to return to Hungary as an honored guest; he believed that in remaining away he would keep his memories of childhood and youth intact. Nevertheless, he joyfully welcomed his parents, who always responded eagerly to his numerous invitations, to both Paris and the Riviera.

These letters remained confidential for forty years until the idea arose to publish them in Hungarian, his native language (the last three were written in French). As Brassaï explains in his preface, he was initially overwhelmed by this idea. He had to reimmerse himself in the exchange of letters with a father he deeply venerated. There were marked affinities between father and son: the same passion for language, for words, and for poetry and a penchant for versification, which Brassaï happily practiced in his spare time.

Brassaï's father wrote poems in a style inspired by that of the Enlightenment, full of charm and humor, embellished with a variety of symbols and images, and leaping from one subject to another. His son was delighted by them. In 1956, at the age of eighty-four, his widowed father made a lengthy visit to Paris. Displaying an astonishing vitality, he searched for the writers and, above all, the poets who had contributed to France's renown abroad. He lost no time in dashing off to the Bibliothèque Nationale as well as the less prestigious institutions, haunting the quays with their booksellers, the monuments, the parks, and the cemeteries. At the age of ninety-seven and

still quick-witted, he died while working on his last book, on Béranger, the political cabaret singer so popular during the nineteenth century.

The present book would not exist if Brassaï's father had not so carefully preserved this correspondence and collaborated, as did Brassaï's brother Kálmán, on its publication. This was achieved in 1980 in Bucharest, thanks to the efforts of Andor Horváth, whose essay "Hallway to Parnassus" and Editorial Note, included here, were first published in the Hungarian edition.

At the suggestion of Anne Tucker of the Museum of Fine Arts, Houston, it was decided to translate these letters into English. I am very grateful to Susan Bielstein and Anne Tucker, who put their hearts into this English edition.

Gilberte Brassaï

It has been many years now since my younger brother Kálmán took inventory of, deciphered, and retyped the letters in this volume, which I wrote to my family in my youth, from Berlin and Paris. When he sent them to me, however, I hadn't the courage to reread them. I did not feel wise enough to safely glance back at my past. I like to turn a new page in my life with every day. I was afraid that if I looked back, I would become a pillar of salt. I got around to reading the letters only after *A Hét* (The Week) had published them.

There is nothing more distressing than to reread one's writings from long ago. How much stumbling and straying, how many illusions and blunders, how much foolishness! Sometimes I blushed in shame when reading these pages. From the giddy perspective of fifty years, I followed every step of this young man — my former self — with anxiety and with the little wisdom acquired in the course of an already long life, without being able to give him advice, guidance, or warning. Shouldn't we be born twice, so that we might truly profit from the experiences gathered in our first life?

Still, there was something in which I found solace: even though the winds swept him in all directions, and no matter how much his ship was tossed and turned, this young man always stayed in control of his destiny. In other words, he never lost sight of his own self. Even in the most adverse circumstances, his serenity, self-confidence, hope, and sense of humor never left him. Does it matter if sometimes his self-assurance seems to recall paranoid delusions of grandeur? "I know, it is hard to recognize worth," he writes, "until it is crowned by success!" To strengthen their wavering trust, does he not ask his parents to trust him blindly? "I would like to offer the sight of my eyes, the strength of my faith, and the concrete pillars of my house of cards." Later: "The work of art is certainly invisible for now, but it

exists"; and "Of what I see, nothing passes by unnoticed, neither the stones, nor the people."

Yielding to Andor Horváth's request and his friendly encouragement, I approved publication of the letters before rereading them because I believe we should never repudiate the actions of our youth.[1] When the narrator of Proust's *Remembrance of Things Past* pays a visit to Elstir in his Balbec studio, he wonders whether the renowned artist is the same person as the scatterbrained painter he once knew as Mr. Biche in Mme Verdurin's salon. Still, he doubts the notion: "Could it possibly be that this man of genius, this sage, this recluse, this philosopher with his marvelous flow of conversation, who towered over everyone and everything, was the ridiculous, perverted painter who had at one time been adopted by the Verdurins?" Then, when he does ask the painter whether he is in fact Mr. Biche, Elstir is not in the least embarrassed. "A man of less distinction of heart and mind might simply have said good-bye to me a trifle dryly and taken care to avoid seeing me again," notes Proust. Far from being annoyed, Elstir answers:

> There is no man, however wise, who has not at some period
> of his youth said things, or lived a life, the memory of which
> is so unpleasant to him that he would gladly expunge it.
> And yet he ought not entirely to forget it, because he can-
> not be certain that he has indeed become a wise man . . .
> unless he has passed through all the fatuous or unwhole-
> some incarnations by which that ultimate stage must be
> preceded. . . . We do not receive wisdom, we must discover it
> for ourselves, after a journey through the wilderness which
> no one else can spare us, for our wisdom is the point of view
> from which we came at last to regard the world. The lives
> that you admire, the attitudes that seem noble to you, have
> not been shaped by a paterfamilias or a schoolmaster. . . .

They represent a struggle and a victory. I can see that the picture of what we were at an earlier stage may not be recognisable and cannot, certainly, be pleasing to contemplate in later life. But we must not repudiate it, for it is a proof that we have really lived, that it is in accordance with the laws of life and of the mind that we have, from the common elements of life, of the life of studios, of artistic groups — assuming one is a painter — extracted something that transcends them.[2]

Could I find a better defense than Elstir's words for those deeds of my youth that may astonish the reader? I myself have put on the disguise of Mr. Biche's countless variants, countless laughable and odious incarnations — I called them my masks. "I have a hundred faces to conceal myself," I read in one of the letters, "and everyone knows a different one of my masks." And elsewhere: "I have the right to rebel in the name of who I am against that which circumstance has forced me to become."

I have no intention, then, of apologizing for the fact that I reported on the Olympic games even though I had no expertise (I did, however, know the jargon); that I was a caricaturist who followed the trail of sports champions and beauty queens and a ghostwriter who, at the request of German press sharks, unscrupulously manufactured fake interviews with world luminaries. We all supported ourselves by such methods, such fraudulent activities. "In this period," writes Henry Miller in his introduction to my volume *Histoire de Marie,* "each of us managed to find some odd jobs, including some rather unusual ones, such as retyping an old newspaper article and selling it to an editor as original work. How many strange activities we engaged in then, grateful if we could make enough for a good meal."[3]

At the beginning of my sojourn in Paris, I had the ardent wish to become acquainted with a French family. An almost impossible dream. Even

today, the French—including middle-class and working-class families—only reluctantly allow a stranger into their homes. Most of the artists who came to Paris from other countries had other foreigners as friends, since they were incapable of breaking through the protective ring of the French family. For them, Montparnasse represented some sort of ghetto that the French visited only out of curiosity. "At about this time," Miller recollects, "I believe I only met foreigners. . . . Our company consisted of six members: Brassaï, Perlès, Tihanyi, Reichel, Dobó, and me."[4] (Perlès was Austrian, Reichel German, Tihanyi and Dobó Hungarian.) Well, barely a few months after I arrived in France, I made the acquaintance of an upper-middle-class family who practically adopted me. Mme D.-B. was a highly intelligent and erudite woman. Her talents led her towards painting and poetry, but especially music. She was an excellent pianist, frequently performing in concerts. I was bound to her by an intimate friendship—she was my Léda, my Frau von Stein.[5] I spent several summer vacations on her estate in Brittany. I owe her my insights into that mysterious universe they call "the world." "A man of the world," "a woman of the world": it took me a long time to understand the meaning of those expressions. Wealth in itself did not allow access to aristocratic circles. The doors did not open for many rich families; nor was a title of nobility sufficient. (I knew families of noble descent who were not received.) Even the title to a castle or property with a grand history did not always suffice. In Proust's time, the aristocracy of the Saint-Germain district constituted the center of "the world," setting the standard for social life and attracting the rich and idle bourgeoisie. In the thirties, however, many "feudal" titles lost their mystery as the descendants of aristocratic families were forced to marry the rich daughters of plebeian families, mostly Jewish and American, resulting in a dilution of the bloodlines beneath those titles. At any rate, the plutocracy had access to "the world" only if their wealth was accompanied by a refinement of taste, lifestyle, and artistic thought. To the novice, which I was, many an illustrious,

historic name with a great past called to mind past glories and the din of centuries. Upon hearing the name, for instance, of Count Villemarqué de Cornouaille, I was reminded of Marc, the King of Cornwall, and along with him the legend of Tristan and Isolde. Today, although the allure of "the world" has faded in my eyes, I am still affected when I hear "Allow me to introduce you to the Princess Richelieu," as it happened at a reception in New York not long ago, even when it was later discovered that the princess bearing the sonorous name was in reality an immensely rich American woman. In those days, however, I was prompted by an irresistible curiosity to explore the mysteries of "the world," know its secrets, its manners, and its customs. After a few years [in Paris], I gave the following account to my parents: "Besides the underworld and nightlife, I am now photographing high life … with the same passion, because all walks of life interest me equally. Now that a perfect whole is slowly emerging from the pictures I develop day after day (light and shadow, front stairs and back stairs, the five-hundred-franc banquet and the cesspit), I have to admit that I must truly be what Henry Miller called me: 'the eye of Paris'" (December 5, 1935). It did happen that, having spent the night among workers (railroad employees, rail cleaners, loaders at the market) and vagabonds, roughnecks and streetwalkers, I would be invited the next day to a soiree or masked ball of the aristocracy at the salon of Count Etienne de Beaumont or Vicom-tesse Marie-Laure de Noailles.

I was delighted to notice in the letters that from the start I saw photog-raphy as a way to uncover and record the world that surrounded me, the city in which I lived, as comprehensively as possible. There were a good number of critics, by the way, who reinforced me in my belief and my expec-tations about photography. "Brassaï is one of the few European photogra-phers who have succeeded in giving their thoughts a concrete shape in an oeuvre forming a coherent whole, and who have become known to audiences in the same way as writers have. It is a rare photographer indeed whose

prints are engraved in our memories in remembrance of emotions comparable to those felt upon reading a literary work. From the outset, Brassaï considered all his works as a unified whole. He is probably the only photographer — at least in France — to have acquired such a vast audience and mastered his material to such a degree that he can express himself with a flexibility and apparent ease that is almost literary in its nature," wrote Jean Gallien in the October 1953 issue of *Photo-Monde*.

Those who read my Parisian letters in *A Hét* might have tired of my financial and moral problems and the detailed accounts I gave my parents ad nauseam, and they surely learned precious little about my successes. It wasn't until December 5, 1935, eleven years after my arrival in Paris, that I told my parents: "You see, even if it took a lot of struggle, I have wrested from fate the opportunity to give my talent free rein after all." The collection, however, gives only a cursory indication of why the years 1932 – 33 were a turning point. This period marked my involvement with the surrealists and *Minotaure,* the world's most beautiful fine arts magazine; during this time I became acquainted with and befriended, among others, André Breton, Paul Eluard, Salvador Dali, Max Ernst, Giacometti, Tristan Tzara, Man Ray. It was also then that I made friends with a whole array of poets and writers: Léon-Paul Fargue, Henri Michaux, Pierre Reverdy, Robert Desnos, Georges Bataille, Raymond Queneau, Jacques Prévert, and Samuel Beckett, to name but a few. Among artists, I met Aristide Maillol, Henry Matisse, Georges Braque, Miró, Léger, Le Corbusier. For whatever reason, neither do the letters mention my close friendship with Picasso. Picasso's friendship! I have attained what thousands and thousands of young artists only dream about. The acquaintance and friendship of the most phenomenal artist of the century were worth a trip to the moon! Indeed, our friendship lasted until Picasso's death. (My book *Conversations avec Picasso* has so far been published in twelve languages.)

There is also very little in my letters about Henry Miller. Eight years older than I, he had just begun his book *Tropic of Cancer* when I was taking the photographs for *Paris de nuit,* which was followed by *Secret Paris.*[6] The same Parisian world came to life in his writings and in my pictures, which were often published together. I myself appear on three or four pages of *Tropic of Cancer:*

> Then one day I fell in with a photographer.... He knew
> the city inside out, the walls particularly; he talked to me
> about Goethe often.... We explored the 5th, 13th, 19th and
> 20th *arrondissements* thoroughly. Our favorite resting
> places were lugubrious little spots.... Many of these places
> were already familiar to me, but all of them I now saw in a
> different light owing to the rare flavor of his conversation.[7]

Finally, there is little indication in the collection of the phenomenal success of my photo album *Paris de nuit.* After being published in France it was published in London, and is today considered one of the most important and rarest books in the history of photography. The years 1932–34 were also when I conducted my study of manners through photography. Working strenuously, I completed a series of pictures on the Parisian underworld, from which, only recently, more than forty years later, I compiled a book published simultaneously in Paris, London, New York, and Frankfurt, and later in Tokyo.

A few words on the mysterious causes of my moral, rather than financial, "crises." Fate has blessed me, or rather cursed me, with many different propensities, all equally strong and each demanding its due. But how to discern that with the greatest potential for successful development? The incessant competition among these inclinations created constant nervous tension and anguish. I was in danger of becoming lost in the forest of my own abilities. At the same time I refused to favor any single talent at the expense of

another. In short, specialization, one of the first requirements—and calamities—of our modern era, has always been odious to me. I follow in the tradition of the seventeenth-century humanists, that is, those great figures of the Renaissance who were granted the right to develop, in harmony, *all* their talents in life and in the arts—including thinking.

Everything I have just described was aggravated by a linguistic crisis. My native language is Hungarian. While I was in Berlin, I perfected my command of German. After this came Paris. Due to lack of practice, after a few years neither my Hungarian nor my German was proper anymore. Since I hadn't yet learned enough French, I did not fully possess a single language. After 1935, when my contacts with the Anglo-Saxon world began to flourish, I should have learned English as well. That was when I decided to concentrate all my efforts on mastering French. This linguistic crisis explains the occasionally slipshod, uncertain style and awkward grammar of the letters written in Hungarian.

The other reason for my crises, which I could also call my profound dissatisfaction, lay in the realization that our era had questioned the very legitimacy of the arts. I read Spengler's *The Decline of the West* in Berlin; it had a profound effect on me. I accepted its premise that the arts had lost the prestigious role they had enjoyed in the past. Consequently, the artist's place had been usurped by the engineer and the builder, as in Roman times. I did not lack faith in my artistic calling but in *art itself.* That is why I quit making art when I arrived in Paris. Instead, I chose to wander, to procrastinate, and to accept solutions borne of necessity. I felt the crisis in the arts, so apparent today, very intensely in the thirties.

I hardly need to add that early in my stay I was so enthralled by the richness of Parisian life that I wasn't inclined to confine myself to the four walls of an atelier all alone. Life seemed much more exciting than the arts. "Could I have done anything wiser in the first few months than do nothing?

Nothing could have been more productive," I wrote my parents on June 13, 1924. One or two rather confused passages in my letters indicate the inner turmoil I was experiencing. My poor parents! How in the world could they have understood my laments, the often obscure ramblings I inflicted upon them?

I have to clarify another misleading point in the letters. They suggest that I was drawn to photography out of purely *practical* considerations. In reality, as soon as I learned to use the camera, I lost interest in having my pictures published as illustrations for commissioned articles. From the moment I realized that the camera was capable of capturing the beauty of the Parisian night (that beauty with which I had fallen passionately in love during my bohemian adventures), I pursued photography solely for my own enjoyment. At the same time I also understood that it wasn't at all irrelevant what form of expression an artist chose in a given era. Photography seemed to me to be a medium specific to our time. This realization in 1930 was another turning point.

Strangely enough, our century now relates to photography in nearly the same way as I myself did then. There is, however, a difference: a delay of forty years. Through the seventies, the world was indifferent and even antagonistic to photography, just as I had been through the thirties. It was only later that general opinion awakened to the fact that photography had become one of the primary forms of artistic expression in the modern era. This realization resulted in a worldwide reappraisal of the value of photography. Museums, universities, private collections, and art galleries that previously had accepted only paintings, sculpture, and drawings opened their doors to photography, especially in the United States, which was less overwhelmed than Europe by the heritage of painting. Over the past ten years, for instance, my photographs have toured America's museums, and a traveling exhibition sponsored by the New York Museum of Modern Art (which had

featured my works in 1953, 1956, and 1968) made its way to Australia and New Zealand, and then to South America (Venezuela, Argentina, Brazil, Bolivia, Peru).

If I made such a conscious decision in favor of photography, one may ask, why the anxiety to free myself from it as soon as possible? Why did I write, in what was undoubtedly the most obscure of my letters, dated August 2, 1939, "It was obvious that, come what may, I had to free myself from photography"? Why did I still consider it merely a "springboard to my real self"? To understand this thinking, one shouldn't forget that photography was my livelihood, a means of support that sometimes involved assignments that I carried out with reluctance. It was mainly this "subservience" that I was attempting to escape. On the other hand, during my stay in Berlin, I wrote that there had begun to emerge in me an "idea" that "had grown into a tree with wide-spreading branches." This was the "treasure" of which I spoke, but that "I could not fully possess." I was tormented by the fear that I would not be able to bring it to the surface, and I felt it was a more important task than creating a photographic oeuvre. Unfortunately, it is impossible for me to elaborate further on this here.

Let us stop for a moment at Picasso's often-quoted remark about the "gold mine." In *Conversations avec Picasso* I related what he told me one day in 1939 after examining my drawings: "You own a gold mine, and you're exploiting a salt mine." The account goes on: "A lively discussion ensued. I tried to explain to him why I had decided in favor of photography."[8] Our discussion continued four years later on May 3, 1944, when I showed Picasso my more recent drawings, made during the Occupation. "I like them even better than your youthful drawings," he said. "I have no reason to flatter you or to tell you a lot of stories. You should have an exhibition. What sense does it make to hide these things? You should show them, sell them." I told him "that since I decided on photography I have not wanted to spread myself too thin, and for the past twenty years I have never touched a drawing

pencil. Without his persuasion, I would probably never have gone back to it." "Frankly I don't understand you!" Picasso burst out almost in anger. "You have a gift, and you make no use of it. It is impossible — do you hear me? — impossible that you are completely satisfied by photography. It is forcing you into total abnegation!" "That self-denial pleases me," I answered. "One has an eye but not a hand; you are separate from objects, can no longer touch them. . . . A man withdraws into photography as if it were a monastery. In the cubist period, you yourself became a member of an order. Your canvases no longer bore your signature." "True," replied Picasso. "But it lasted only a very short time. When you have something to say, to express, any form of submission becomes unbearable in the long run."

The painter of *Guernica,* who was very talkative that day, also revealed his thoughts on the notions of vocation and success: "You have to have the courage of your vocation and the courage to live by that vocation. The 'second profession' is a trap! I was often penniless myself, but I always resisted any temptation to live by any means other than my painting. I could have followed the example of Van Dongen, Villon, and Juan Gris, and done drawings for some of the satiric periodicals. *L'Assiette au Beurre* offered me eight hundred francs a drawing, but I stuck to earning a living with my painting. At the beginning my paintings didn't sell for very much, but they did sell. My drawings, my canvases, they all left me, and that's what counts." I noted: "Few artists have your gift for imposing a painting such as the *Demoiselles d'Avignon.* They would die of starvation. Matisse told me one day: 'One must be stronger than his gifts, in order to protect them. . . .' And you had that gift: at the age of 25 you were famous, you had already known success." To which Picasso replied, "But success is an important thing! It has often been said that an artist should work for himself, for the love of art, and scorn success. It's a false idea. An artist needs success. Not only in order to live, but primarily so that he can *realize* his work. Even a rich painter should know success. . . . I wanted to prove that success can be obtained

without compromise, even in opposition to all of the prevailing doctrines. Do you want me to tell you something? It is the success of my youth that has become my protective wall. The blue period, the rose period—they were the screens that sheltered me." "The best hiding place is a precocious glory," I said, quoting Nietzsche, upon which he commented, "Perfectly correct. It was in the shelter of my success that I was able to do what I wanted to do, everything I wanted to do." I then explained to Picasso "that I did not choose photography as a second profession, or just as a means of earning a living, but because I considered it *one of the means of expression of our times.*"[9]

In a 1971 article, *New York Times* critic A. D. Coleman had this to say about Picasso's "gold mine":

> Picasso has not often been noted to be incorrect in his evaluations of other artists, but he surely erred when, during the Second World War, he said to Brassaï, "Why did you give up drawing for the camera? You have a gold mine and instead you exploit a silver mine [sic]." For, interesting and effective though much of Brassaï's work in other media may be—he has created films, drawings, sculptures and poems—his major creative contribution is unquestionably his photography. His photographs, unlike any of his other creations, are entirely and unmistakably his own; taken all together, his silver images form one of the most rewarding bodies of work in 20th-century photography.[10]

Raptures aside, I think Coleman is right about all of this. When in 1960 French television broadcast the film *Brassaï: The Eyes of a Man,* François Mauriac wrote in *L'Express:*

> Brassaï. Famous photographer who is unlike anyone else, in reality a painter and sculptor who has preferred photogra-

phy to sculpture and painting for some profound reasons
that would merit a serious study in themselves.

Could Mauriac have been anticipating the turn that would put photogra-
phy in a more positive light ten years later?

Sometimes I wonder what my life might have been had I met Picasso
earlier. What if he had instilled in me a contempt for a "second profession"
and warned me sooner about the importance of success? What if, prompted
by his motto ("You have to have the courage of your vocation and the cour-
age to live by that vocation"), I had devoted all my time and energy to the
fine arts? If I had chosen the career of a painter, a sculptor, or a filmmaker,
I undoubtedly would have made more money, though I would not have
achieved a greater reputation. Today my name is recognized worldwide.
Doesn't human life most resemble a river delta? The branches of the river
represent the possibilities in our lives. Some branches remain narrow, with
a meager flow, while others become wide. But no matter which branch the
water flows through, isn't it always the water of the same river, and isn't its
volume the same as well? All in all, I don't think I should regret that pho-
tography has turned out to be the widest branch of my life's river.

Brassaï

Paris, 16 January 1978

P.S. Before I conclude this preface, I feel it is my duty to indicate that
this volume is incomplete. It contains my letters only, from Berlin and Paris,
and none from the city at the foot of the Carpathian Mountains. I am
thinking of the letters I received from my father. Not only did he not oppose
my artistic ambitions, but he supported me all along, not only morally but
financially, even though his teacher's salary was rather modest. He had once
dreamed of becoming a poet. He undoubtedly passed his mantle on to me,

his eldest son, to fulfill his dream. He decided before I did that France would be my chosen homeland. My father was an enthusiastic admirer of Paris. He completed some of his studies here, then moved back with his family for an entire year in 1903. That is how I became a Parisian for the first time when I was barely five years old. When I returned in 1924, I felt I was returning to my second homeland — my childhood memories were still vivid. My father's letters! I have preserved them through all these years. Wit and joy radiated from them, along with encouragement and concern, of course. The dialogue that never ceased until his death at the age of ninety-seven can only be complete this way, with his voice.

Berlin, 26 December 1920

Sweet, dear Mom and Dad,

After so much adversity and so many unexpected obstacles I cannot believe that I am really in Berlin. I have always felt, even in Brassó, that something would come up at the last moment making my departure impossible.[11] Even during our painful trip to Berlin I felt the same anxiety. Now the worst is over: I am reclining in one of the rooms of a pension on Nürnberger Street. I can hear the ring of the streetcars, which have a peculiar Berlin overtone. The most important thing is that we are here, and this gives me the strength to cope with the difficulties yet to come.

To turn to our painful and long journey: We had an excellent trip — by Romanian standards — in the heated mail car until Nagyvárad. We stayed at a nearby railway hotel in Nagyvárad. Our train left for the Czech-Romanian border at 4 A.M. We arrived at the border in the afternoon on the local train, which has a bad reputation but was surprisingly decent, had tight-fitting windows and a small number of passengers. It was rather unpleasant that the train left only the next day and we had to spend another night. After leaving our passports with the authorities we received accommodations from an innkeeper named Blau (in Halmi they used the French pronounciation "Bloh") for 80 lei, 130 lei with service. Under the circumstances we slept fairly well, except for a lot of mice that made quite a racket. Next morning it was cold. We had to wait a long time for our passports. We finally got them back at noon. We got into the train and went through a mild and polite border control.

We arrived at Királyháza in the afternoon. Crowds of people waiting to

get through, many emigrants to America. We managed to get into the customs office and we passed through the second control as well. To our shock, we learned that the train was not leaving for Kassa until the next morning, so we had to spend yet another night. By then the boil on my neck had grown to the size of a walnut. For lack of a better treatment the ladies put an alcoholic poultice on my neck.[12] The swelling was aching and caused a fever. At Királyháza we succeeded in obtaining iodine, Goulard water, gauze, and cotton wool so I could have a decent bandage.[13] I decided to have it cut open upon arriving in Prague. At Királyháza we found a room for 80 Czech crowns at an old Jewish lady's house. (I wish we hadn't!) The night we spent there was a nightmare. No sooner had we gone to bed than our landlady came in and slyly told us that there were mice in the room and we had better move our food onto the table from the floor. An hour later she came in again and asked us to put our shoes and stockings on the top of the cabinet so the mice wouldn't chew them up(!). She had hardly left before an infernal rush began: rabbit-sized rats were galloping around in the room making palm-sized holes in the wooden floor. All of a sudden we realized that they had bored through one of the clothes bags. They also gnawed on a piece of our luggage and wreaked havoc on the wrapped meats. There was no way, of course, that we could sleep. We got on the Királyháza-Kassa train completely exhausted. By that time I was running a high fever. Unfortunately it was one of the last days before Christmas, and the train, which normally would not have been overloaded, was packed with people. We could hardly get a seat in second class, and the corridor was so obstructed that for twenty-four hours (till we arrived in Prague) we were locked into our compartment. It was so stuffy in the compartment that both my lady companions became sick (seasick). So we arrived in Prague in high spirits. (The tickets were expensive, almost three hundred Czech crowns to Prague. Meanwhile the exchange rate of the lei had dropped. We received only 94 crowns for 100 lei, although in Brassó 95 lei were worth 100 crowns.)

With great difficulty we found a room in Prague. In the meantime my wound opened up by itself and Grete Hoffstaetter gradually cleaned it out so that I did not need to see a doctor. It was already Wednesday and we discovered that if we could not make our arrangements on Thursday we would have to wait in Prague until Monday, because all the offices would be closed on Friday. In the evening we visited the Mensiks. They were very happy to see us. They were in the middle of their Christmas preparations and we chatted for a long time. I was, however, rather tense because the receptionist at the hotel had told me that there was no way I would receive a German visa without an entry permit, which Feri Mensik confirmed, and he is quite well informed in these matters. So the next morning Olga Weber and I went to the German consulate with great anxiety. To our great surprise, we received the visa within ten minutes without any special problems (it may have been the spirit of Christmas). (The invitation from the *Kreis-ausschuss* helped a lot.)[14] Of course, we were inexpressibly delighted and relieved. We could even have gone on to Bodenbach at two o'clock in the afternoon but we did not have enough time left, and little Burschi, who had tolerated the trip the best so far, got a 104-degree fever, which frightened us all.[15] Towards the evening his temperature dropped slightly, so we decided to move on. We arrived at the Czech-German border at midnight. Our train was scheduled to leave for Dresden at five in the morning. We stayed up until four. During the passport control, oh, what a surprise! It turned out that Grete Hoffstaetter's passport was not in order. She, too, should have obtained a German visa in Prague. Of course we looked for accommodations again and stayed in Bodenbach for the night. (We sent a telegram from there that you must have received.) Next morning, with great difficulty, we obtained Grete H.'s visa, and from three to five we celebrated Christmas Eve in the hotel room. The Angel was active all around.[16] We parted ways in Dresden: I came to Berlin while Olga Weber and Grete Hoffstaetter went on to Leipzig. I arrived in Berlin at two o'clock in the morning. I spent

my first night in a hotel room. Next day I moved into a pension recommended by Mattis-Teutsch,[17] where for 20 marks I got a good meal and a comfortable room. As soon as I can, I will rent an apartment and move out. During the two holidays I spent my time wandering around the city. I did not call on any of my acquaintances, since I would not have found them at home. Today, I started to scramble for a residence permit. The consulate at Prague gave me permission to stay for only eight days, which, I believe, can be extended without any problems. Everything is a dreadful distance from everything else. The School of Arts and Crafts is closed until the sixth of January. At the pension, I met a pretty girl from Brassó, Stella Popp, who is studying at the music academy. She was very pleased to have some recent news from Brassó and we had a nice conversation. There is another Hungarian boy at the pension, a medical student from Zenta, who gave me all kinds of directions. I also met the Veszprémi boy, who attends a painting school. He was very happy to see me and asked me to move in with him. I will probably do just that on the first of the month. It would cost too much for one person. My first impressions are most favorable and I do not regret for a second that I came here. I guess within a couple of days I will be totally acquainted with Berlin life and can start regular work.

The other day I started my work as a correspondent. My articles are mostly about art, of course; therefore, I send them to the *Napkelet*[18] and the *Keleti Újság*.[19] I occasionally submit them to the *Brassói Lapok* as well.[20] Starting in the middle of December, please monitor the two papers from Kolozsvár.[21] The articles will bear either my signature or the initials h-gy. Please put aside a copy of each paper, and mail one to my address in Berlin.

Thank you ever so much for your love and care,

your loving son

Gyulus

Berlin, 6 January 1921

Now that I have settled down a bit, I am relaxed enough to write at greater length. The first days following the holidays were spent reporting to many offices. Everything went fine, beyond my expectations. For now, I have a residence permit for six months, but I will be able to extend it later without any problems. Beginning the first of January, I had wanted to rent an atelier with Veszprémi but we were unable to find one, so I am currently living in a furnished room for 200 marks. I am still having lunch for eight marks at the pension, but in a few days I will get a meal plan in a smaller restaurant that is cheaper.

I started looking for a school as well, but new students are not admitted to state schools until the second semester. For the time being, I am working almost all day in a private atelier drawing nudes and portraits. In the coming two months, I intend to clarify my intentions so as to settle on a definite goal.

Unfortunately I have not been able to send anything to the *Brassói Lapok* yet. The papers here are so empty, full of jealousy toward the French and referendum issues. I sent a fairly long Berlin letter to the *Napkelet*. I hope they receive it and publish it in the feuilleton section of either the *Napkelet* or the *Keleti Újság*.

Berlin, 16 February 1921

I have visited several schools. I liked the School of Arts and Crafts the best (relatively speaking). It is very likely, unless I decide to do otherwise, that I will enroll there and take graphics and decorative painting. They readily admit foreign students. The second semester won't start until after Easter, however, and they don't even take applications until the middle of March, so I'll have to wait. For the time being I am still working in the private atelier I have mentioned several times before.

As far as apartments are concerned, I am still living in the same old one. Basically, I should be satisfied with it. It is close to both my school and the Hungarian restaurant where I currently take my meals (which is to say a lot in Berlin). It is a nice, spacious, bright room, but . . . I cannot stand my landlady, who is a grumpy, lonely widow. Second, we have gas lighting. Third, the room is on the third floor of the garden house, without an elevator, of course. One certainly gets spoiled here. Basically, it's a question of simple comfort, but why should I pay 220 marks when I can get electricity, an elevator, and a more genial landlady for the same amount? Today I gave her notice that I am leaving the room on the first of March. I do not have a new room yet, but you can quite safely send letters to my old address. Here everything is astonishingly well organized. The letters are delivered on the same day to my newly registered address.

The other day, I left the eatery, too. The food was quite plentiful and cheap but it was deadly boring. Mock meat soup, boiled potatoes instead of bread, meat with broth, compote with the same juice all the time — everything looked the same. So I moved over to the Hungarian restaurant. Here, I pay 220 marks per month for lunch, 60 for dinner, for which I get some

kind of soup—it's not important what kind—a large bowl of vegetable stew with boiled potatoes, and, for the third course, some kind of pasta (potato vermicelli, cabbage ravioli, sweet gnocchi with custard and grated walnut, and similar things), which keeps me at least until four in the afternoon. I can choose meat instead of pasta, in which case the menu consists of soup, and stew with meat. I regularly opt for the pasta; that is, for the most part I follow a vegetarian diet. Dinner is a bowl of vegetable stew, but sometimes I go for pasta if, for instance, poppy-seed dumplings are on the menu. The cooking is excellent. I can read all the Budapest newspapers here as well. The same is true of Café Nürnberg, which is also owned by a Hungarian and has great Hungarian gypsy music.

Food, by the way, is very expensive. Fish and cheese products are about the cheapest. There is no trace of café latte. In the morning I drink only plain (very plain) black coffee (called "mocha"!), poured into my cup by my landlady. Sugar and bread can be had only with ration cards. The bread is just about enough and we replace sugar with saccharin, which can be purchased without any restrictions. (A real paradise for diabetics!)

I go to a lot of museums and art exhibitions. (There are quite a few of them here.) I often go to the theater, too, mostly, of course, in the heavenliest of heavens.

I received a long letter from Kánka just today.[22] Since Dad complained that you have not heard from him since December 27, I will relate the gist of his letter to you. He received several letters from home, and was rather annoyed by the fact that you had not received his five registered letters containing reports.

I have not been able to send any new materials to the *Brassói Lapok* since the first. If I were not a correspondent, I would not even touch the German papers, they are so empty. I cannot write about Upper Silesia forever. The Prussian elections are scheduled for next Sunday. I think I'll be able to send a larger bundle at that time.

I have a lot of things in the works for the *Keleti* and the *Napkelet,* but I am awfully short on time. Time, time, time . . . I wrote a long review, "Einstein and His Theory of Relativity." I finished it today. It is about twenty pages long, each page filled with writing, just like this letter. I will send it to the *Napkelet.* They could publish it in three installments. I would most appreciate it if the publisher released it as a booklet. As far as I know, a review of his theory has not yet been published in Hungarian, at least not in Transylvania. I would sell it for 800 – 1,000 lei. I believe it could sell around two thousand copies.

I am waiting for the newspapers I asked for. You might also send a *Brassói Lapok.* I would also like to ask for a couple of programs from my poetry recital;[23] I need them.

All right, I'd better go now. It is a quarter to one in the morning and my landlady is already grumbling quite enough that I burn too much gas. (May she blow up along with her gas!)

Berlin, 28–29 March 1921

I will attend the School of Arts and Crafts starting in mid-April. The en- ⁄
trance exams will be given between March 31 and April 7. They admit for-
eigners unless all the available slots are taken by Germans. I hope there
won't be any great difficulties. I will write more about the school and what
I want to study there after I have been admitted. I will be changing apart-
ments. I haven't rented a new room yet, but I want to stay in this part of the
city. If I'm attending school, my current daily schedule will change greatly.
I will be busy between eight and twelve and between one and four, so I will
have to eat lunch closer to the school and give up the Hungarian restaurant.

Mattis-Teutsch will have an exhibition at the Sturm in April.[24] I sent a
telegram to him in Brassó so he could make arrangements in case he wanted
to be here for the opening. I just received his answer, however, in which he
says that he cannot come up for financial reasons and asks me to collect the
reviews, etc.

Unfortunately, I worked for the papers in vain. I did not write to the
Brassói Lapok because Dad informed me that it had folded. The other day
I read in the *Est* (Evening)[25] that the Hungarian papers in Kolozsvár were
shut down as well.[26] My three long articles on the London conference, sent
via registered priority mail, are all for the birds.[27] At least I had the luck to
have read this news in the *Est* because, quite inconsiderately, no one from
Kolozsvár informed me. I would have kept on working for nothing. For the
time being I do not dare write for the *Napkelet* either, since it, too, was al-
legedly shut down. Teutsch suggested that I work for the *Bukaresti Újság*
(Bucharest Paper). Has it been resurrected again?

Berlin, 11 April 1921

I have been very busy: I've been taking my entrance examinations at the School of Arts and Crafts for six days. The results were posted yesterday. As I wrote to you before, I was certain to be admitted on the basis of my work. They could have rejected me only if all the available slots had been filled by German students. I was prepared for either of these two outcomes and never suspected that a third one was also possible. I was all excited when I went up to learn about the results. The sheet that announces admission or explains the rejection said that, based on my work, they had determined that I was a painter who belonged in the academy, not the arts and crafts school. The professor who told me this immediately added that I should go see Professor Orlik (the best German graphic artist), who would give me further instructions. Orlik was very cordial. My work, he said, had caught his attention. A man — I'll try to convey his words accurately — who is a talented painter must not attend the School of Arts and Crafts. One can tell from all of my work, he said, that I was born a free artist who could not confine himself to painting signs and planning commercial designs. I would be better off if I attended the academy. He said he would even write me a letter of recommendation stating that I had applied here but that they had determined that I belonged in the academy. Here at the School of Arts and Crafts, I would not receive what I needed the most. I could not draw portraits at all, and only a few nudes. As a foreigner, I would have to pay 650 marks for the three summer months, but it wouldn't cost any more for two or three of us to draw nudes in an atelier.

It is the tenth of the month and here I am with this crazy dilemma. I have been both admitted and not. If I want it, yes; if I don't, no. I am upset,

while I believe I have reason to rejoice. In fact I *am* joyful. I would not have attended the school with unconditional joy, but, at the same time, I would very much like to stand on my own two feet, more or less. Dad, while not interfering with my plans, one day expressed his desire that I find some solid footing for my goals. This is how the school came into the picture. I was attracted to it because the course of study is not divided into years; the time it takes for a student to finish depends entirely on his own ability. I also figured that it would be easier to get a job if I attended this school. The very fact that I had graduated from the Berlin Kunstgewerbeschule would guarantee me a position. I also knew, however, that the school would necessarily slow down my artistic maturation, if not block it completely. When I decided to apply to the school I was aware of all this. Now, after the exams, the jury determines that I am a painter and that I should not attend the school. Now the dilemma is the same as before. If this concerned only art, I would not hesitate, because I *could* not hesitate. However, it is about life. I can see numerous examples here of how difficult it is to succeed in art (I mean in terms of making a living), and how much struggle it takes to break through. I cannot expect you to support me indefinitely. Even today, every check results in a guilty conscience. It is a torment that Dad has to support me even though I have my own two hands.

In the given situation my immediate plans are to go up to the academy tomorrow and hand over Orlik's letter. If the admission process has not yet started (it probably hasn't), then I will apply there. If it is already in progress, in which case no letter of recommendation can help, then I will either attend the school or continue to work at the same place I have worked until now (tuition costs 300 marks for three months).

It is a great relief that I finally acquired an atelier and I am completely satisfied with it. Although it is not far from my earlier flat, it is in Schönberg, another section of the city. The atelier is completely isolated from the other flats in the building and located on the sixth floor. It has running

water and gas lighting. The gas meter will be installed tomorrow. I even have a gas stove. I can now cook breakfast and dinner at home. (Eggs, for instance, have become very cheap: 1.30 marks apiece.) Since I will have hot water, I will be able to wash my clothes. The atelier itself is very romantic. The walls are angled and wallpapered with one big round front window. The sun shines through the skylight and I can work until seven in the evening, it is so light in there. As far as furniture goes, I have two tables, two cabinets, lots of chairs, an armchair, and a sofa that I use as a bed. My landlady gave me bed sheets as well. I have lots of drapery and a ticking wall clock, the only other sign of life on the sixth floor. I have only a little problem with cleaning, which is not included in the 200 marks rent. Sometimes I have to pick up a broom instead of a pencil.

I did not write to the papers, partly because I was busy, partly because I still do not know whether they are being published. I did, however, receive the bulky Easter issue of the *Napkelet* with my forgotten poem. I do not know whether it was sent from Kolozsvár or Brassó, though. From this issue I can tell that the *Napkelet* is in business. Soon I will mail a packet of my completed articles.

Berlin, 21 May 1921

I received a postcard from Kánka in which he informs me that direct postal service to Transylvania has been restored, so my life as a post office box is over.

The admission process continues. First it was supposed to be over by the fifteenth of May, but they later announced that it will be extended by two weeks, or rather one week, because the week of May 15–22 is Pentecost vacation. The results will be announced in the first week of June. The admission requirements are very strict. Altogether, the academy has only 130 students and only 30 of us were permitted to participate in the entrance exam. (There are hardly any foreigners at the academy; I know of only one Hungarian boy.) The academy demands a high level of drawing skill. Things are going well so far and it is likely that I will be admitted. In any case, I was able to work for free for two months, during which time I benefited a lot. I won't make a big issue out of it if I am not admitted, and even if I am I will enroll only for the winter semester.

I really like my atelier. The greatest advantage of the place is that I do not have to deal with the interference of a landlady. (I've had enough of them!) It is quite nicely and comfortably furnished. I had a gas stove installed, and since I have running water I can often cook and even do my laundry. Here, for example, is the lunch I am preparing today for a writer friend (Nándor Pór). We will skip the soup because of the heat, but we will have a cheese omelet with cucumbers and french fries, followed by rice pudding with jam (which I made this morning), and, finally, rhubarb compote, which I prepare with cinnamon and cloves. For dinner I often make fried potatoes and I even fry cauliflower and asparagus spears (first drenching

them in boiled water, then frying them with bread crumbs in grease). Tihanyi (the painter), who is a great chef as well, often helps me out with a recipe or two.[28] He used to room with Bölöni in Vienna.[29]

Here are the problems with my atelier, just to cover every detail: (1) I have to climb up to the sixth floor; (2) during the summer it is especially hot (it is not even summer yet, but the heat is already almost unbearable); (3) the toilet is located in an impossible place—across the attic through two iron doors.

Now let's turn to the newspaper issue. The last time I sent an article to the *Keleti Újság* was on the ninth of March, about the London conference. As Dad wrote, it wasn't published because the paper had been discontinued. The two long articles I had written about the conference a couple of days earlier could not be published either. I haven't sent anything since then, partly because I was very busy, partly because I was uncertain whether the paper would come out again. I was waiting to see what would happen. Meanwhile they restarted the *Napkelet* and began to send it regularly to my address.

Just recently, on the twelfth, I received a letter from the publisher of the *Keleti Újság* in which they repeated their February 23 letter word for word. They invited me to be a regular correspondent of the *Keleti* and to send a political summary at least once a week. At the end of the letter they asked why I had stopped sending articles to both the *Keleti* and the *Napkelet*.

I received a letter from Ligeti in which he urged me to send reviews of artistic events and said that they have been waiting impatiently for my articles (twice underlined). I will definitely make use of this "boom" and later this week I will send two articles to the *Napkelet* (they are partially finished). I will also write to the publisher of the *Keleti* and accept the position of regular correspondent. I will ask for 800 marks. (Is that enough?) I will send them political articles, altogether thirty printed half-sheets, four to five

times a month, and occasionally news clips (*weisse Blätter*). I will also subscribe to the paper. I will ask for extra royalties for every other manuscript intended for the *Keleti*.

I find it peculiar that the *Keleti* has sent me no royalties for my mailings so far. Now I will call on them to send the money either home or here. The political article I mailed to the *Keleti* on the thirteenth, which you might have received, indicates my reinstatement as a correspondent.

I think highly of the idea of a puppet theater and I will inquire about it. It is interesting that after watching a puppet show here it crossed my mind how wonderful it would be to do something similar in Brassó. Here, of course, performances are of a very high quality, with perfect set designs and lighting. I saw a dramatic performance with a large orchestra and famous actors declaiming backstage. The opera *The Abduction from the Seraglio* has just been performed as a puppet show. They say it is a great success. If I find out about some positive developments I will report in detail. Would you consider inviting a puppet theater from here?

For the time being I cannot visit home. If the deal with the *Keleti* works out I won't come home at all. If it doesn't I may visit in August and September. I can live here for two months on the money it takes to travel there and back.

May I ask, if possible, to have someone bring me (or perhaps send by mail) the script of my ballet? You might have a copy of it. Even though it is completely foreign to me now, a large ballet troupe (the ice ballet at the Admiralpalast) is looking for this kind of material. I might be able to place it there. In any case I have just finished a new ballet. I am having it translated into German and I may be able to come to an agreement with a German composer to write the music. I will also send a copy to Bartók.[30] He might accept it.

Berlin, 1 June 1921

First of all, the entrance examinations are over at the academy (earlier than we expected). The committee made its decision yesterday, and today they announced the results: I have been admitted.

If we take into account that I am a foreigner, that I started the course late, that I had no connections at all (like most of the others), and that out of thirty-two candidates they admitted only twelve, we can be satisfied with the result.

But don't get me wrong. The fact that someone was admitted to the Berlin Academy does not mean much (even though this is the most rigorous academy in Germany and those who are not admitted can sometimes gain admission in Munich). All it reflects is good drawing skills—not the same as artistic skills—which I seem to have. If I hadn't been sure that the academy could do me no harm (since I accept things with a grain of salt nowadays), I would not have tried to get in. I have several reasons, however, to be very happy about the result.

The academy is an ideal place today precisely because of the small number of students there. The ateliers are beautiful. One can work all day. Almost everyone has a separate atelier and his own model paid for by the academy. I found everybody to be very helpful and attentive. I will now work, for a month, at the private atelier on Kant Street where I was before the academic admission course. I still don't know what will happen in July.

I haven't yet had an answer from Kolozsvár regarding my demand for a regular salary of 800 marks (nor could it have arrived yet). As I said, if I get the position I will not come home. If the answer is unfavorable I might come. At this moment I am still not sure, since it depends on many things.

You can read a number of my articles in the *Keleti:* May 13: "On the Road to Reconciliation"; May 20: "The Exiled German Kaiser," "Larceny as an Approved Industry," "The State of German Internal Affairs"; May 24: "The World's Most Expensive Government Ministry"; May 30: "On the Road to Reconciliation," "Counterfeiters of 500 Lei Banknotes Arrested in Berlin." In addition, the June 15 issue of the *Napkelet* may publish my article on Béla Bartók and even a long review on Berlin theaters.[31]

I have not received anything from home for fourteen days and I do not know whether or not my letters got lost. Dad said a while ago that he would let me know as soon as you received my long letter.

It is very hot in Berlin, especially up in the atelier, even though I always create a draft so I can work. Not to worry, it will get even hotter. Lately I have been cooking dinner at home with Lajos Tihanyi. I admire him a lot as an artist, but I like him as a person, too. He's not reserved. He recently had an exhibition of his work in Berlin, although his success was more moral than financial.

Please, Mom, don't take my apparent resolve not to come home as a lack of desire to visit at all. Of course I would love to come home right this minute, but if you want something you cannot let yourself be influenced by emotions. Rather, you have to weigh the pros and cons with a cool head. That is why I still have to stay here.

Berlin, 21 June 1921

The academy gave a garden masquerade.[32] I had a major part in the preparations. Besides designing a tea booth and painting decorative walls I also designed a terrific lamp, 6 meters tall. We worked on it for three days. First we had to build a wire frame, then cover it with paper, and then paint the whole thing. What can I say? It looked excellent. I was racking my brains over what to do for my costume. Finally, at the last moment, I solved the problem in brilliant fashion. I bought a piece of black satin and a bunch of big wooden buttons, which I then covered with the satin. Then, based on a predesigned plan I sewed the black pom-poms and the buttons on my white painter's gown. The costume was planned to match my face and hair, which is long beyond imagination, so much so that if I ruffle it up it would cover three faces. You can imagine the impact. At least ten people asked me at the masquerade whether my hair was real. Someone even bet five bottles of champagne on it. The winner promised me one bottle but I have not received it yet. Since I had not gone to any balls during the winter the artist masquerade was a novelty. Lots of Hungarians and people from Brassó were present; you might know them: Irmgard Szikes, Stella Popp, Hartwig and his wife (Lenke Elekes), the Siegmund boy, Tihanyi, Róbert Berény, and other painters.[33]

I am very satisfied with my school. I can work peacefully and undisturbed there, which is the main thing. There is no pressure and no aggressive interference. I have been eating in the academy's cafeteria for two weeks now. The school closes on July 15 and I do not yet know where I am going for the summer. I would like to go to a small inexpensive village where I can work undisturbed, but I am not ruling out staying in Berlin, given that

its surroundings are so beautiful. The riverbank of the Spree is lined with summer resorts. Potsdam, once the residence of the kaiser, is one hour from Berlin and it is beautiful, as are the lakes around here — the Nikolassee, the Wannsee, the Demeritzsee, etc. Unfortunately I've seen these places only in passing; I've yet to get a better look at their beauty. The weather is not very suitable for excursions now. After the May heat the weather turned completely autumnlike and chilly. It almost always rains. Is it doing this in Brassó?

Brassó must be beautiful. Rakodó, Noa, Postarét.[34] You must be walking a lot, picking wild strawberries and mushrooms. There is a lot of fruit here, you can even buy cranberries, though they are still a little expensive. A pound of cherries costs 2 to 3 marks, cranberries 3 to 4 marks, strawberries 6 to 7 marks, etc. Do you go to the theater often? The theater season is over in Berlin. It is fine with me. One less thing to keep me excited all the time.

Berlin, 27 July 1921

I am enclosing a picture in which you can see, on the one hand, that Berlin has not worn me down completely, and I am in my Brassó shape — somewhat reduced — and, on the other hand, that the Berlin climate has had a favorable effect on my hair, which, as you can tell, grows visibly in this heat. If I might also mention, in parentheses, that I combed my hair before taking the picture, then you can imagine its length if it's not properly combed. The charcoal with the dark background is one of the things I did back in February; it is the head of a Russian major named Militzin who was once the vice president of the Russian House of Representatives, later a long-time officer in Wrangel's army;[35] today he is the editor of a Russian journal in Berlin. The other two heads are from works completed during the admission course at the art academy. Even though the instant photographs look primitive (they are cheap, though — 5 marks a dozen), I figured that even in this form they may show something; mailing original drawings is very difficult and no one likes to take such things back with them in person. Occasionally, I will also send photographs from the academy and maybe some of the paintings I am currently working on, although those are more difficult to make good copies of. All I can send for now are a larger self-portrait and several stills.

Now I will turn to the Berlin visit of Aunt Margit and her brother, Uncle Jen, since, as I recall, I mentioned them only in passing. I first received a notice from Karlsbad that they were leaving for Berlin on the second of July and would like to spend some time with me. This happened on a Saturday and they arrived in Berlin on the very same day. Of course they stayed at the most distinguished (and the most expensive) hotel — the Hotel Bristol on Unter den Linden, paying 400 marks per day for the two rooms.

They wrote me a *Rohrpost* card that same evening, which the mail service tried to deliver, but I was not home and therefore received the card only on Monday.[36] In it they invited me for lunch the next day (Sunday) at noon, which I understandably missed. They were waiting for me, but since I did not come Aunt Margit sent me another *Rohrpost*, which I did receive that Sunday afternoon. But when I hurried to the Bristol I could not find them there. The long-awaited meeting was left for Monday morning. My uncle immediately recognized me by Aunt Margit's description and I, of course, flung my arms around his neck. An American uncle does not turn up every day. To his question, whether I would have breakfast, I answered yes, and since in Berlin one can eat at any hour, I was willing to join him. He paid a mere 100 marks for the breakfast. Meanwhile Aunt Margit got dressed and I finally met her as well. Aunt Margit, enjoying her new role playing the millionaire and the Englishwoman, is still very much her old self—even as she drips food on her beautiful London and Paris clothes while eating and rubs the spot into a heavy stain (like in Révfülöp). Initially, my uncle was somewhat reserved but later warmed up to me. He mentioned that he had bought three tickets to Potsdam on Lloyd Enterprises' company car (160 marks each) and that I should join them. Though I have already been to Potsdam, I saw it only in passing—so of course I joined them. The car was for ten passengers and the rest of our company consisted of young Swedish women. It was here that I realized how charming the Swedish are. We became very good friends during the trip. We had lunch at a very posh restaurant in Potsdam and went on to Sans-Souci in the afternoon. When the driver asked me what Eastern nation I was from, I said I was an Armenian from Asia Minor, which the Swedish women were very happy about. Eager to learn, they immediately wanted to study Armenian. I responded willingly, making up some impossible words by combining the names of all the Armenian foods I knew. The best thing was when the driver showed us fig trees in a greenhouse, and, as he turned towards me, he said that these

trees might not be news to me. I nodded and said that I had spent my entire childhood in fig trees. By six o'clock we were back in Berlin. My uncle had a meeting and asked me to take out Aunt Margit. Naturally, I had to hail a cab every place we went; she would not go anywhere on foot. Aunt Margit wanted to have dinner in a posh restaurant so I whispered to the cab driver to take us to the best. Here we had a modest 180 mark dinner, and since I wanted to show her something wondrous I took her to the Admiralpalast, to the ice ballet. On the third day I sensed that there were some problems. After my uncle bought a pair of binoculars and a camera for his Argentinian sisters for 5,000 marks he started to feel uneasy. It turned out that from the money they still had (they had arrived in Berlin with 15,000 marks) they could barely pay for their hotel room and the return train ticket. In spite of this, we ate a magnificent lunch (I guess I will never have such a lunch again in my life). On this last day, my uncle became very fond of me. We became friends for life and I told them all my bad jokes. They were packing on Thursday morning and went on to London at noon. In any case, it was my tough luck that they visited Berlin at the beginning and not the end of their trip to Europe; otherwise I could really have benefited from them. As it was, all I got were a few good lunches and my uncle's apologies. He felt really embarrassed that they were broke by the time they had to leave. I have been waiting for the dollars ever since. This is the Argentinian story. At any rate these three days were a good opportunity for me to have a glance at Berlin's profiteering society and see all the extravagance.[37]

I have been able to work for the *Keleti Újság* and the *Napkelet* only sporadically. I sent them a theater column, which was published in the July 15 issue (they always send me issues of the papers), but unfortunately it is full of misprints. It is partly my own fault since my handwriting may have been hard to read, but even so I find it unusual that there were thirty serious misprints in a single article in a respected literary magazine. On page 797 alone, it should read "Ivan Goll" and not "Ivan Soll," "its circumference"

(*kerületét*) and not "its surface" (*területét*), "on his little finger" (*kisujján*) and not "on his car" (*kocsiján*), "they are rushing" (*rohannak*) and not "they are gliding" (*suhannak*), "on the sunlight" (*napfényre*) and not "sunlit" (*napfényes*), "daring break-up of its shapes" (*alakjainak merész feltörése*) and not "audaciously proposed assumptions" (*alapjainak merész föltevése*). It was just yesterday I wrote to the *Napkelet* (Ligeti) asking them to be more careful, and I also sent the second part of the article about Gerhart Hauptmann and Georg Kaiser. It is likely that it will be published in the August 15 issue or, if they print it with the as yet unfinished last part (about Reinhardt, new direction, new dramas, new stage, etc.), in the September 1 issue. I wrote a letter to the publisher in which I solemnly declared that I do not have time to be a regular correspondent for their journal, and if they want to look for another one I will understand. Now that I have started to paint seriously I realize how other affairs distract and hinder me. The letter of resignation I sent to Kolozsvár is the result of this realization. I would like to change my way of life; instead of regularly going to bed at one and two o'clock in the morning I want to go to bed earlier and get up earlier. When I sometimes wake up around four or five in the morning, the sun is already shining into the atelier, and I eat my heart out. I always make resolutions, but the evening comes and I cannot go to bed before late at night and consequently cannot get up early. It is also a big problem that the window of the atelier is facing the street, and in the evening, if my light is on, it is obvious that I am home, so I cannot hide from my friends. Recently, I remained firm when on several occasions they yelled up from the street, but I told them I was busy and could not let them in. Of course this is not always so. Tihanyi has become very attached to me; he turns to me with his day-to-day affairs and problems. When he goes somewhere he takes me as his interpreter (for he is deaf), to which I cannot say no. I also stand to gain from this, since I have gotten acquainted with several artists, collectors, and critics this way. My little Russian girlfriend, who fell madly in love with me (I have known her

for about two months now) will leave Berlin within a few days, so I will no longer be subject to her pestering. (I am not particularly attracted to her anyway.) I would gladly translate some interesting work of literary merit for the *Brassói Lapok*. Perhaps the translation rights would not cost too much. Primarily, I am thinking of Gerhart Hauptmann's *Heretic of Soana* (*Der Ketzer von Soana*), which has not yet been translated into Hungarian, and, as I found out from Fischer Verlag, has not yet had its translation rights sold. This is Hauptmann's most beautiful work, and, in addition to its splendid style, it is also interesting.

Now that enough time has passed I have an important confession to make that will clarify several things. I am not sure what I wrote earlier about the cost of my trip. If I remember correctly, I might have written 1,000–1,200 marks, even though the trip, because of all kinds of unfortunate circumstances, cost me around 1,800 marks. As I arrived in Berlin at night I unluckily and unwittingly ended up in one of the most expensive hotels, where I got a small room. I was surprised how cheap it was; it said 10 marks on the slip. Only the next day did I find out that the room, in fact, cost a hundred. The high travel costs are partially explained by the fact that there were a lot of passengers at Királyháza (we were traveling toward Prague on Christmas Eve), and, since I was running a 104-degree fever, and Grete's son was also restless, we decided that instead of traveling in third class, as we had planned, we would take second class. We asked the porter to bring our belongings to second class. We took our seats. The corridor was jam-packed with trunks and people. One could hardly move; we were sitting comfortably inside and I was surprised how nice second class was. The conductor came and it turned out that the stupid porter had seated us in first class. Those standing outside in the corridor were all passengers from second class. Czech railways have the following system: second class costs twice as much as third class and first class is double that of second class. Thus we had either to leave our seats or pay double the price. It was impossible for

us to get out of the compartment in that situation. Rather, we paid up until Kassa, then (since the conditions did not improve there) till Prague. Instead of 250 marks as planned, the Királyháza-Prague trip cost us 1,000 lei. Even more disastrous, we ran out of Czech crowns on the train and we were forced to change money through the conductor, who charged a reversed rate. For instance, we exchanged 95 Czech crowns for 100 lei, unparalleled in world history. In this way I arrived in Berlin with a one-month deficit in my budget that took a couple of months to balance completely. Now I can say whether 1,000 marks are enough or too much. My expenses are as follows: I pay around 250 – 260 marks for the apartment, including cleaning, cooking, and lighting. Laundry costs 40 – 50 marks per month. One can count another 50 marks for street cars — so far 350 marks. The most important item, of course, is food, which depends on whether I eat at school for 2.50 or in the Hungarian restaurant for 8 – 10 marks. Now that school is over, I cannot eat there, only at the restaurant or at home. This is about 300 marks a month and with a glass of beer or milk, sometimes dessert and tips, it certainly goes up to 400 marks, excluding breakfast and supper. True, I gave up eating breakfast, not to save money but because I can work better in the morning if I do not eat anything. The cost of supper also reaches 150 – 200 marks a month. Then come mailing expenses, etc. . . . In short, on the whole, 1,000 marks are enough to make ends meet. In the last six months I have also bought at least 600 marks' worth of books, mostly ones I will need sooner or later such as volumes on dance, anatomy, and painting. Mattis-Teutsch has an exhibition at Sturm. I am sending him a notice now.

Berlin, 26 August 1921

On Sunday we went out to Wilhelmshagen to visit Grete with Tihanyi and a woman dental technician from Kolozsvár. I sent you a postcard from there and, though I am one or two days late, here is the promised continuation. It was a beautiful day. We were swimming and rowing all day. One returns to the city completely revitalized.

I am completely satisfied with my achievements during the past eight months here, despite the relatively small number of works. For I am over the worst. Here in Berlin, I have finally found the path I need to follow, a firm direction that I lacked until now. What I did in Brassó was child's play, let's say, a preliminary test of strength through which I ascertained that I had a sense of color and form. I could not really call the work I did my own; it was Mattis-Teutsch who spoke through it. No wonder, since I followed him through all his developmental phases starting with his first brush strokes. This did not bother me since I knew that all I needed was a starting point, the opportunity to immerse myself in my own vision of things and to find my own way. This, of course, does not mean that I want to do something utterly new and different, something *nochniedagewesen*.[38] On the contrary, I have finally become clear about the mission of painting, which has been the same since the primitives made art: to express the essence of things. It is irrelevant whether this happens consciously or unconsciously. So I had to reformulate my own conception for making art. I came to the conclusion that expressionism is a magnificent orchid on which each bud may blossom into a flower more beautiful than the next. But new sprouts can grow only out of the soil. I admire the art of Mattis-Teutsch even today. Comparing him with the greatest German expressionists, I see his true value. What I

have had to do is reject expressionism itself. Nature is the starting point for everything; progress is a matter of constant simplification, a purer and purer emphasis of the essential. I am in the midst of healthy progress and I can already foresee its various stages. This is the primary condition of all sincere and systematic artistic activity. I can easily declare my recent works to be my own; therefore, I am not so reluctant to sell them as I was in Brassó. I hope that if I add graphic art (copperplate and lino cuts), I will be able to sell more. I will enroll at the academy in the fall (it opens on the tenth of October) mainly because of the military.[39] If you reach the stage in your development that I have, the academy is no longer important; you progress exclusively through independent work.

As I read in the *Keleti Újság*, the second installment of my theater column was published in the August 15 issue of the *Napkelet*. Ligeti wrote to me that the readers were pressing for it. I am still working on the third and the fourth installments, but since I have not yet sent them in, it is uncertain whether they will make it into the September 15 issue. They would also like to have book reviews. Ignotus came back to Berlin;[40] I met him the other day. He became the literary advisor for the *Tribüne* (Jen Robert's theater). I am on good friendly terms with Sándor Márai as well (he has also published some of his short stories in the *Napkelet*).[41] He moved here from Frankfurt.

Berlin, 23 October 1921

I am enclosing a bunch of photographs, taken mainly of drawings. Of the larger works, I have had a picture taken only of the sketch of a still life with mirror. I am sending my self-portrait only because it is a self-portrait; otherwise it is not worth much as a drawing. The rest are twenty-minute nudes. The ones in india ink are less good but there are some beautiful pieces among the pencil drawings. They are, of course, not academic (after all, I didn't draw them there), but, then again, what academician would be able to capture a nude so monumentally? What rhythm the human body has! I am completely familiar with the structure of the nude now. My aim is not simply to draw but to reconstruct. I construct a nude as it appears in nature. In my representation, I am freely remolding the shapes, even at the expense of anatomy and proportion if necessary. In general, I am completely satisfied with the results. I never had any doubts about my talent. I was convinced that all I needed was to move out on my own and prune the influence of those years I lived with Mattis-Teutsch; then there would be no more obstacles. If circumstances had been different and I could have stayed in Budapest, it would have taken me years to reach this point. I give thanks to Fate for not allowing me to become an art teacher, and to you, Mom and Dad, for making it possible for me to come and live here. I will definitely come home for the summer at the end of the academic year. I am already saving up for it. I intend to work a lot. My feeling is that seeing the Brassó region again with my current artistic skills can lead only to good things. (Won't the military queer the pitch?) My standing with the academy is somewhat ambiguous now. (I will mail my registration documents within a couple of days.) Actually, I write about it with satisfaction because I am

comparing it with the art academy in Budapest. I am impressed by the comfortable working conditions here—but you cannot make a silk purse out of a sow's ear! An academy still remains an academy, even in its best form. As long as we are talking only about anatomy, drawing, and art history, all right—I accept it. But why do they assign compositional themes? Can't they grasp the concept that one may learn to draw at the academy but one cannot learn art, and those who go there to learn art are finished? In any case, I will keep my independence and will do my best to avoid those things that I do not need—this is the smartest move I can make.

Tihanyi painted two portraits of me. The first one is finished—his best picture this year. He is currently working on the second, larger one. I am sitting at my desk and writing.

No unusual news in Berlin. Autumn is nice, or rather, it was nice. The weather turned foggy and rainy today. There are strikes going on all the time. Café and restaurant employees have been on strike for two weeks, printers for one week, the newspapers are not coming out. The final clash of labor and capital.

Berlin, 2 December 1921

For years, I had only conjectured that I was an artist; in recent months I have become absolutely sure of it. As a result, my self-confidence has grown incredibly. The gates opened up almost overnight, and one day I realized: I am an artist. I have thrown off all the mannerisms that used to so absorb me. I express my experiences ever more clearly. I am enclosing more recent photographs. They are still of my October drawings; I am one step ahead now. (Unfortunately, the photos are of poor quality. They render the values of the originals in a rather nebulous way.) I make some progress every day. The skills to express are a given; therefore the only other requirement for artistic creation is the artistic experience. If there is experience, all obstacles are overcome and expression occurs. If there is no experience, nothing can be expressed, even if the skills are there. At the academy, experience is out of the question from the start, and conscious work is required. They train painters in a workmanlike manner there. Artist and painter are, however, two different things. I am an artist. That is why we are incompatible. I do not do any work without experience anymore. If I have an experience, I can express it without any problem. Thus I hardly create any work that does not have artistic value. If someone asks me which of my works I rate the highest, I hesitate. One year has been sufficient to give me the skills that will last for a lifetime. Recently, I got to see the greatest painter of the past century at Cassirer's: Cézanne, who is claimed by every "ism." This exhibition tops everything. I could pack and go home. Cézanne did not weigh me down, rather he strengthened me as I was able to confirm the intimate connections between my aspirations and his art.

Olga Weber was kind enough to send me the package. It was great! The

pastry was so tender! It was as if Mom had baked her heart into it instead of butter. In any case, I finished it. Kánka told me that he inadvertently ate the bacon that was intended for me. To compensate, he sent me a kilogram of Pusztador cheese, which Tihanyi welcomed with shouts of joy.

Unfortunately the mark has fallen, resulting in higher prices for almost everything. Too bad, since I wanted to purchase larger quantities of paint.

Berlin, 19 December 1921

I received your long letter and I would have loved so much to kiss you both. How much worry, how much faith, and how much love! I sincerely believe in my mission, which is the only way I can explain how willing you were to support me without reservations, doubt, or misgivings when I was only thinking about being an artist, even though you could neither account for all that was going on inside me or understand my intentions. I also think that it is the economy of fate that you, Dad, view me as the fulfilment of your own aborted artistic career. At my age you were in Paris, as I am now in Berlin, surely full of dreams, reluctant to let everyday life pull you back into its eternal circle. Still, this life made its voice heard through your family. A realistic career, "a pleasant, comfortable way of life, free of any worry" — exactly the way life speaks to me now through Dad. And then comes a teaching career, and a woman — the Earth Spirit, the primary force of attraction in this circular life, pulling you to her like a magnet, stabilizing you for life. This is the only way I can explain the fact that I was barely grown when you already had plans for my future — a free career. What else would this be but the continuing strand of your own broken dream? When I enrolled in the art-teacher training course, I was almost reprimanded for not joining the artists' program. When the teaching career — thank God — ended by accident (which I now regard as a necessity), and I returned home to Brassó, it was once again you who (without knowing my motives) immediately made the idea of my escape to Berlin your own, supporting and helping me in every possible way.

So what's the whole story? I'm a bright kid who took his first peek at the world at an early age; and I can draw skillfully. That's all. I am of course

interested in everything new. That's how I got to know Mattis-Teutsch, who attracted me from the first moment we met. He conveyed to me everything that was new. Finding me quick to respond, he infused me with his conviction. One day—I was still a green realist—I realized that I could no longer draw. I couldn't draw the way I used to because I sensed that *he* did it the right way. However, I had enough self-respect even then to feel that it wouldn't be right either if I did it his way, because it was *his* way. We all pass through this crisis—we all have to (as far as I know, even Beethoven started his career copying Mozart, and Michelangelo imitated Donatello until he was fifty). In my case, however, the crisis lasted eight to ten years. I did not have a single picture of which I could have said, "Yes! This is my work." The burning desire I felt to go to Berlin was the fever of this inner crisis. I needed to be free, free at any cost! I had to find my own means of expression. And that was when, one bitter winter evening, I ran into Tihanyi in a Hungarian restaurant. The owner's wife later told me that she had felt sorry for me (I had just stumbled into that restaurant) because she could see how lonely I was. I believe I was having goulash or something when Tihanyi looked over at me from the next table. No one who has ever seen that face even once in a lifetime, even for a fleeting moment, will ever forget it. The face is dominated by two deep-set eyes. The eyebrows run upward in an incredibly bold line, and the tension in the hundred wrinkles of his forehead never lets up. Tihanyi is deaf. And while his deafness drove him inward to a degree and made him profound, it also took him back to primal nature. In this way an instinctive child and a profound thinker are united in him. How spontaneous are his outbursts of joy, enthusiasm, anger, and indignation! When he likes something he laughs with the unconstrained joy of a child. When he is troubled or annoyed by something he expresses it in a ferocious voice and stamps his feet in rage. He is not sentimental about himself or others. His judgment is of absolute value to him and is so deeply rooted that he will never change it. He looks through

people as one does through a window pane. No one can hide anything from him. Two minutes spent in his company, a gesture, a movement, are sufficient for him to form a final opinion about a person's character (which is true in ninety-nine cases out of a hundred). He is convinced that no matter what a person does they will always remain the same. Their personality is completely revealed by a gesture, by the way they speak, walk, write, or express themselves. Often, when we have a word or two with someone, and before I've even had a closer look at the person, he will have already stripped them to the core and can give me a full account of their character. This instinctive judgment is so decisive for him that he will leave a café simply because a bad pianist is playing, although he is deaf and cannot hear the music. So when he looked at me and stripped me with those small, piercing eyes, he must not have found me repulsive, for he joined me at my table, came to my home later that very night, and we became friends. So as I was trying to feel my way forward, fate sent a man to meet me. I owe to Tihanyi the fact that I didn't take a wrong turn and that the explosive change occurred within half a year. Everything that's within me, everything that I had been unable to express for so long, was suddenly given a voice. For the first time in my life, I found satisfaction in my work. Tihanyi's statement "You are an artist, unfortunately," sums up the awareness of an artist's constraints and the tragedy they involve. Nevertheless, I don't take a dim view of my future. Earning a living is easier these days, even for independent painters: Hungarians like Kernstok,[42] Berény, Czóbel,[43] Tihanyi, et cetera, all live on their earnings, without any subsidy. Tihanyi has just sold two paintings for almost 20,000 marks. Presently, he is negotiating his portrait of me, and he is unwilling to sell it for less than 10,000 marks.

The fact that the nude drawings I sent filled Mom with "holy terror" and that you, Dad, cannot find any "manifestation of experience" in them is entirely understandable. (I might almost venture to say that if you accepted

my work with delight, then *that* would be dangerous and suspicious, given the nature of artistic creation.) Hauptmann is now being applauded by the same bourgeois who booed him twenty years ago. The bourgeois who are ecstatic over Cézanne's paintings today are the same people who laughed at him twenty or thirty years ago. The bourgeois who storm Mahler's concerts are the same ones who ten years ago created a scandal to make his performances impossible. And in ten years' time (or perhaps even less) my Mom and Dad will like the very same nudes that now fill them with holy terror. Not everyone is filled with holy terror upon seeing them. I have seen people filled with holy devotion. I was having thirty of my drawings mounted at a gallery. By coincidence, Kernstok stopped in and looked at my work. I don't care what others think of my work when I am convinced of its worth. But you, Mom and Dad, although you are unable to enjoy the drawings right now, might be pleased with the words of the bookbinder: Kernstok expressed great pleasure and appreciation again and again after looking at each one. It is not without reason that each time Tihanyi comes over he bursts out in joy looking at my latest pieces. "I tell you, this is the best one!" This, however, lasts only a minute, for when I show him the next one he decides that *that* is the best. This is how he has proclaimed, with spontaneous enthusiasm, at least fifty of my pieces to be the best. I am already renowned within the Hungarian colony. The other day the son of a rich factory owner came to see me explaining that Kernstok had spoken of me at his house and he wanted to look at my work. Mrs. Ignotus also recently wanted to know where she could see something of mine. An art critic named Kállai also visited me. He writes articles on aesthetics for art journals. He liked my work a great deal and promised to publish an article about me with a few reproductions in a journal called *Ararát* in the near future. (An article by him was published in the same journal, with reproductions.) Yesterday Illés Kaczér came to see me saying that he'd heard a

lot of good things about me and that he didn't want to return home to Kolozsvár without having seen my work and being able to inform the people of Kolozsvár.[44]

I can be completely satisfied with the results and start the new year with the most beautiful hopes and full of confidence. It hurts, though, that I can't please my parents and that I can't paint pictures of Adam and Eve, but I must resign myself to the fact that it has to be so. This is exactly the mission of art: it initiates the uninitiated. Through the eyes of the artist, to whom everything manifests itself intuitively, they are shown the world, which grants a higher level of existence to those incapable of attaining it on their own. What I have accomplished over the last three months is merely the beginning. Whether you understand the meaning of all this or not, I'm asking merely this: if you have trusted me so far, instinctively and of your own accord, trust me now when *I* am requesting it. I assume all responsibility. The New Year's report is now complete and the reporter is saluted by many people.

My stove was installed, with all solemnity, about two weeks ago. It cost me 500 marks, but I believe it will pay off. I bought coke and wood as well, so I didn't freeze even on the coldest days (the temperature was below zero for a few days). My stove is very nice; we took to each other quickly. There are rings on the top and you can cook in two pans at the same time, which reduces my gas bill considerably. My only trouble is with the coke, as I have to take out the ashes with my bare hands.

My larder may be empty from time to time, but right now it looks good again. Jars of rice, oatmeal, flour, lard, and plum jam, as well as lots of American canned beans are lined up next to one another. When I received the news that those great supplies were on their way I cleared an entire shelf and hammered a nail into the wall for the bacon and smoked meat.

Literary activities are completely suspended for now: Thank God I've lived to see this. By the way, it seems that in Transylvania I am considered

a writer who has made his name. I received a letter from the *Forum* recently. It read, "We cordially invite you to honor us with a shorter, five- or six-quire manuscript of a novel. We would be delighted to publish it as one volume in the Transylvania Library's series of novels, beginning on the first of January. We calculate a royalty of 1,000 to 1,500 lei," et cetera. That's the last thing I need now . . . to write a novel.

I had thirty of my drawings mounted; they all look splendid. I also need to have a few frames made. I might need them suddenly. Glass is becoming frighteningly expensive. It is by no means certain, but the Hungarian painters in Berlin may well stage a group exhibition. Kernstok is the prime mover behind the project. He would like to show his *Last Supper* and he needs a foil.

We're going to spend Christmas Eve at my home; it will be some sort of potluck. There won't be too many of us, only a small circle: Tihanyi, Faludy, Sári Berger (from Kolozsvár), Nándor Pór, Veszprémi, Ida Andorffy (a former actress from the Hungarian theater), and, perhaps, Panny Elekes.

Berlin, 15 February 1922

The change I have been through has made me turn more and more inward, even if the extroverted side of my character seemed predominant. Since then, my introversion has become even more intense. I must start where I left off last time, when I happily told you that I was painting with all my energy. I have found a way of expressing myself. I also declared that the scattered state in which I used to live had come to an end. All this remains true, as it was then. I was only mistaken when I identified the artist with my *entire* self, when I believed that the solution to my inner crisis was final and that it was a solution that satisfied my *entire* self. It turns out that beside the artist and independent of the artist, there exists another ego within me, whom I call the "thinker" or the "philosopher." After the first conflict, in which my artist side was permitted to speak at last, I felt that the other side deserved equal rights as well. Usually each requires a whole person; the two can coexist only with difficulty, and seldom come together in a single person as they do in my case. When one of them becomes silent — when I cease to react intuitively — the other, with the unquenchable thirst for knowledge, speaks. This is how they alternate endlessly. This duality may bear fruit and result in many discoveries in fields like aesthetics (for instance, it may mean that the aesthetician can observe the artist within me), but it currently creates a tension that knows no rest. This is why for days or even weeks I barely make contact with anyone. I avoid people, I hide in my owlery between the two eagles, which looks like a pigsty during these times; my hair grows and so does the filth from which I can be dug out only with difficulty. That is the situation. The fact that I am able to write all this down, i.e.,

am aware of it, proves that I am now getting closer to what is called self-knowledge. Now I admit what a strange bird I am. In the process of getting to know myself I have also arrived at boundaries that perhaps I'll never cross.

And now I have to stop this train of thought and write about something that seems entirely outside the subject. Nevertheless, you will be interested in it purely because of its novelty, namely, graphology. The gist of it is that one's character is entirely displayed in one's handwriting. Little by little, they are beginning to investigate the matter scientifically, but not yet with the zeal and seriousness it deserves. There is a famous graphologist (Scheermann) in Vienna who analyzes handwriting in a scientific way. He can say that "X" and "Y" correspond exactly to a particular characteristic. There is a pianist in Budapest who has discovered her graphological talent for character analysis, the only difference being that she works entirely intuitively. Tihanyi was holding a letter in his hand when they met here in Berlin. She looked at the envelope and said that Tihanyi had written the letter unwillingly, simply out of obligation. She returned to Pest a few days later and Tihanyi began to send her samples of handwriting, mostly those of well-known artists. Thrilling revelations followed one after the other about the most private matters of various people, secrets that had been shrewdly concealed (contact between people is nothing else, anyway, but a constant machination for concealment), or secrets of which they had been totally unaware. Not only did she report on characteristics and capabilities, but also on physical properties, illnesses, and events that had played important roles in people's lives, or on other people who had had a decisive impact. And she accomplished all this by studying two or three written words, an addressed envelope or other similarly nonexpressive writing. Tihanyi always felt gratified and reassured by these character analyses, as he saw his own observations justified. There's hardly a Hungarian writer whose handwriting he

didn't have analyzed. I can't remember exactly what she wrote about Ignotus, for example, but something about his self-complacency, his patronizing tone and snobbishness, and that he is used to being a recognized figure. She wrote amazing things about Béla Révész.[45] Let me relate as an example her character analysis of a German aesthetician: "Pedantic, scholarly type, great knowledge, expertise in some particular field. Some kind of pose. Strong critical sense. Self-important. Extraordinary sense of aesthetics. Stubborn and unyielding in certain matters, sometimes in minute ones, but sometimes in significant matters also. A certain kind of bashfulness or secrecy, I cannot detect that exactly. Reserved character. He may have had a relative or close family member whom he either didn't like, or this person harmed him in some way or treated him badly. (This might have happened in childhood.) Strongly attracted to objects: for example, works of art, although not necessarily art."

I happen to know the person in question. He sits in front of a picture for hours. He doesn't say a word, he just sits and sits. He cannot be moved. He was chased away from home by his father when he was young. About Archipenko, who is a famous Russian sculptor (he lives in Berlin), she writes that he's a great artist, he always wants to create something new, but he becomes decadent in the process.[46] Also, he is said to be a handsome man, with beautiful blue eyes. Having analyzed the handwriting of the Hungarian painter Róbert Berény, she says that he takes poisonous drugs. She says about another person that he has a kidney disease (of which he himself was unaware). Her first word about a Russian princess was that she descends from an aristocratic line, that she is naively simpleminded and extremely good with her hands (she does small craft projects). It was sensational when the graphologist exposed one modern Hungarian painter (whose work is exhibited at the Sturm at the moment). She wrote that he is full of affectation, creates incomprehensible new works, and wants everyone

to believe that he is a great artist. The greatest moment was that after he had asked Tihanyi to send him the result of the analysis, he attempted to defend himself, in an apologetic letter, against the "defamations" of the graphologist. He admitted, however, to having been depressed for days because of the results.

This is how, a few months ago, Tihanyi secretly sent her my handwriting, too. He wanted to surprise me. I was sent in good company. He also sent the handwriting of Kassák,[47] Mihály Károlyi,[48] and Józsi Jeno Tersánszky (who is the best Hungarian writer of prose today),[49] along with that of the greatest living German painter, Kokoschka.[50] She wrote the following about Tersánszky: "There is something false in this (that is, in this particular piece of handwriting), he either speaks differently at other times or he seeks to mislead. I don't know, but it is a strange tone. Otherwise, quick thinking, playful, reckless, bohemian, witty, full of ideas, conceited, and presumptuous at times; at other times easily discouraged, insecure, and short-tempered." (To exemplify how excellent and apt the analysis is: Tersánszky sent a two-act play to Berlin for publication. Tihanyi asked me to read it and give my opinion. I read it and found the theme very good, but only the theme: the piece itself struck me as poor, boring, and flat. Which in no way detracts from the greatness of the best living Hungarian novelist. I even wrote an impromptu review of it for Tihanyi, who sent more or less the entire text to Tersánszky. Tersánszky retorted that he didn't give a damn, that it's his duty to consider his piece good, although it was possible that it was in fact poor, etc. After a few days a letter arrived from his wife, stating that Tersánszky had fallen back into his earlier neurosis and begging Tihanyi to write to him, for God's sake, and explain that the play was indeed a fine work, only he hadn't been able to appreciate its quality after a single reading, etc. Isn't it magnificent how the graphologist described him in these two words: conceited and presumptuous?)

The part about me reads as follows: "You send me nothing but talented people. Which is fine, but this is why they share a number of qualities. Better read than usual. Love. Tenderness. It is *important* for him to be good. (She never underlines anything, as everything she states is equally important; however, in my case, I don't know why, she underlined this word.) Creative. Complicated. Colorful. Strong. Sad. Unstable mood, yet loyal, faithful. Contradictions. Has a tendency to be an intriguer sometimes. Plenty of artificiality, affectation, though it is possible that it should be interpreted differently and traced back to the above. Changing attractions." The handwriting Tihanyi sent her was from last summer. Still, this came as a revelation. Behold, there exists beyond all human subjectivity an objective evaluation that cannot be defeated by machinations or deception. It is not difficult to see that it is not only handwriting that carries your entire personality but that it is present in all your movements, gestures, the shape of your head, your voice, your manner of speaking—briefly, in all physical manifestations and your whole physique. It just happens to be your handwriting in which it can be most easily observed. This fact also shows that the *artist* can never be separated from the *person*—if it can, the person is simply not an artist. It also proves that there is indeed art, and that art is capable of objective evaluation no matter how many critics wail over the loss of standards in our age, maintaining that art can no longer be distinguished from nonart, and no matter how much malicious joy is expressed by dadaists who argue that art has never existed and that all art is nothing but deception. It is actually incomprehensible that science should have treated physiognomy with such unconscionable negligence and with so much hostility—aside from its great practical significance, it holds the key to the deepest problems. An elementary-school student's handwriting will manifest all the abilities that of course the child has no way of knowing about and the parents have not the faintest idea of. A day-old baby's head, or palm, reveals the inclinations and characteristics with which it has been born. Yet, from the

fact that a person's handwriting changes (however imperceptibly) from one day to the next, it follows that a person's fate is 50 percent in his or her own hands and 50 percent predetermined at birth. The graphologist can perceive, with her infinitely acute sensitivity, the changes you go through from one week to the next, or from one day to the next (otherwise she is an absolutely ordinary woman, no different from others). From a week's worth of letters by Tihanyi, she traced the history of a whole love crisis, in a sharp and clear-cut manner that the person in question would have been utterly incapable of achieving.

The analysis she wrote about me is brief. She used to write in greater detail, but she doesn't take so much trouble these days because, by her own admission, she is passionately in love. Nevertheless, it came in handy as it helped me with the work I call "gaining self-knowledge." It distinctly expresses the duality of my character that I referred to earlier: "complicated," "contradictions," "changing attractions"—these all indicate the same thing. There is the artist and the creator on one hand: "colorful," "strong," and also "goodness," "love," and "tenderness," without which no artist can exist. On the other hand, there is the strong emphasis on being well-read, which doesn't even mean having read a great deal, since it is not compared to the reading of others. Rather, it means that what has been read is immediately systematized and evaluated. In one word, this observation has a qualitative, rather than quantitative significance. As far as "sometimes an intriguer" is concerned, well, it is perfectly true. You, Mom and Dad, may not know it, but it is indeed a characteristic of mine. The fact that the graphologist describes me as "sad" might also surprise you both; generally, people know me as a cheerful person (even Tihanyi was surprised by this remark). I am the only one who knows how true this is. She can see cheerfulness only in the form of an "unstable mood."

Having said that, I would like to write a few words about the drawings I sent home (you have no idea how pleased I am to chat like this again, at

last). I must begin by confessing that the nude drawings are all third-rate, without exception. I apologize, but I thought they were good enough for a first batch. I'll send better ones later; there are plenty of those, too: I have about two hundred good drawings.

The academy? I've written a lot about it, both pro and con. Finally, I can, I think, explain the way I relate to it, both in practice and in theory. I confess that I have only worked a total of twelve hours, that is three mornings, at the academy. Everything else I have written on the subject is hence null and void. It was actually the preparation course for the entrance exam that did me some good. When I enrolled last year I chose the teacher (there were three to choose from) with the fewest students. The first morning, I drew a head, doing it my way (the teacher and all the other students, of course, start from the eyes and finish with the nose). The teacher comes over and looks at my work. "What is this going to be?" he asks. "A head," I reply. He says nothing. "Just continue, please." The same scene takes place the next day. The head is finished on the third. It is Saturday. The teacher comes to correct my work. "Well, you could actually be good at drawing, but . . ." et cetera, et cetera. "But I would still prefer if on Monday you started the way I and the others do it." "Is that so? Adieu!" These were the three mornings. This year, I applied properly. Fortunately, the left hand doesn't know what the right is doing, so the administration doesn't know . . . et cetera, and I received my documents, and so now, exercising my rights, I'm going to attend the masked ball, wearing such a sensational costume that everybody will faint in admiration. I built a colossal nude figure from wire and paper and I will be inside. All that's left to be done is to paint it, and then I'm going to have it photographed, and I believe the pictures will be printed in magazines. Originally I made it for the Sturm ball but I was unable to finish it because of the strike, so it shall be worn to the academy ball. By the way, the entire Hungarian community will be there.

To give you my final judgment on the academy, as promised — well, the

thing is that I would be glad to go because there are models and one can work there, but the problem is that there are teachers, too. I must say, however, that (1) the academy would be an excellent institution if only there were no teachers, and (2) the academy should still be viewed as a neutral forum. Whoever is born an artist will eventually be one. No academy has ever undone an artist. The individuals it spoils can be spoiled precisely because they are not artists in the first place. It is better for them to learn how to draw and paint and become professional painters rather than playing at being artists, armed only with drawing skills that have nothing to do with art. In their desperation and helplessness, they do horrendous things, as do 70 percent of today's generation of painters. Ultimately, I owe the academy this appreciation, once and for all.

I'm not going to write about my present work now for lack of both time and space. Yet I must give you the joyful news that I have achieved my first financial success, even though I have yet to cash in on it. The thing is that an immensely wealthy merchant family took a liking to my portrait drawings and commissioned me, first, to draw a portrait of the grandmother and the two little children. The very same people purchased a drawing and an oil painting from Tihanyi a year ago. The family being rich, and the grandmother extremely fat, there's a lot to draw. And since she is ugly, there's a lot to erase, which means that my services are likely to be well rewarded. I've had dinner with them twice so far, and yesterday—as I was drawing at noon—they insisted I stay for lunch. I'll probably have to immortalize several other members of this rather extended family. I'm going to finish the old woman tomorrow.

Berlin, 24 March 1922

I went through a severe crisis — I had to go through it — now the whole thing is behind me. You ask me what it was? A huge rebellion I had to quell, and indeed I did. It was Tihanyi who helped me through this crisis, and the moment I most needed it, Goethe started to speak to me. I kept a vigil beside him — with him. As though he were not talking to Eckermann, but only to me. He spoke about the false tendencies that conspire to deceive one, but that one does not easily believe to be false. He spoke about amazement, which is the maximum of what a human being may attain; he noted that the majority of people are not satisfied with it and are like children who, upon seeing their own reflection in a mirror, turn it over to see what lies behind. This is, regrettably, the disease of the age, and I cannot disown my age. "You are an artist, you are endowed with the ability to be amazed, leave philosophy alone, don't speculate, don't look for the reverse of things, don't keep turning the mirror around, be grateful for being allowed to look into it in the first place." It was at the best moment that a gust of wind tossed me into the world of these intellectual giants. I felt I wouldn't have a moment's peace until I had devoured them all. The crisis was not, even for a fleeting moment, a crisis of the artist. It was that of a man who has to husband his energies. Self-knowledge cannot and should not be taken any further than this. However, this threshold must be reached no matter what, so that one's strength can be employed efficiently and not wasted on things of little or no consequence. This is the result. The file is now closed.

Meanwhile nature has changed, too. Winter has turned into spring, the weather is clear again and so is my workshop. The spring cleaning was done yesterday and today; all the filth has disappeared — the floor has been

scrubbed, the pots and pans are gleaming, my clothes have been ironed, and order is bound to take over in my correspondence, too. As I sit here in this spotlessness — I could call it the neatness of a pedant — the whole period behind me seems like a dream. But it's not only the workshop that appears new, so does nature (I've been on a walk in the Tiergarten). Order and tidiness can be enjoyed only by someone who has lived in a mess and squalor for months. People would find the world a new miracle each time if they were to sleep, like bears, in their caves for months.

Berlin, 6 April 1922

I received Mom's loving letter today and was overjoyed. It wasn't in fact a letter, but a huge slice of bread upon which she had spread her love and her heart.

And now a brief introduction to the high cost of living in Berlin due to the decline of the mark. Food prices have climbed the highest: a pound (half a kilo) of pork costs 36 to 40 marks, veal 45 to 50 marks, lard 60 marks, ham 70 to 80 marks, butter 70 to 75 marks and eggs 4.50 to 5 marks. As a consequence, a meal that cost 8 marks when I first arrived now costs 20 marks at the very least. These are the rates in general. A city train ticket used to be 50 pfennigs; it costs 2 marks now and will be 3 in a matter of days. Clothing, although its price has also increased, must still be cheaper here. Better quality material costs from 450 to 500 marks and up. A tailored suit costs from 3,500 to 4,000 marks, although one can be purchased ready-made for 3,000 marks. A winter coat (thick fabric and lining) costs about 6,000 marks. A topcoat is 3,000 to 3,500 marks. Shoes cost 700 to 1,000 marks, ready-made shirts 300 to 350 marks.

I bought as many painting supplies as I could. Here, too, prices have doubled or tripled in just a few days. To mention just one example: Castell pencils (I need a lot of them because I work with them) cost only 4 marks three months ago; they went up to 7.50 marks three weeks ago and cost 12 marks now. The same can be said about paintbrushes, canvas, and paint. I bought canvas — 10 meters — of different qualities, for about 600 marks. It was a bargain. I purchased about twenty brushes and a lot of paint. They must still be cheaper than in Brassó and cheaper than the French materials

available in Bucharest, if you can get certain items there at all. And I want to work in the summer, and work without any distractions.

Lili Alexander, Bernát Alexander's daughter (a film actress), visited me the other day accompanied by Edit György, Alexander's granddaughter, and she bought two drawings for a thousand marks.[51] I'm still expecting money from the family in which the old woman had to leave suddenly and the children came down with the Spanish flu; I have been unable to finish any of their portraits.

I don't yet know the exact date of my journey home. I expect it will be the end of June, as I've written more than once, although it may be earlier. I have decided to take the same route I took to get here. I have been invited to Kassa by a writer named Mihályfi and I'm likely to stop over for a day or two. Secondly, I will have a lot of luggage so I may have to mail a trunk or two. So let me ask Dad to send me the Berlin address of that shipper.

I can't deny the fact that I've come to love Berlin and that it hurts to leave it, although the shop has long been closed and I can't purchase anything. However, I'm chock-full—and I'm secretly awaiting the moment when I can decamp and go.

Anyway, I have a friend here who will do anything for me. He's taken up my cause as if it were his own, and this is Tihanyi. I've written about him many times. The relationship that at first was more like that of a master and his disciple deepened little by little until all the barriers fell down on both sides. And I have been able to observe this phenomenon, forced to experience eternal silence and isolation up close. Sometimes when I want to tell him something extended, I write to him. A few months ago, he wrote me a kind of memoir. You may well understand our relationship better if I quote what he has to say about it:

> I happened to be struggling with one of the knots in the
> curiously strong threads of the "tale" as an old, enchanted,

49

brass-nosed witch or Prince Charming, and I said unto you: "Go to the crypt and lie in the coffin and however temptingly and beggingly the resurrected virgin princess asks you, do not get up until the cock crows three times. The rest will go by itself; there will be much ado, a wedding feast, and nothing will part you from immortality." You see, it cannot be explained more simply than by a tale. It wasn't any different in reality. Only a part of the tale is missing. I don't care whether my laying bare the whole story makes me look any smaller or any greater in your eyes. But only this part of the story—*not* the tale—concerns you, or rather concerns us, inasmuch as it shows that chance is inevitable: your coming here was as necessary to you as it was to me. Don't get me wrong: it wasn't a "spiritual" need and it wasn't a question of "occupation." I don't occupy myself with anyone or anything. I don't look to anyone for an occupation or for anyone to occupy themselves with me. The fact is that not even in the most emotional moments of self-adoration—if such existed at all—would I be willing to admit that I had found in you the incarnation of the "grateful pupil." On the other hand my superconscious self wanted to find this in you. You know that I wanted to assume the role of the "master" for somebody else at the time, although I sought no more or less than the reassurance that I can influence another person; if only I were able to impress on them the need to size up the image of a thing without losing sight of its immeasurable internal value.

I told you then, as I am telling you now, about a lot of things whose meaning you've begun to experience and—as I see now—absorb. It is not my teachings that you have

made your own, but rather the right way that leads to the goal. There's no system here, but there are tracks, as there are footprints at the roadside.

Or towards the end of his writing:

> The same way (it's not a method) you understood me a year ago, when I told you to measure the weight of the bodies: construct yourself, carry yourself into the dead matter by pounding the space to make room for the bodies; with the force of the momentum your own spiritual balance will follow the eternal laws of motion along the contours and through individual studies. The road swings into a straight line as you proceed upward. There are no footholds as you proceed upward; it is simply faith holding you by a strong, invisible bond.

I still don't understand, only suspect, why he, too, needed my coming here. Perhaps he has never broken out of his isolation the way he did with me. Our characters are different, completely opposite, I might say. He has immense willpower, he's overbearing and likes to dominate others. He's a piece of nature, still attached to its umbilical cord, as an infant or animal. He never thinks about the fact that he's thinking, everything rises to the surface from his unconscious. He is, in essence, selfish, the way children and animals are. Nevertheless, he will do anything for those within his scope of interest. But it may be precisely because our characters are opposite that they are complementary. I am aware that my departure is hurting him, but he is not sentimental. He's staying in Berlin, his financial existence being guaranteed. He has just sold two pictures for 40,000 marks and he could sell as many as he wished.

I visit museums quite frequently since at home I won't have the opportunity for a long time. I've read a great deal of Goethe. It is precisely when

he says the greatest things that he makes me feel he is saving me the effort of saying the same. We cannot gain anything new from the outside world simply by reading; all we do is to clarify and realize what is within us. And when I became aware of that, it suddenly mattered little whether or not I knew Spinoza's ethics, as everything he says already has its place and value within me, and reading will only show me the same thing again, in a more definite form through an absolutely secure inner voice.

Kisses to you all, in the hope of seeing you soon — your loving Gyulus.

Paris, 29 February 1924

Here I am in Paris at last. My temporary hotel room, where I'm writing
this letter, is on the seventh floor. As I woke this morning I caught sight of
the top of the Eiffel Tower above the sea of fog and the mass of buildings,
and now I can see the sky, crimson from the light of the boulevards. Unfor-
tunately I haven't been able to go to the city yet, I have only roamed around
Montparnasse and the Quartier Latin, hunting for a room. But this is Pa-
ris, and wherever you go, whoever you talk to, everything is nice, charming,
and, indeed, captivating.

 The route through Tirol was beautiful; I couldn't get enough of gazing
at the Alps. Unfortunately we were traveling by night, so I couldn't see
much, but the Lake of Zurich and the twinkling sea of stars that was the
seventy-kilometer stretch of villas on the other side provided a fairy-tale
spectacle. I will write about this in more detail in the *Brassói Lapok,* as I
(unfortunately) have to start my journalistic activities tomorrow (the first
of the month). Our train got into the Gare de l'Est at half past nine in the
morning. Several of my fellow passengers and I shared a taxi to get to the
rue Delambre, and I woke up my friend Tihanyi from his "dawn" dream.
(This is where I'm living presently, two floors higher, for 8 francs a day.) My
trunk is still at the station and will be until I can find a nice place to live.
I've been running around for two days now — without too much success thus
far, but I've had promises from here and there. (People are friendly and un-
reserved; furthermore, my knowledge of French is a great deal better than
I thought.) I'd take a cheap hotel room or any kind of room for now — after
some searching I will be able to find an atelier or something similar. I hope
to bring matters to a head tomorrow morning because this room here is too

expensive.[52] Last night, although I'd been traveling for three days and running around for one, I put in an appearance at the Rotonde. This is the artists' haunt in Montparnasse—a place where my hair was duly appreciated at last. What lovely, charming women—my God! If there is a drop of bitterness in my delirious enthusiasm (among the good old croissants, brioches, artichokes, extremely light meals, shop windows, ravishing women, and all the other things that cannot be listed and described) it is because Mom and Dad cannot be here with me now. But all is not lost that is delayed. I don't know if it is due to the good wines Tihanyi is treating me to, but my brain is numb and I'm struggling to get out each word. However, I'm not in so bad a condition that I can't thank Mom and Dad for the huge, and definitely final, sacrifice they've made for me. I bestow my gratitude upon you for what you have done for me.

Paris, 6 March 1924

I've been in Paris for exactly a week. You may have received my postcard and my letter, but I wonder whether the magazine has received my first article (about the journey), since I thoughtlessly neglected to send it by registered mail. Well, if they have, you probably know that, as I wrote to Seress, I found a permanent place to live after searching for two days. It is a stone's throw from the Odeon stop, not far from the intersection of the boulevards Saint-Michel and Saint-Germain. It is a fine location. I can walk to the Louvre or to the Beaux-Arts if I wish. It is just close enough to Tihanyi's home, should I want to be with him, and far enough to ensure a necessary distance. By day I have to walk through the Luxembourg gardens to the rue Delambre; the free schools are on the other side of the Luxembourg, in the small streets leading into the boulevard Montparnasse. In the evening, there are croquis sessions, which I will also attend. My room is 200 francs, to which an extra twenty francs were added. It is expensive all right, although by Paris standards it is cheap and very good. It is on the third floor. There is a huge window from the floor to the ceiling that looks onto the street, there's a good, wide bed fitted into the wall, there's hot and cold running water, a large glass cabinet, a closet, steam heating, a lovely little fireplace, and so many mirrors that I can see thirty-two copies of myself if I wish. My "desk" is small, but I won't really need it as they still have free ink, pens, and papers in the cafés. It is also strange to find, after Romania, that shoes are placed neatly in front of doors, and that you can rummage freely in street stalls and at department stores, as the customer is trusted everywhere. My pictures are now hanging on the walls of my room—they arrived safely along with everything else. They were packed perfectly. The trunk hadn't

even been opened at customs; I found everything in the same order as I had packed it in Brassó.

I eat wherever I happen to be, most often, however, in a cozy little restaurant not far from Tihanyi. He thinks that the food there is the best in Paris, and it must be true if he says so, since if anyone knows, he does! Everything is as it used to be: the tables are tastefully set with bottles of oil and vinegar and jars of mustard; there are wooden spoons and forks for salad and long slices of white bread *à discrétion;* the butter is placed next to the sardines in little turrets, just as tastefully; the roast beef is just as rare and juicy as before; the *pommes frites* still melt in your mouth; the hare meat (that's what I just had today for 2 francs 10) is just as excellent, its gravy delicious and brown. Everything is still fried in butter: green beans, cauliflower, and lots of small vegetables that I don't even know by name. There is chicory, too, and company. You can still find *riz à l'anglaise* although it has a different name now. They have superb crème fraîche with confiture — but what's the use of all this talk; next time I'll send you a menu. The food, of course, is expensive, but no more so than eating out would be at home, and, anyway, it just doesn't compare. (I certainly don't mean Mom's cooking!) For four and a half francs you can have an appetizer, a nice meat dish with vegetables or salad, a quarter of a liter of red, white, or rosé wine, some nice dessert or cheese (a considerable portion), and as much bread as you can get down your throat. You *can* eat cheaper, though. There are 3-franc prix fixe restaurants. I've seen a large student restaurant on the boulevard Saint-Michel — and I'm sure their cooking is just as first-rate — 3 francs for lunch, 2½ for dinner — that's, let's say, 6 francs altogether. The metro, which you can take to get to any point in the city (they have only one type of ticket) costs 30 centimes. A coffee with a croissant or brioche costs 60 centimes. So, daily expenditures come to 10 or 12 francs but that includes two feasts — this is exactly why I feel my situation is secure here. If my room

were a little cheaper I could make ends meet, albeit humbly, from my earnings alone (about 390 francs). With the money I brought from home *and* my wages, which may increase a little, I'll be fine for the next three months. In the meantime I'll see to some other sources of income. The price of clothing and underwear is considerably lower than at home; you can buy fine, elegant shoes for as little as 70 francs or a tailor-made outfit for 350 to 400 francs, since both supply and competition are great in every area.

I'm not worried about anything for the time being. I stroll about the Louvre, go with the flow on the boulevards, stand agape before stones and people, watch the anglers by the Seine, the smokestacks as they bend their heads under the bridges, and the pigeons and parrots of the animal dealers; I walk around Notre-Dame, first on the outside and then inside — indeed, the columns are so sublime, so beautiful, that I even said a prayer.

This afternoon I was invited to tea at the home of the Russian painter Ivan Puni and his wife, Boguslavskaya, with Tihanyi and Karcsi Kernstok.[53] I'm sure it was a nice gathering and I'm annoyed at having missed it. Tihanyi and I had agreed to meet in a café. I went there to write an article for the *Brassói Lapok* (I've already mailed it, thank God), but Tihanyi never came. I don't know whether he meant a different café or whether I had misunderstood him — anyway, it was foolish of me not to have written down the Punis' address. At least it's to your benefit, in that this letter was born and will soon be on its way.

I think you'll like the articles; they will soon start to come at shorter intervals. If only I could pull myself together and get the hang of the French language! It is still a struggle, not so much the speaking because I speak as much as I can, but rather because my vocabulary is so sparse that I can barely understand half of what I read. Just browsing through the newspapers, though useful, takes far too long, not to mention that I can't even begin to think of doing an interview in French. Still, I am making progress, slowly

but surely. I pick up five to ten words every day, which will add up to a lot in six months. I would like to ask Dad to have the paper sent to my address, or if it's too expensive, to send one or two issues containing the published things. I'm going to try to apply to a Czechoslovakian paper. Unfortunately, the address of the *Kassai Újság* (Kassa Paper) is the only one I have, so I wonder if you could send me (after consulting Seress, maybe) the addresses of a few Czechoslovakian and Yugoslavian newspapers.[54]

I'm looking forward to one day finding a letter waiting for me, in box number 8 next to my room key. And, you must come to Paris this summer or in late spring—with others or not. A round trip to Paris, in a first class hotel and restaurant, can be easily organized for 16,000 lei. If five people sign up, one person's fare will be covered. I will have long made myself at home here by then.

Paris, 17 March 1924

It's true that this is not the best time for letter writing, but I'm hard pressed for time, I owe you two letters, and, anyway, even if I didn't . . . today is *mi-carême.*[55] I'm sitting on the terrace of the Café de la Paix next to the Opera, or, to be more precise, I'm completely squashed between two small round tables and there's a deafening noise all around me, whistling, buzzing; people just refuse to budge from the edge of the pavement. Alleging the holy day as a reason, the waiter refused my request for paper and ink; as a result, I'm trying to write with a pencil until the carnival gets here, or until a shower arrives and disperses the crowd (the sky is threateningly gray already) — because then I'll definitely be knocked over along with my letter and table. Yes, life is all vivacity, here, there, and everywhere. Since I've been in Paris, I've become interested, more than anything else, in the way Paris lives and moves and how one moves with it *today,* and not in the way people used to live and move centuries ago, as can still be observed in museums and buildings. No, Paris is not a museum like Florence or Rome; it is still very much alive. I've been here for a month and I've barely had the opportunity to stop in front of the monuments — and how eagerly I used to yearn for those very monuments! I often stroll quite indifferently past the greatest works of Rubens and Leonardo da Vinci at the Louvre, but I never tire of the view of the Tuileries, full of children, or the Seine. I am the first to be surprised at how untouched I remain by the relics of past eras and the precious dead. But in this initial period I cannot, and will not, do any differently, and I'm doing my best to put aside what I had in mind when I came here. I'm definitely not interested in exhibitions. The few I have seen in art dealers' galleries were enough to make me realize something that is not new and has long

haunted me like a nightmare, something from which it will be difficult to free myself unscathed: how little life there is in these pictures and how little they have to do with today's life. Someone like me, who doesn't look for aptitude and acquired or learned skill in a picture (or for anything for that matter), but rather for human values, can see them as nothing but decoration in nicely furnished salons, often worth less than a prettier cushion. To become a maker of pictures and deliver goods to order, or to respond to assurances that the merchandise sells — this I've never been and never will be able to do, unlike nearly everyone both here and everywhere else. I did not become a painter — or, to use a horrible phrase, I did not "choose this career" — because I wanted to "succeed" as a painter. I'm envious of those who can paint the way others repair shoes or write business letters. Had I sought to establish myself as best as I could, mindlessly using my abilities, I would probably be in an enviable position by now. However, someone like me, who looks at life differently and whose thoughts start where those of others end, could never entertain such a position. If I did, my life would lose all meaning. I understand perfectly that petty bourgeois thinking is incapable of evaluating me otherwise: it sees only incompetence in what is in fact heroic struggle. Yet can even the most loving parental affection, which is always there, fortify one alone with his thoughts, without any friends or support?

It has already started to rain and it looks like it won't stop until tomorrow morning. The crowd is surging around me, it is physically difficult to write, and I find it hard to collect my thoughts. To be continued later today, or, if I don't get home, tomorrow.

Well, I'm continuing on Good Friday. And if the thoughts I put aside earlier happen to resurface here in Paris (God knows how) — let me wrap them up. I have developed such high expectations of life and of my own values — which are one and the same — that my life will lose its goal and all its meaning if I cannot make these values manifest. It would be a lie if I said

I didn't want to be successful, but since I've become aware of my values I've had to avoid every opportunity for success that didn't help them to become manifest. Mesmerized, my eyes fixed on one point, I rush past things that might make others happy and satisfied, things others would grab with both hands. I know that I am worth too much to draw cute caricatures or write little articles, and any success achieved by these means would be both demeaning and shameful. I know that nobody else can experience this—not even Dad, despite all his goodwill. Unfortunately I feel it all the more acutely and this feeling is nearly unbearable. And now that I've resigned myself to journalism—since I still have to make a living somehow—there was a good reason why I wanted to create the figure of Gyula Brassaï, who wrote these little articles and assumed responsibility for them. Indeed, just like a novelist I had to create a separate being with superficial journalistic opinions; I never write what I think. All the more terrible and degrading that I still sign my name to them. I often wonder whether we are even yet: have the 3,000 lei been worked off? Do they have the right to demand this additional humiliation?

But let's drop these thoughts, which are not exactly carnival-like, and also those, even less carnivalesque, that I've been trying to brush aside amid this carnival atmosphere, which has suited me well this past month despite certain disturbances. Only in my worst moments have I seen Paris, the age and the people, with the eyes of a warrior examining the terrain before a battle. But I feel strongly that this is the only possible place for me, the only place where it wouldn't seem comical were I to stand and declaim as the audience headed for the cloakroom. And I will try to cultivate the values that elsewhere I haven't thought worthwhile even to reveal. Only Paris can be the arena for this struggle.

I come and go in the city like an old Parisian and I feel completely at home. The same applies to my room, which is entirely satisfactory. In the

evenings the cooktop hums on the mantelpiece — it's true that it cost 15 francs, but it certainly burns better than our cooker at home. Next to it is a beautiful metal jug with water for tea. When the water is boiling I pour it in the china teapot. There's butter in a china cup. My kitchen equipment consists of one aluminum pot, which I've used so far only to make ham and eggs or scrambled eggs.

I have run into a lot of acquaintances from Berlin — Russians, Hungarians, and even Germans — but I have only a few French acquaintances as yet. It's true that I haven't made too much of an effort. Apart from being with Tihanyi, the only time I'm in company is when I go to the Rotonde café at night. There I see French, German, Russian, Spanish, Negro people — indeed, from all the nations in the world. Through Tihanyi I've been invited to the house of a Viennese engineer and his wife, once for dinner and once for tea. I sometimes spend time with the Bölönis or the Kernstoks. Just yesterday, when I interrupted my letter, they called me to go and see the parade with them; that is, we got soaking wet together. The Bölönis are pleasant, nice people. They used to be good friends of Ady's[56] here in Paris and they remember many events in connection with him. There was an agricultural fair on the Champ-de-Mars not too long ago. We went to see it together — I don't know if he wrote an article on it for the *Keleti*. I've also been to a big masked ball — it was organized by some Russian painters in the Bullier; it really was enchanting. Such vivacity and liveliness — what costumes and what women! — you couldn't begin to dream of at home.

Paris, 9 April 1924

I'm going to break the order and write without waiting for a reply. I feel
some pangs of conscience regarding my previous letter. It may have seemed
as though I was blaming others for something whose stigma—with all its
unpleasant consequences—I had taken upon myself. I was certainly not
blaming anyone! Yet, am I not permitted to speak my mind about the cir-
cumstances? I've swallowed enough, while putting up a good face, on the
verge of stamping my feet and destroying everything that I could lay my
hands on. Be proud that I have moments like that! I have the right to rebel
in the name of who I am against that which circumstance has forced me to
become. Who understands my pride, a feeling that is beyond being satisfied
by any old success? Who understands that any success that I don't achieve
through what I am hurts? Who will comprehend my demands, which are so
great that I am willing to give up all my needs for them? What else does
parental affection wish for if not some fat tidbit, a peaceful, calm, and "nice"
life? Who the hell needs that? And if talent is no more than a hobby—to
hell with talent! I don't need a "nice" life but a great one—otherwise every-
thing, everything is meaningless.

The honeymoon is over. Thoughts are beginning to rush to the fore.
The city and life here are more enchanting than I could ever have imagined,
but what about art? Well, art is dead, here, there, and everywhere, for good.
Not only in its creative force but also in the eyes and the souls who would
need it and perceive it. And if someone contradicted this, mentioning the
salon or Picasso's latest "classical" works, they would only be revealing the
extent to which the perception of art has become nonexistent—for how
else could they call these things art? Should I deny that I like to spend time

in the Louvre and it gives me great pleasure? In the French and Italian primitives, in the rich Egyptian collection, in Ingres, and in the honest art of Corot, Courbet, and Delacroix I have found some true human values. Great spirituality radiates from nearly every piece in the Cluny Museum, and the Indian collection of the Guimet Museum is an entire world that I've just come to know and appreciate. Regrettably, however, my immersion in these worlds, which entrance me, in which every last button or pot inhales and exhales the air of great art, makes it that much more impossible for me to see anything but canvases, more or less skillfully colored, in the pictures shown at these living-corpse contemporary exhibitions. And I won't deny that I was so disgusted by the collections of the horrendous Luxembourg museum that I could hardly get through them; I would like to blow the whole thing up, with all its sculptures and paintings, even if I had to sacrifice a few nice paintings by Cézanne and drawings by Degas. I have an overwhelming feeling—and here in Paris it's stronger than ever before—that I am still capable of offering something of value. But is there anything to encourage me? I see only practical, reasonable types everywhere who evaluate everything in terms of money. A new world is being constructed with the wonders of technology, and art, for which the age has lost every sense, has no place whatsoever in it. There will be a big crafts exhibition here next year. The organizers are seeking to demonstrate the union of art and industry. They have no idea that they are erecting a tombstone for art. Seventy years ago, Hebbel, who had an eye for such things, could see here in Paris the iron logic that would shape the future, despite all protests. He wrote in his diary in March 1844:

> I've seen the industrial exhibition. I could really feel the boundaries of my personality here. Not only are these things of complete indifference to me, but also total repulsion. The more they're nearing art, the more repelled I am.

They awaken the same feeling in the artist as seeing an ape does in a man.

I've been to the industrial exhibition once more. I was wandering in a world that is stranger to me than Herculaneum or Pompeii would be, because I have no contact whatsoever with these machines, expensive furniture, priceless paraphernalia, the products of handicraft elevated to art; I find no pleasure in them, I don't want to yearn for them; it is simply revolting that objects intended for everyday use dupe their way into the world of art, and who knows, maybe they will expel all higher truth from this world, furthermore painting will withdraw into glass, china and wallpaper and sculpture into metalwork to fulfil everyday needs in an even lower sense than at present — when needs are at least intellectual, although of only a limited religious nature.[57]

But what was Hebbel's disgust compared with the disgust that we have to feel today, we who have been trapped here with an artist's eyes? Who can measure this disgust? Leonardo could never have anticipated that what he painted with his own lifeblood would serve as an after-lunch delicacy for American epicures in lorgnettes. I lose my mind when I think of the people who are looking at the pictures next to me and what they see in them. But Leonardo could at least offer his own age something great, and as he lived in an age of ascendance, he could count on later generations. Today the age works against us with its every move. Is there a need for values? Who needs them? No, not at all: what the world needs are goods, goods that sell well, if possible. Paris, the center of the arts for centuries, is a market fair, with its painters, sculptors, art critics, art dealers satisfying rich Americans' demand for luxury.

Here are the thoughts that are oppressing my brain; it is impossible to free myself from them. I have my strength and I have my self-confidence, for which no obstacle is too great, but I only have to open my eyes—before even taking the first step—and the icebergs make me freeze. Oh, the formula: talent = Paris = success. It's not that simple! Of course, had I come here only to market my talent, were this my will and only thought, I could even call the prospects rosy.

15 April. I'm continuing the letter today. We went to Saint Cloud a week ago Sunday. The park is more varied, and I prefer it to the one in Versailles, maybe because of the wonderful view of Paris, the Seine, and the mountains of Meudon. We were invited to Rueil by an acquaintance of Tihanyi's. The road takes you along the Seine. Of course the neighborhood is full of people—that was the first day of the Longchamp races; there were cars all over the place. Trees are green everywhere now. The weather has become really mild. We went to Bourget the other day to attend a festive ceremony in honor of the Romanian king. I've never seen such an impressive event before! Just imagine: an exercise with two hundred airplanes in the air! We wanted to go to Fontainebleau, but the journey is too expensive—approximately 16 francs round-trip, and anyway there aren't enough leaves on the trees yet. We managed to see the last three hours of the six-day race from eight to eleven o'clock: this is sports mania at its wildest. Everything gets on one's nerves, and if there is any place to study the French temperament, this is definitely it. By the way, I'm going to write a short article about it for my paper, let people read my name. I haven't seen anything published recently, although I have sent pieces diligently. Of course I have no way of knowing what to send and when. I wonder if they've received all of them. I'd like to be aware of their wishes and work accordingly. I asked Seress to write to me about everything, as his previous letter—if he did write it—was lost. I would also like to know whether my pay could be increased.

I'm going to get a commission through a Viennese engineer and his wife. I've been invited to their home several times. An English acquaintance of theirs would like to have one of the walls of her bedroom painted, and she has set aside 500 francs to have it done and they recommended me. It seems serious and I only have to wait for a call before seeing her, and, of course, I'm going to accept the job.

I'm very often with Tihanyi. The fate of his exhibition will be decided in the near future. After a long period of trying, and lots of encouragement, deception, and disappointment, the only remaining question is whether the exhibition, to be mounted by one of the best art dealers and collectors, will be in May, June, or the autumn. A definite answer will be given on Wednesday evening. This is what Tihanyi's trip to Berlin depends on, as he still has part of his workshop, furniture, pictures, and belongings there.

Paris, undated (May 1924)

In the course of the great hunt for a room, in which I was intensely en-
gaged before the first of the month and again during the past few days, I've
roamed all over the suburbs from the Montparnasse cemetery to Malakoff
and Montrouge. I've gone as far as the wonderful park of Montsouris, out
by the castle wall. I wouldn't say this apartment hunt is an unpleasant ac-
tivity. I like life in the suburbs, and Paris is beautiful everywhere, but at the
moment it is vital to find a cheaper apartment since the franc is going up,
like bubbles in wine,[58] and 220 francs is too much.

I could find something inexpensive outside Paris, in a villa in Auteuil,
Boulogne, etc., but I'm tied to Paris for the time being. If I were to travel to
the city daily it would take only more time and money. Now that the franc
has become so strong, in such a frighteningly short time, I really have to
start earning some money. I'm glad, in a sense, that circumstances have con-
trived to force this situation upon me. Unfortunately the 500-franc fresco
painting—it is now up to 600 francs—is as distant and uncertain a hope as
Lepadatu's scholarship. When everything had been prepared, this Mrs. Pil-
linger left for Nice, and as a consequence everything is void until she re-
turns. I wrote to three newspapers asking whether they needed articles, but
so far only the *Bácskai Napló* (Bácska Journal) has replied, stating that they
already have a correspondent here.[59] I don't believe the others will ever reply.
The Olympic committee has accepted me as a correspondent after asking
me to complete an application in French—thanks to the letter we sent on
behalf of the *Brassói Lapok*. This means a great deal to me as I felt I had to
link my money-making plans to the Olympics. Brandishing my press card I

can freely attend matches and training sessions, and I'm going to start draw- /
ing caricatures. As I wrote to Kahána, I've been accepted by the committee
only for rugby and soccer matches, and they've asked me to submit my ar-
ticles. I need to get an assignment from the editor of the newspaper ad-
dressed to the committee for other sports. The deadline for this is May 15,
but, as I've already sent an application, a few days' delay would be of no
great consequence. Therefore, I'd like to ask Dad to transcribe the applica-
tion in French from the enclosed text, on the newspaper's letterhead, and
return it to me. This, as I said before, is very important not only for the
newspaper but also for me, and therefore the sooner it is done the better.
There's another matter I must convey here in the prosaic part of my letter.
Although the franc is high, old etchings, bronzes, books, etc., of which there
is a bountiful supply, are still very cheap here. A number of people I know
live and have made fortunes by purchasing antiques at auctions or from an-
tique dealers and selling them in Germany, etc.

Now Bölöni has devoted himself to antique dealing. He has bought a
great number of manuscripts, Egyptian sculptures, etc., with a major outlay
of capital and is now in London to buy and sell. I, of course, cannot even
think of buying really precious items, but I sincerely believe that it would be
well worth starting on a moderate basis, and Romania would not make the
worst market. I have the following in mind: I buy, at a low price, a whole
lot of etchings that I think would sell well at home and ship them in rolls.
Money, of course, have I none, either to lay out or to lay in, although yester-
day I received, incredibly fast, a 150-franc mailing (with which I paid the
overdue rent to my landlord, who was starting to become a little impatient —
although such situations are handled with the utmost discretion and deco-
rum here). For this to be realized either Dad or whoever wants to enter
into a business relationship with me as an art dealer would have to send
the money. Aside from all this, I must ask you, Dad, to advance my June

salary or have it advanced. By the time this letter gets there and the money here, it will be the first of the month. If I don't receive any money by then it may come to a major bust and I may have to get acquainted with the pawnbrokers of Paris.

I'd like to reassure Mom: neither have I lost weight, nor have I gotten out of hand. Quite the opposite, I have never paid such meticulous attention to my hair, face, and hands. I shave almost every day; indeed, I'm invited to do so by the good soap and the hot water that is always running. Tihanyi gave me a hand-stitched English hat, shaped like a fur cap, in which I resemble a dethroned Persian shah. I very rarely see Tihanyi—only at night in the cafés. The case of his exhibition continues to drag on.

I enjoy spending time with the Bölönis. Mrs. Bölöni (Ady used to call her Itóka,[60] and the name has stuck) is short, rotund, and talkative in a womanlike way; she is sometimes highfalutin' and effusive, and sometimes she curses vehemently. But she knows a lot about Anatole France, whose secretary she used to be, and also about Ady. It was just now that I heard for the first time that Ady once wanted to jump off the Eiffel Tower. After a long search, the Bölönis have finally found an apartment: two bedrooms and kitchen for 450 francs. I frequently have supper with them at an Italian tavern. Your stomach can get so full of a foot and a half of spaghetti with tomatoes and cheese that there is no room left for anything else. This is the advantage of Italian cuisine. But the Chianti goes down all the more easily, and doesn't take effect until half an hour later.

On Sunday, as you could see from my article, I went to Colombes to the rugby match between Romania and France, perfectly decked out in an English hat and dazzling gloves. I sat in the grandstand next to the box where the Romanian queen was expected. Well, isn't the *Brassói Lapok* a world-class publication? I'm being punished for the long silence by having to write about everything at random. I myself am the first to feel the need to share more of my Parisian life with those at home.

Paris, 13 June 1924

I wasn't too willing to get involved in the business of sports reporting, a field in which I have neither ambition nor expertise. However, after the first few carefree and joyful weeks in Paris—in the meantime, life has become threateningly expensive—I had to admit that ensuring my subsistence was the first, the most essential, condition for realizing my plans. As I wrote earlier, I've tried to approach *Auto* and another sports magazine with my illustrations of rugby players. They liked the caricatures and kept them, with the promise that they would give me an answer within a few days if their own paid illustrators did not do anything by then. When I returned to *Auto,* the rugby editor gave me back my drawings, with great regret that they'd already received illustrations from their in-house caricaturists. He invited me to return with further drawings; next time, I might be more fortunate. It was no different at the other magazine. I would have had to look for new players (half a day) and besiege new editorial offices—which in itself takes several days, as you are kept waiting or sent from one place to the next—and in the meantime, if the pictures are not placed, they quickly become obsolete. This is why I accepted the offer from the *Sport-hírlap* (Sports News). I asked for 2 dollars per article. The articles were published, and when the editors arrived they asked me to write articles on the games, too. I outwitted them: after a single lesson in sports terminology, I wrote articles that must have made them think I'd grown up in the grandstand. I don't want to waste paper on all the deceitful maneuvers of that leech of an editor (Dr. Földessy) in opposition to my rightful demands and the sweat of my brow. Had it not been for the steadfastness of my resolve, my threats, and, in part, the fact that they will need my work in the future, I couldn't have

wheedled 300 francs out of him last night; nor could I have made him honor my demand of 26 dollars for the 13 articles already published, which I am due to receive next week. As far as the future is concerned, we agreed that Bölöni (who represents *Sporthírlap* here in Paris) would pay me as soon as each article was published. Therefore I won't be subject to such machinations as long as I continue to need this kind of work.

However, it would be a mistake to assume that all the months I've spent here have been wasted time. I haven't been painting and I haven't been drawing. Even the last two hectic weeks were more beneficial than they would have been had I been painting, and I am not talking about money. Could I have done anything wiser in the first few months than to do nothing? Nothing could have been more productive. I will be satisfied even if I don't get a chance to paint in the next two to three months. There is, indeed, an abundance of things that demand one's attention here, particularly for a person like me, who is intrigued by every particle of this living monster, its outside, its inside, the way it breathes, lives, and moves. The monuments, pictures, and sculptures will not pass without a trace; nor will the characters who pass before me, for a moment, in the surging crowd—from the Dalmatian Uzlak who, in his vinous stupor, boasted about having been Francis Ferdinand's first bomb thrower in Sarajevo to Endre Ady's Léda, a broken redhead turned yellow. What destinies, and how much is visible through them, as they pass across the stage! It is obviously only in Paris that the French spirit can be observed in its thousand manifestations. Political perspectives and thoughts are as narrow and close as the flats, as random and momentary as life, decorated with a thousand pleasures, with art dragged down to the earth, beautiful and indolent—a rococo romanticism frozen in time. Everyone is still rushing to Paris for culture, taste, sophistication, and gastronomic magnificence, but the modern man who directs his eyes and steps to the future is completely alien to the French spirit. Like cats in shop

windows slumbering in the sunshine or prettifying themselves complacently, they lap up life with a carefree, bohemian, and oblivious smile: giving all the beauty to the eye, the stomach, and the other senses — and their perspective ends here. I cannot free myself from the thought that all I see in Paris is nothing but autumn sunshine — without denying my empathy or my compassion. Enjoy life to the last drop, gild it with sauce, wine, and love — such is the horizon of the French intellectual. Even money is needed not for power but for making life beautiful. There are neither Cecil Rhodeses[61] nor Hugo Stinneses[62] here, in whom the new era's dictatorial type is foreshadowed — people who dress in gray and eat baked potatoes, yet want to seize half the world. Oh, I understand the fear and suspicion with which the Prussian spirit fills the soul here. Despite free elections and parliamentarianism, democratic Germany is a lie. Imperialism lives on in the soul, even if in a disguise. The most desperate resistance ceased with Poincaré[63] and Millerand.[64] And I, who came here from very far away, see this conflict as inevitable. When I think of the German cannon that once more will come rolling down the Champs-Élysées, and of all the suffering and humiliation awaiting this great nation, I cannot help but affirm with all my soul that which has to come by organic necessity, and, bowing to the suffering for which neither side can be blamed, I proclaim that I love France's past and have faith in Germany's future.

A few words about those who are lured to Paris by its enormous and radiant magnetism, flocking here mesmerized day after day, without money, thought, or reasoning. What a struggle for bread, more cruel than in the jungle, where at least the weak perish — here they are left alive and condemned to slavery. Sometimes from characters who surface occasionally one gets a notion of this bloody wrangle over the spoils. One day Halasz Sanyi's brother-in-law turned up, a nice pleasant boy; after taking his final exams at school, he became a printer, and failing to get work in Vienna and Berlin

came here to work as a painter, with neither money nor any knowledge of French. He couldn't attempt to get a job here of course. However, he plays the viola well and was encouraged by several people to make his career as a viola player; he visited one impresario after another and everything happened according to the French recipe: polite welcome, promises, then nothing. He must have visited at least forty impresarios, each on more than one occasion. I escorted him wherever and whenever I could—not that I am in a position to patronize anyone! And then one day he exhausted his pitiful supply of cash (although the boy lived on the basis of "I ate yesterday, so I needn't eat today"), and so, willy-nilly, he had to seek employment. He insisted on telling me about a launderette where he felt sure he would be employed but was keeping for needier times. Inevitably, when it came to it he was turned down by the launderette as well, also by the car factory, and now at last he's carting luggage weighing hundreds of kilos for 17.50 francs at a railway station, where graduates of various nationalities are building their muscles. Still, there's now some hope for him to join an orchestra that's to perform at a spa. I did all I could; it was no fault of mine that success proved so elusive.

My friend Tihanyi left for Berlin, as I wrote that day. It was miserable to look at him, he was so depressed at the thought of leaving Paris behind. The taxi took the most beautiful route from Montparnasse to the Gare du Nord. He was on the verge of sobbing as we passed the Luxembourg gardens, crossed the Seine, passed the garden of the Louvre, drove along the boulevards, et cetera. He left the majority of his pictures here now that it is 99 percent certain that his exhibition will be held next autumn. He writes from Berlin that he's going to rent out his workshop, sell one or two pictures, and return forthwith. There is the prospect that he will also have an exhibition at a favorable venue in Brussels.

I'm suddenly recollecting—and as I've been able to write home so little I'm bound to write about things as they occur to me at random—that I

went to a concert of the Dutch Philharmonic Orchestra bout three or four weeks ago: they came to Paris with a four-hundred-member company and chorus to perform the Ninth Symphony. As a journalist from Olympus, I was seated with the tailcoats and an overpowering armory of female adornment, in the second row. While Mengelberg (the conductor) was being applauded a first violinist with a familiar-looking face started to wave at me. I learned during intermission that he was Alfred Indig, from Brassó. He asked me to mention him in the *Brassói Lapok* in connection with the performance; maybe I'll have the chance to do so.

I haven't yet been able to search for antiquities. It takes a lot of time and continuous effort, if one wants to hunt for bargains, to buy valuable pieces that will sell well. The difficult part is the transportation: not so much with etchings and drawings, which can easily be sent through the Klingsor business (by post, rolled up), but with the bronzes, which could be sent only occasionally.[65] We all know how difficult it is to burden passengers — especially for such a long journey — with additional luggage. Nevertheless, I'm going to invest Father's money, now that I might have more time, and I'm going to propose more concrete arrangements for those interested in the business in the future.

Neither am I going to neglect the request you made for the books and articles featuring Romanian references. Tristan Tzara is one of the most talented French poets here: he is of Romanian origin, and one of his plays was recently published. Tihanyi, who drew portraits of several young writers for an album that will soon be published, drew him as well. I'm going to write about him in more detail and ask about the books you would like.

I receive the *Brassói Lapok*, although quite irregularly, and I can see just from the editorials that they are doing well. Of late I have been able to send only sports reports (there were days when I actually had the time to dip into the newspapers). Would that I could send further material now that a pay raise is on the agenda.

Having used the last sheet in the café's pad, I have had to continue using my own paper. And this café, on the bank of the Seine, is about to close. It's two o'clock. There are cocottes and couples still trickling in for a "bock" beer, black coffee, or Cointreau.[66] Two drivers have settled down facing me — a bit tipsy. I'm going to depict them in ink. They're looking at the drawings, laughing coarsely.

Believe me, my thoughts are very often at home; it's regrettable that the hand is slower and tardier than the mind.

Paris, 3 September 1924

I managed to get hold of Ascher by sheer coincidence one evening in my local café, the Rotonde; I can see now how lucky I was. I thought he had brought my money, not the August payment, which I'd already received, but the one for September and also the reimbursement for the postal expenses, which I had asked for urgently. He replied in a perplexing manner: he was to bring money but he didn't; however, if he had some left over, he would give it to me. At the same time I was awaiting, daily, the transferred amount from home. My ventures all end in failure. I still haven't received the 200 francs due from the *Sporthírlap*. I may get it soon, since I've threatened both a lawsuit and a public scandal; this might frighten them into action. The English paper went bankrupt before it ever got off the ground. The editor made off with my money, or, more precisely, with 300 francs of my money, as I had been swift enough to wheedle 200 francs out of him earlier. It is cold comfort that Bölöni, who meant well when he first persuaded me to get involved, having described the situation as an absolutely secure one, is himself mourning the loss of 600 or 700 francs. I may well receive my money yet, since the fellows who had invested 5,000 francs in the venture are unlikely to let the matter rest. This is how Bölöni consoles me; at any rate, I was really counting on this money. Only Tihanyi gave me 3 dollars as the first morsels of a venture that may turn out to be fruitful. I was asked to send nice, timely photographs, rare reproductions, and articles from Paris to the *Börsen-Courir's* illustrated daily supplement (I am enclosing one that features a photo I submitted from Paris of a Toulouse-Lautrec painting), and to the Ullstein papers (*Vossische Zeitung*, etc.), with which

Tihanyi and I have some connections through one of the editors of the *Vossische Zeitung*. They paid twenty-five gold marks (six dollars) for the initial mailing, which didn't cost me anything; and one of my German articles—about Panait Istrati, allegedly written in flawless German—is awaiting publication, to be paid for no less handsomely. Well, in my past and "passed away" letter lost I asked Kánka to send a couple of extremely beautiful (this is the main thing!) photographs of Brassó, especially ones featuring the Cenk and the Black Church, because I wanted to write an article about Brassó's celebration of the Teutonic Order (for the seven-hundredth anniversary). But I'd also like to ask Dad to send me the article I wrote for the *Brassói Lapok*. I hope it can be found somewhere in a drawer or with Dr. Szele. Of course a nice photograph of the ruins of the old knights' castle in Földvár would be useful, since it could be placed next to a photo of the Prussian Marienburg, which was built later—but how could we possibly come by one? It would be well worth the cost incurred since I was guaranteed to be paid—now, how much was it indeed?—about 1,400 or 1,500 lei if the photograph is published. Please don't tell anyone who might beat me to it.

I'm living on borrowed money—thank God my creditors see my confidence in them as an honor; the most unpleasant side of it all is that they have to be paid back and as a consequence one is unable to act as one wishes. For example, I was supposed to get some new photographs (timely Parisian themes), but I would have to pay for them. And then what am I going to live on? Fortunately my flat is no longer 220 francs but only 120, and it is at least as good as the hotel—it will do until I can grab an atelier by a similarly fortuitous accident. Its window looks out onto the yard and the sixth floor and mansard of the neighboring buildings. I have already made the romantic acquaintance of a girl under the lovely jagged Parisian chimneys. After a four-day siege of words and gestures thrown into the air across a distance of a hundred feet, the ice was finally broken and I was given a date

and a room number via Morse code she signaled with her fingers. I replied with a pierced-through heart hastily painted in india ink on a piece of cardboard. (Curtain.) I can already see the benefits of my move to Montparnasse and the proximity of the Rotonde café, especially in terms of new acquaintances.

Paris, 11 September 1924

I'm not going to wait for a reply, and I would like to make up for the lost letter, if it is at all possible to make up for the annoyance it caused at both ends. First of all, the English lady, Mme Pillinger, who wanted a fresco painted on one of the walls of her flat, has returned from her vacation. The engineer from Vienna who recommended me said that the lady is willing to spend 600 francs so she can wake up to a beautiful view on the wall facing her every morning. I went to her home last night and she invited me again for tea today to discuss the view business. I managed to convince her that it would be foolish to cover the entire three-by-two meter wall when a smaller panorama would give the same effect. (That is to say, I'll have less work to do that way.) Naturally I'll paint what she asks me to, that is, the park of Versailles with the fountains, which she would like to be in mirror image so that it will resemble the Galerie des Glaces. I'd be happier to paint a horse's ——. Indeed, this would be the most appropriate view for such artistic taste. Yet in Mme Pillinger I have found someone who can push me forward. If you are without capital in Paris, it is only through women and sofas that you can achieve something. This English lady is already in her late thirties.[67] She's been living in Paris for seven years. She is very rich and a member of society. According to the engineer from Vienna, she'll introduce me everywhere if I win her favor. And if I'm not mistaken this I have already done. It's curious that Mme Pillinger should have spent two months in Bucharest before the war as a guest of Marghiloman's.[68] I haven't been so brave as to pry into her past yet. For now, to stick to the subject of the fresco, I am to make a small sketch, for which she will pay 50 francs extra,

and if she likes it she'll pay half of the amount in advance. I think I'll do the picture in a few days' time; I hope there won't be any fresh obstacles, or — considering how unlucky I am — that she won't be murdered. The other English person, who resembles a character from a Jules Verne novel, is constantly extending invitations, oblivious to my miserable financial situation. He has two female acquaintances arriving from Switzerland on Saturday and he has invited me to a banquet in their honor. He's repeatedly invited me to London and, in particular, he would like me to come for Christmas, when he is not busy and I could attend the family celebration. Another thing that is so enticing that I can hardly believe it relates to an inheritance of 360,000 francs belonging to a Romanian lady who was married to an Austrian engineer in Vienna. The French seized the money, claiming it was Austrian. This in itself is quite legal, but with the husband dead, the lady had once again become a Romanian national — which is recognized here, but somehow things hit a snag. The person handling the matter happened to tell me the story, adding that they would give as much as 4,000 francs to anyone who had the contacts in the appropriate Romanian circles to get things moving again. Hearing all this, I immediately ran to Floresco the violinist, who is, as I know, the best friend of Popesco, whose responsibility it is to deal with such matters.[69] Floresco spoke with Popesco yesterday, and tomorrow at noon we are expected at the Romanian embassy. In Floresco's opinion the matter can be settled through Popesco and we can split the money. I might know as early as one o'clock. Even if the answer proves to be negative, I will have expended no effort whatsoever.

I got acquainted with a Dutch diplomat, Baron Waillant (from the local Dutch embassy), who likes my drawings and has commissioned me to draw a portrait of his wife; this seems certain although the wife is not yet here.

Other news: Tihanyi returned from Berlin last night; I'm happy to have him back. He almost cried for joy as we were driving across Paris by

night and he caught sight of the Rotonde café. Now there's greater hope that he can organize an exhibition for this autumn. Through a female acquaintance of his, he might acquire an atelier for 300 or 400 francs per month, which is a lot of money. I cannot even think of such an expensive atelier yet, although I feel it would be necessary from the point of view of better earnings. The *Brassói Lapok* is coming to my old address — or, rather, it is disappearing there as some Hungarian seems to be incessantly stealing it. Therefore, I haven't seen the paper for a week. I was very surprised today to see it in its new format; indeed, it looked so attractive I could hardly believe my eyes. Now the Paris correspondent feels a greater inclination to write. That's enough for now. It was half past two in the morning when I bade goodbye to the Englishman, Tihanyi, et al.; now it's a quarter to four, and I have to be at Floresco's by half past ten. I'm looking forward to the letter from home.

Paris, 2 October 1924

The article about the Teutonic Order and the photographs are going to be published in one of Scherl's newspapers, possibly the *Lokalanzeiger*. I've just handed it to Werner Sinn, the Paris correspondent for the Scherl papers. I'm going to be paid about 200 francs for it. I have good connections with the German papers now, and the most important thing is that they want drawings, which go for 60 francs each. I now have to do three drawings for Dr. Herschel, the Paris correspondent for the Leipzig newspapers: one of Poiret, one of Worth, and one of a fashion designer's dress. I've just received the invitation from Poiret for tomorrow morning. A German periodical starting now—it's called *Magazin* and as far as I know is published in Dresden—wants theater drawings of the rehearsals of the opera and a Dutch opera company giving guest performances here. Now that I have to draw on commission and not just as the cat jumps, I'm more inclined to begin. The fresco commission is still in negotiations. Mme Pillinger, this capricious Englishwoman, has already invited me for tea four times, always to discuss the fresco matter. I made a few sketches and she finally chose one. I thought that I'd finally be asked to do it and get the advance. However, she had yet another idea: that I should make a fourth sketch, with either a sunset or a sunrise. It really takes great strength of mind not to lose my patience. My other Britisher, Mr. Phillips, of whom I have made a good friend, is now back in London. He's in a very high position and he's wealthy; he's *Oberregierungsrat* in the Ministry of Agriculture and Fishery. I accepted his invitation for Christmas; he has a large apartment and I can stay with him. I drew his portrait and ate and drank with him for about two weeks. Since I did the portrait as a gift, he gave me 50 francs for "materials"

and asked me to turn to him with confidence should I have any financial difficulties; he would always be at my disposal with his pounds. Therefore, unless something happens, I'll be in London around the tenth of December. I sued *Sporthírlap* (Tihanyi's younger brother is my attorney) and went to the police about the guy who ordered the map and absconded. He is allegedly in Vienna now; my statement has been forwarded there. I cannot allow myself to be duped after all my hard work. Mr. Móricz might have given you an account of the contents of my letter. I wrote to him again yesterday, asking him to intercede with the publisher for a "reporting fund," with which I could cover my reporting costs and join the association of foreign journalists. They will, perhaps, agree to that. Thank you, Dad, for your efforts with the photographs. I can place the picture of Brassó (as the designated future capital of Romania) in English, French, and German newspapers accompanied by a brief article, but I still need a few beautiful photographs, three of each, to carry this off. Two more of the one with the Black Church. Please deduct the expenses from my pay. I have received my October salary, as I wrote before; however, I need it now along with the mailing expenses (85 francs according to the bill). Dad, as you said in your letter you were going to mail that on the first — so it's on its way. I hope that I can consider it my November salary, and that I can instruct you in my next letter to keep that money at home. At present, I must by no means allow cashflow problems to deprive me of any favorable income opportunities. Once there's money and a bigger income, there will also be an atelier, which is again mainly a question of money (a question of a lot of money) and which has now become an almost indispensable necessity.

Paris, 11 October 1924

I don't know how to explain your silence. The last letter I received was dated 15 September, while I've been writing so diligently! I wonder whether the letter with the check enclosed went astray.

Only in my last postcard—if you received it—did I have the chance to tell you about the favorable turn in my financial situation. Since then, I have witnessed a miracle: the editor involved in the map affair, who had made off with my money from *Sporthírlap*, has turned up in Paris. Bölöni came to break the good news to me this afternoon. Apparently, I'm going to receive the 250 or 300 francs I'm owed on Tuesday. Werner Sinn, the Paris correspondent for the *Lokalanzeiger*, the *Tag*, the *Deutsche Allgemeine Zeitung*, etc., thought the article I wrote in German on the Teutonic Order very beautiful. He found my style nearly flawless. In his opinion, the article is going to be a sensation. He liked the photographs, too—this, in any case, means 200 or 300 francs. The three drawings, for which I have received 180 francs, have already been published in the Leipzig newspaper (*Neue Leipziger Zeitung*); since they were only simple fashion drawings, I did not sign them. I haven't made any drawings of the Dutch opera company yet— something I was commissioned to do—the Englishwoman's 600-franc fresco still remains to be done; so money is presenting itself from all quarters and I must simply seize the most favorable opportunities. My connections now guarantee me, I believe, a secure existence even with such casually dashed-off work.

Last night I had dinner in one of the most distinguished restaurants on the Quai d'Orsay with Mme D.-B., the wife of a car manufacturer, and

Floresco, a Romanian violinist. I don't recall if I have written of my acquaintance with Mme D.-B. before. They once invited me to their table in the Rotonde. I kept in touch with Floresco (the best Romanian artist after Enesco and Bosco) and we've become better friends since I've been living here in Montparnasse, as he also lives nearby. From the start, I perceived friendly feelings toward me emanating from Mme D.-B., and even more from her daughter, Jacqueline. It was my fault, however, that the relationship ended, because although Madame sent me an invitation I was unable to attend her piano concert. (I was in Saint Cloud with the Bölönis and had been invited to dinner at their home that evening, and I hadn't even excused myself.) Apparently, Mme D.-B. has not forgotten me even so; she sent me several greetings from her castle in Brittany, and upon her return she requested that Floresco bring me to the station to meet her. Initially I considered that it was all the work of little Jacqueline, but it turned out that she was to arrive in Paris a week later.

It was a wonderful dinner. Appetizers as you desired (they were presented on huge silver platters and you could eat as much of the pâtés as you wanted) and other delicacies; of course, as always in restaurants as expensive as this, desserts and fruit were unlimited. I "devoured" the opportunity, as I did not have to pay 120 francs out of my own pocket.

Mme D.-B. is separated from her husband. She's a quintessential great French lady of the old school. She was visibly happy to see me and asked me to visit her salon often, as Jacqueline would also be very happy. This is another connection I feel I will need badly in the future.

Paris, 10 November 1924

My dear ones, I really don't know where to begin. I asked to be awakened at 8:30 this morning, which hasn't happened for a long time especially if you consider that I'm never in bed before three. Five francs in my pocket. The portfolio and my walking stick under my arm. I have coffee and two croissants at the Rotonde. By metro to the Etoile. I have to interview Unamuno for the German editor.[70] (His portrait is already in my portfolio.) The editor, Werner Sinn, is at home until 11 A.M. and will pay me immediately for the drawing and the interview (he, of course, makes another 300 on it). I get on well with the Spaniard, I'm done with him in ten minutes. Next, to the Trocadéro, where Sinn lives. He's a very nice man; both he and his wife like me. They're just having breakfast and they insist on my having a cup of coffee. The drawing's good, the interview's good. I hand him the two photographs (of the Avignon papal palace), each bought for 3 francs yesterday. They're great. He pays me 140 francs. Sinn is talking to Berlin in the other room, and I discuss with the wife where and when I could draw their young son. (I asked 200 francs for the portrait; it'll be a Christmas present for the husband.) I haven't been so wealthy in a long time. One hundred forty francs in my pocket. I say goodbye. "Do bring the photo of the two duchesses tomorrow!" "I was told I'd get it by two in the afternoon." I earned 40 francs on the duchesses the day before yesterday. And this is how *that* happened. Floresco gives me an invitation and tells me to visit the Russian duchess Rotschakidze, who is the most beautiful woman I've ever seen in my life. She's a friend of Mme D.-B.'s. She's opening a fashion salon with Mme Spada. The same evening, about four or five days ago, we're having wine at Sinn's house and I have two drawings of the *Siegfried* rehearsal of

the Dutch opera company with me. As we are talking he says that I should get him some interesting photographs, and he'll pay me 20 francs for each (which is not too much, actually). I happen to mention the duchess. "Yes, certainly, just get a photograph of her." I go and visit the duchess the next day. She is indeed a spellbinding woman. And of course it's me doing *her* a favor by "having their pictures published" in such a lovely German periodical. I go to Mme Spada next, where, I know, there are two other duchesses working as models. They're pleased, too, and I receive the pictures immediately. This is how I earned 80 francs from the duchesses.

Lunch on boulevard Raspail, in a bar. I always go there when I have money. When there's very little, I go to the Chartier, and when there's none . . . I hope I've seen the last of the times I don't have any. The meal: half a dozen oysters, which I lap up with French expertise but also with pleasure with the help of the small three-pronged fork. A quarter of a liter of Bordeaux blanc, hare, *pommes rissolées*. Crème fraîche, confiture. Afterwards, a cigar, which it seems is completely replacing the pipe for me. I want to have a coffee at the Rotonde (I feel sleepy as I went to bed at three but got up early) and who do I run into but Mrs. Csáki, Grete Copony from Szeben. What is she doing in Paris? She's happy to see me. She's been here for two months, her husband is in Berlin, she's going to stay here for another week or two. Then I return home and I pay the final arrears in my rent to my landlady — blessed, thankfully, with the patience of a saint. I'm writing an article. Postman. Registered letter. From Aunt Mici and from home. There's money in it, of course, now that I have some and will have more. Not at all like . . . It has been a wretched two weeks indeed. The bell rings. (It's an old-fashioned tinkling doorbell that you have to pull on.) This must be Kiss. Kiss is a boy from Arad, he doesn't know a word of French. Electrotechnician. He came to Paris with so little money that he had nothing left after a week. How did I get stuck with him? Some acquaintances of

mine brought him here and then left for Rennes, saddling me with an electrotechnician wrestler. He can't find a job, of course. He's starving. He hasn't paid his rent and dares to go home only at night. Now he reports that he has been turned down for a job once again. And that yesterday he had only a pound of bread. I give him three francs to go to hell and let me work. It's only for this reason that I give him anything at all. I've hardened my heart. There's no other way here. They're going to eat you alive ... Well, these two weeks ... I earned 900 francs last month and it was spent on everyday life and old debts. The Leipzig editor has gone away. (He's back now, I saw him just last night. He told me to bring some timely drawings, he'd pay sixty francs, as he did previously.) My article with seven photographs, for which I expected money first, still hasn't been published. Sinn didn't give me any money for it although he has twice urged publication. He sent the drawings of the Dutch opera (two of them) to *Sport und Bild.* I haven't received anything for those either, although 300 francs are due for them. Sources of loans that can be exhausted (Tihanyi, etc.) have been exhausted, since everyone is expecting money. I am scraping along by means of incredibly complicated schemes. And if you have no money, you can't earn any either, because you need to invest, if in nothing else then in paper, pencil, or, God forgive me, 35 centimes for metro fare.

A little scene from my diary: *Monday, November 2.* I fell asleep at four in the morning. Good Lord, it's a quarter to twelve and I had an appointment with Bölöni in front of the Crédit Lyonnais at 11:30! I get dressed in record speed; fortunately my watch is half an hour fast. I'm waiting for Bölöni. Balassa comes and tells me that Berec is wanted for check fraud, etc. Bölöni arrives at half past twelve. We're looking for our hiding map-debtor. In bars, cafés, his usual haunts. To the Etoile. "I see this pig is staying in this expensive hotel and won't return my 250 francs!" He's not in, or rather he doesn't answer. We're going to report him to the police tomorrow. Home. I

have one franc left. An invitation to Mme D.-B.'s concert tonight. My blue suit is at the pawn shop. It's a quarter to two. I have a silver case with me, lent to me for appearance's sake. I must hurry up because the *engagement* takes half an hour, and the *mont de piété* closes at three.[71] Who's standing at my door with huge packets? Who else but Kiss, of course. Complaining that he's looked for me three times and that he had only a pound of bread yesterday and nothing since. That he was turned down at the pawn shop and he didn't know why. "We've no time for negotiations. Let's go." We hand in the stuff. I already have experience. The summer suit went in two weeks ago, then the blue one, so that the moths can't attack it. I receive 15 francs for the case. Kiss receives the same amount. Quickly through to *dégagement*. It's half past two. There's enough time for me to be served. I pay 10 francs 5 centimes for the bill, out of the 15 I have. I buy butter for 2.50. Kiss eats like a wolf, I can't bear watching him, I leave the room . . . Dinner: bread and butter and cheese. Mirjam is leaving. A red rose, 1.50. She's not at home. I leave a card. Salle Gaveau. Beautiful audience. Mme Combemal. I sit next to her. Floresco is not present, because Mme D.-B. is not playing with him, but with Pierre Foll. She introduces me to Curie's nephew. Jacqueline in the first row. She sees me and waves her arms. She comes to the back after the first sonata. I don't go backstage. The Rotonde. Ujvári, Acél come . . . with Tihanyi and then Loos, the architect, and Count Zabolsky, the sculptor. I have 2.20 francs left. Tihanyi's going to get some dollars back tomorrow and he will change them then. Onion soup for 1.50 francs. There's 50 centimes left. Nice old man. He's been thrown out of the hospital. He'd like to have a coffee. I walk him to a bar, and talk to him until four o'clock. He lies down on a bench. Two of his sons died in the war. I give my 50 centimes to him. The driver's bar opens at four, let him have a coffee . . .

Today, all this is just a nice memory. The door to the German papers has been opened thanks to Sinn, it depends on me whether or not I can seize the money-making opportunity. I would like to write about plenty of

other things but the hands of the clock are hurrying in the direction of seven with frightening speed. I've been to the academy. I've joined the Paris students' association. It's easy to join the Beaux-Arts, but you need a recommendation from the Romanian embassy, and one of the masters has to accept you. It costs 120 francs if I want to work, and it's free if I only want to join. When I've joined, I can get the grant, even without connections, I think. Tihanyi's exhibition will be next January. I'm often with Floresco. He's very loyal and introduces me to a lot of people who might prove useful to know in the future. I now speak French more than either Hungarian or German, although I have never made any special effort to learn the language.

Paris, 2 December 1924

I cannot tell you how pleased I was with your long letter from the other day. You chatted about everything so well that I felt I was on Rózsa Square. Of course I would love to take a peek at the freshly prepared cracklings out in the kitchen — I bet you have just melted the lard — but most of all, I would like to be there again for a while, close to you all. What can we do if all my ties are keeping me here for the time being and I can't even think of returning home? But be patient! I don't think the time is far when my income will have grown — thanks to these drawings and scribbles — to the extent that Mom could stay with me here in Paris for a few months. So you shouldn't take this separation so much to heart. I would turn the prayer "I wish he would come home" into "I wish he felt as much at home in Paris as he did in Brassó."

As far as lamenting the state of my garments, underwear, and stockings is concerned, my toiling is quite enough, no need for precious maternal tears. My light brown suit is in perfect condition and could not be in a better place than at the pawnshop, protected from and insured against fire and moths. I definitely won't redeem it until spring, as it would just be in my way. My gray suit has been resisting the ravages of time. My blue suit I wear only for the most solemn occasions, so it is still completely comme il faut. My underwear is kept in order by my landlady, Madame Segas, who is a seamstress herself. Moreover, my inventory of shirts has increased by another two shirts I have received as presents. If I mention the fact that I have forty-two collars and ten dickeys, and that should the need arise the collars and the dickeys can all be turned inside out (that is, I could have supplied

Napoleon with clean collars during his one-hundred-day reign), I think this should give you quite a favorable picture of my "housekeeping."

The weather is pleasant and autumnlike in Paris right now. If I had the time, I could go to the ice rink here, the Palais de Glace, as well. Mme de Combemal, a friend of Mme D.-B.'s, has already invited me to go with her. I really will give it a try once, or else I'll forget all my artistry.

But I am saying goodbye for now. It's already very late, I don't even dare mention what time it is.

Paris, 2 December 1924

I am afraid that even with the best of intentions this letter will again be sort of a "military dispatch," since it is truly difficult to send anything else from this "battlefield" in the midst of constant gunfire. Here one's life is taken up by never-ending activities, making contacts for immediate and distant goals, laying mines, placing bombs. You can't close your eyes for even one moment. Every man can be of use, but every man can also be an enemy. Woe unto you if you are not alert, or if you drop one of the reins you had seized through hard work. My ways and interests are complicated, as I am complicated myself. The ways and interests of the stomach, the ways and interests of success, the ways and interests of the spirit . . . There are many of us, a multitude, but alas, man is alone: I'm the sentry and the general staff, I run to the transport, I fight in the trenches, I look at the ordnance survey map, and run complicated military operations. It's awful, one person having so many ears and so many eyes. Awful, this ready submission to people and events, this distance separating me from my self. A person is an orphan in slavery here. I feel like an instrument, a mirror in which all things are reflected, a mirror that accepts everything and elevates it to a higher reality. I have tramped all over the domain of human values. I have grazed with the herd and inhaled the alpine air of the great solitary men. I have been exposed to ideas and events. How difficult it is, though, to remain firm, where one can *see.* How difficult it is to play at being the judge from here, from afar, farthest from myself, to say yes or no, to love or to hate with passion. Don't I have to be inscrutable, impenetrable, and unreliable? How difficult it is even to take the militant steps of everyday life when one is soaring: how difficult is every individual deed, self-care, and trouble with

one's body. One gets cynical about one's own misery so as not to fall prey to self-pity. One becomes tough and cheerful, otherwise one would not be able to stand the sorrow. I have a hundred faces to conceal myself behind, and everyone knows a different one of my masks: how convenient is this clownish bohemian cloak in which I can lie about not making problems for myself, or this journalist cloak that makes people believe I am superficial. How terrible this clumsy tragicomic role is! It's terrible with this temperament. This waiting is awful! Sometimes I dance, like a Leiden bottle bursting with vapors, and I chase away my dream by walking up and down between three and four in the morning. Sometimes I no longer know what to do with my impatience: when can I sling the masks against the wall? Oh, I await and fear the moment in which I will find my own voice, but also the place that will multiply it. This moment may bring disappointment to all those who know only my masks.

Can I hide the spirit from those who have eyes to see? The face betrays and so does the hand. The other evening a strange character entered the café. Thin, sickly, wrinkled face, big spectacles, reddish eyelids. He ordered one grog after another. He was making jokes and everyone was making jokes with him; I thought he was drunk. All of a sudden, he sat down next to me and began to speak. I was listening absentmindedly. From time to time his voice choked as tears trickled down from his eyes. "You are the only person here who might understand me, the only one I can tell everything to. You will listen to me, you are capable of having respect for masks. I'm an actor, a psychologist, and I can read faces." This was not the first case of strangers baring their souls to me. Tihanyi is dismayed if he can't talk to me every day. Floresco is jubilant when he spots me. I just received a book and a letter from him today: "À l'un de ceux, qui savent entendre — et voir — à Jules Halász, dont l'avenir multipliera sans doute le spirituel écho des paroles qu'il a déjà su dire — ce souvenir de Silvio Floresco."[72] Sometimes at the café, they fight for my ear over whom I should listen to. Why is all this?

Because they feel from my radiating eyes that everything attains a higher reality here that can give it new life.

I can write about a great many people and events. One evening, in the atelier of Floresco—the future atelier of Halász!—I was with Mme D.-B., her friend Mme Combemal, the elder daughter of Mme D.-B., and her husband, who is a French baron, the two of whom had come to Paris from the garrison of Coblenz for a few days' vacation. They took me to dinner, then we went to an American bar. Mme D.-B., who shows a constant interest in my affairs, promised that evening that she would hand her atelier over to me as soon as Floresco left for an American tour; this is a promise that I can definitely count on. There is also a furnished atelier in her castle in Brittany that I could occupy at any moment, but I can't even think of leaving Paris for the time being. Negotiations are currently under way regarding Floresco's American tour, and if they sign the contract I will immediately be in possession of a very well equipped, and free, atelier. This is a great thing, considering that one can barely find an atelier without a premium of 2 to 3 thousand francs. Should Floresco's American tour fall through, it is possible that he may go on a Transylvanian-Romanian tour. I'm just about to write Zillich to ask under what conditions they would be willing to undertake a concert in Brassó, or perhaps a contract for the bigger towns of Transylvania.

I again met the beautiful Grete Csáki, the painter from Szeben, at the Rotonde café. I revealed the secrets of Parisian nightlife to her, which, for lack of a guide and companion, she did not know. She returned home with her hair cut, wearing an apache scarf and a man's black hat. I don't know what the good people of Szeben thought of all this.

The day before yesterday, in the afternoon, I was talking to Mihály Károlyi for two and a half hours at his hotel.[73] (Those in the "groves" of my newspaper need not know about this.) He is a very likable man, impressive in physical stature, yet not without spiritual greatness. Honest

and straightforward—that is precisely why he will never make a good politician—and in the midst of a spiritual dilemma that is hard for him to escape. At ten this evening, Károlyi also came to the Rotonde with Bölöni and Itóka and they invited me to their table. I wasn't allowed to submit anything to the paper about Károlyi's Paris speech and even less about my private conversation with him. By the way, I made 60 francs on Károlyi, since I drew a picture of him for the *Neue Leipziger Zeitung*.[74]

I am going to organize an Ady soiree at the end of January, on the fifth anniversary of Ady's death. The idea is an old one and it is mine: to put up a memorial plaque for Ady in Paris. The revenues from the Ady evening would in part serve this purpose. Bölöni is going to help me, and tomorrow we will discuss the program, the matter of the hall, the tasks of organization and promotion. I find that something like this requires less running around and effort here than it would in Brassó. The soiree will have no political overtones. Of course, both Bölöni and Itóka will talk about Ady's life in Paris and I will recite some poems. A Hungarian singer will sing two Bartók-Ady songs and two Harsányi-Ady songs accompanied by the composer.[75] Another reciter, and the program is complete. We may also add an Ady lecture by Sándor Márai or Kádár and a couple of extra musical numbers. We can count on the participation of a thousand Hungarians, and if my calculations are correct, on top of the cost of the memorial plaque there would be a nice sum left for the participants as well.

Paris, 16 January 1925

Perhaps it's hard to believe it back in Brassó, but it's really true that in this crazy city, especially here in the frantic confusion of Montparnasse, I have been trying in vain for weeks now to get a few minutes of rest when I could write home. Alas, no matter how much one is master of one's will, here one dances as one is pushed and pulled by circumstance and one's necessary contacts. "This is insane," I often say when I have to choose the most important of six tasks at hand, time and time again. Talleyrand's diplomatic genius was nothing compared with all that I have to apply here each moment. I can't help it that it's impossible to satisfy every mouth and interest, whether mine or those of the unfortunately numerous others who like me. When from one side little Lisette is pulling on my hair to be with her, and when from the other Tihanyi is trying to persuade me that Lili Alexander would like to be with us in Montmartre this evening, and when Floresco shows up, conveying Mme D.-B.'s invitation, when I have already made a promise to the Dutch Caminada and his wife even though I know I should be writing a letter home, not to mention articles and other things, I cannot say anything in my despair other than "I would love it if they didn't love me, if I didn't belong to anyone."[76] This situation demands a lot of sacrifices in the present for the future, the sacrifice of momentary happiness for the sake of distant goals. Even if I use all my diplomatic skills I cannot avoid clashes that may be tragic. Nor can I avoid stirring up resentment or alienating people — and it is simply because of time constraints, the feelings have not changed. For a few months now, I have been noticing with sadness that Tihanyi feels we are becoming increasingly alienated. This situation with my best friend finally became so tense that I decided to bring things to a head in

order to clarify the misunderstanding through an exchange of notes and to blame circumstances for his reproach. The cure was radical, but also successful, because I managed to resolve all the other misunderstandings in our friendship.

My God, what should I write after such a long break, when I can never remember the day before yesterday for yesterday's events? We are indeed living here at a speed of 300 miles per hour. But how long will the engine hold?

If I could send a photo — my lady photographer, since there is such a thing now, is just waiting for sunnier weather to take some pictures of me — you would see that I look fine and in high Parisian style in my recently purchased hat and red apache scarf, which is supposedly worn by the *maquereaux* (gigolos), though I persist in wearing it and am not ashamed, to admit that I have already been a *maquereau* as well. Now I'm beginning to earn my living more and more from drawings and photographs. The big problem is that I still don't have direct contacts with the German newspapers, only indirect ones, so it is the editors here who skim off the profits from the drawings, photographs, articles ... It is to my great advantage that I have finally found a photographer — a very good one — who comes with me everywhere I want her to and takes the pictures. She sells the plates to American and English papers, while I sell the copies, which I obtain free, to German ones. Just this past Tuesday I sent twenty photographs to my editor, who left for Berlin after Christmas for a month of vacation, and I am now waiting for the check for 400 francs to arrive. So I am turning into a sort of photo agency. Perhaps I will have direct contact with the *8 Uhr Blatt* of Berlin. I have also entered into negotiations with a Swiss paper (through their Parisian editor). They would like a drawing from Paris every day. I don't know if anything will come of it. In any case, even though I sometimes run into financial difficulties for technical reasons, as does everyone else here, I am already making a living without *Brassói Lapok*. I will, however,

send them some articles in the future, so far as I will be able to write, although I can't deny that when I think of the local gang of Hungarian journalists and their everyday impudent mendacities that I would have to compete with I lose all interest. For instance, the person of Gyomai (who told me with great adulation that he had written an article about me for *Újság*) epitomizes all that I hate in today's journalism. To write of someone that "they have a nice ring to their name" without even knowing their name: that's impudence! I can only be grateful that he christened me Lajos Halász, since, as it turned out, it was merely a matter of him wanting to place an effusive article in Kolozsvár, after Weisz (who is just as untalented as ever) lent him 200 francs, and he needed me as filler. Just by way of characterization!

I stopped writing here because somebody was pulling on our ancient tug-bell. It was Kiss, the character I wrote about who had been starving for weeks, out of a job. He has put on some weight, as he's got a job in a sugar plant (during the first week, when he hadn't yet been paid, he lived on sugar cubes). With a box of camembert and a pound of bread in his hands, he asked if he might eat at my place. I will make some tea for him. Then I will shave. I have to look dashing this evening. We are going to the Mère Catherine (a merry pub next to the Sacré-Coeur) with Lili Alexander (the film-diva wife of Cserépy,[77] the movie mogul from Berlin, who bought some drawings from me in Berlin), Ödön Mihályi[78] and his wife (with whom I was in Sárosbogdány, near Kassa, and who are now in Paris for three weeks), and two other pretty girls who are currently attending an expensive Parisian boarding school (one of them is the seventeen-year-old daughter of Endre Nagy, the cabaret owner).[79]

Well, it's already half past two and the entertainment is over. Lili Alexander did not come, but the two girls were very charming, especially the cherry-eyed Kató Nagy. That girl, she is like a thousand devils! This was

their first vacation from school and their first time in Montmartre. I also had a funny experience in the pub. During the dance, old granny Katarina, while clapping, told the couples on the dance floor, "Kiss each other!" Little Kató asks me what she is saying. I tell her. "So why don't you kiss me, then?" So I kiss her. Then she says, not too indignantly, "That was a mistake, because I said, why don't you kiss *her?*" (the old woman). You can imagine how dumbfounded I was when, about a half hour later, Mrs. Mihályi suddenly told me indignantly that she would not have expected me to behave in such an ungentlemanly manner with the girls entrusted to her. An unbiased tribunal acquitted me, accepting my defense. Even the mischievous Kató accepted the verdict.

They just closed the Rotonde and the Dôme, and even the Select, an American bar that opened yesterday on the floor below me in my building. At this time, about two o'clock, all the night creatures driven out of the cafés are scurrying around in panic. "Is the Dôme still open?" ask the ones from the Rotonde. "Let's go in for a shot." Last night Mme D.-B. invited me for dinner. First we visited the salon of one of her friends, where they played some Beethoven sonatas with Floresco. What pomp and glory! I did not dare take my hands out of my pockets for fear of bumping against a Venetian glass or a Chinese vase worth thousands.

Lisette is a nice girl from Alsace, here in Montparnasse. She still has her hair tied in two tresses and rolled above her ears, although all Parisian girls now have hairdos *à la garçonne.*[80] She is no more than seventeen. God knows how these girls get here. She is an affectionate, kind creature—I don't even remember where and when we met. All of a sudden she just flung her arms around my neck. The "honeymoon" lasted from Christmas till New Year's. We danced through the night of New Year's Eve, like two crazy people. In the street, in bed, at the bar. I had a red top hat on my head; who knows how it got there. It still hangs on my wall among other masquerades.

Lots of people, acquaintances; one would really need a *numerus clausus* here. But if I have a free night and a "loose" 20-franc bill, I prefer to blow the top off with little Lisette.

My present finances are intimately related to those of France: a few debtors, who are not paying, and a larger number of creditors, who, however, are more patient than France's creditors.

To change the subject: the Englishwoman's fresco fell through. I got tired of her whims, and I was getting the impression that she was trying to have me on her sofa, using the fresco as an excuse—and I had no interest in her perspective. The other day I met another Englishman, a seventy-one-year-old diplomat who has not been in Montparnasse in fifty years and is here now to see how it has changed. He, too, wants a portrait but gave me such a fantastic story that I don't think the matter is serious. (He belongs to a ten-member secret society, for which I would have to paint a portrait of a girl who has disappeared, using her photo. They would pay me a thousand francs, and he would send me the photo as soon as he gets home.)

Paris, 27 January 1925

By the time these lines reach you, I will already have moved into a new apartment. After the private room, thank heavens, it's a hotel room again, although unfortunately more expensive than the previous one: 210 francs. I couldn't, however, pass up this favorable opportunity: finally a studiolike arrangement, also suitable for work, and in Montparnasse, no less. The room is on the sixth floor of a fairly new hotel by the Montparnasse cemetery. It is spacious and airy, has two windows, water pipes, electricity, and a small kitchen stove, which I can use to heat, cook, and bake. After the discomforts of a private apartment, I can hardly wait to move in. The move will take place the day after tomorrow with the assistance of some friends. We will celebrate the completion of the *déménagement* with a small party. It is still a mystery whether I will be able to afford all this, as it is an enigma what on earth I am living on, what with one of my editors in Corsica, the other in Berlin, and the bacon, the good, homemade smoked bacon, floating on the ocean toward Havana.

The way I see it, I will be able to earn more and more through the photo agency. I already have a small network, two women photographers and several French photographers who send me their photos automatically and practically free of charge. I just forward the pictures for 20 francs each. Sometimes I also supply Tihanyi's paper (*Bilder Courier*), which pays more, and we share the profit. It's a comfortable and pleasant profession (after all, the people as well as the photographers are obliged to me when I "publish" their photos in prominent German journals) through which my predecessor, who has fallen ill, is said to have made 2,000 a month and through which I can also earn well if I develop a big enough network.

They have written from Klingsor's regarding the Floresco concert
and they are now negotiating with each other—with success, I hope. It is
enough for me if I get the atelier from Mme D.-B. Floresco—just to char-
acterize him, for private use!—is a very informal, likable person, not too
intelligent, but you can tell that he is someone who has frequented the
"proper circles" all his life. A good musician, though not a musical intellect,
and if he were not such an incurable romantic he could achieve greater suc-
cess. I don't know if I wrote you that Mme D.-B. first met him in Vienna
and asked him to come to Paris, that she offered him her studio and wanted
to make him a renowned violinist. This was thwarted only by his utter folly
and romantic dreams. He was asked to play in the best Parisian salons, he
even received 5,000 francs at a soiree. He could also have given many public
concerts but he is a capricious man. When he has money he immediately
begins to lead a grand lifestyle, eating 100-franc dinners, traveling by car—
in this respect he is merely a disciple of Mme D.-B., by the way. If he has
no money, he lies in his bed all day, for many days even, and lives on raw
eggs. I have already made many valuable connections with his help, and if I
had a dinner jacket, patent-leather shoes, an elegant coat, etc., etc., he would
long since have taken me to visit a few notables in Paris and he would have
had me invited to one of the soirees. Anyway, even now he promises to take
me along to the next party at the salon of Maurice Barrès's sister—where
members of the academy come together.[81] Through him I have also made
the acquaintance of a young Belgian writer, Henri Michaux, and we are
together almost every day.[82] He is the editor of a Belgian literary journal
(*Le disque vert*), and we're going to translate something from German into
French together. Of course this is an excellent opportunity for me to perfect
my language skills, since I mumble French fluently, and supposedly with a
southern accent—where could *that* have come from?

I have been neglecting my paper (*Brassói Lapok*) this month, but I had

to prove to myself and to the people responsible for the paper that I am by no means dependent on it. If Kahána and company thought that under the new arrangement they would be able to force me to write more, they have not succeeded. I wanted to show that by turning from a diligent correspondent into a negligent one I wouldn't be the only one to suffer the consequences; the paper would, too. I feel no obligation, nor do I have a guilty conscience, if I leave the paper without coverage of important events. Even if I have sent them fewer articles than they expected, I still must have written enough for them to keep me as a regular correspondent. If they don't, I don't care, even if they find another correspondent. Naturally, under the new arrangement I write only if I feel like it.

On Saturday evening I was supposed to recite some poems at an Ady celebration in Paris. As far as I remember, I wrote that I wanted to organize an Ady evening, and that the event would not have been without merit, but it would have been tiresome, thankless, and delicate, with or without the various Hungarian elements in Paris. Now some zealous youngsters have organized an Ady cultural society and are already organizing the second Ady evening, without much expertise and feel for it. I have agreed to read (there will be several readings in French, Bölöni will talk about his friend in Paris, as will, supposedly, Barbusse, who has accepted the sponsorship). I have already participated in the rehearsal, but yesterday, before the programs were printed, I canceled my performance, taking into consideration the pros and cons. Have I done the right thing?

There are many newcomers around the Rotonde. Mattis-Teutsch has already found a job and is happily carving picture frames for 3 francs an hour, if I'm not mistaken. I was very happy when I sighted him. Freytag, a good acquaintance of mine from Berlin, turned up and was looking for me, but we haven't met yet. I'm quite often with the painter Bertalan Pór, a kind, pleasant man.[83] The Mihályis have already returned home. Recently

we visited several French painters with Tihanyi. Most recently, this afternoon, we saw Albert Gleizes, who is one of the best French painters and the most informal of those I have met.[84]

Many, many thanks to Mom for the great package of cookies, which compensated for the lost, or seaborne, bacon. Every piece has arrived safe and sound, and I only felt pity for Bandi, who was probably chased away from the cookie plate under the pretext that it was for Gyulus.[85]

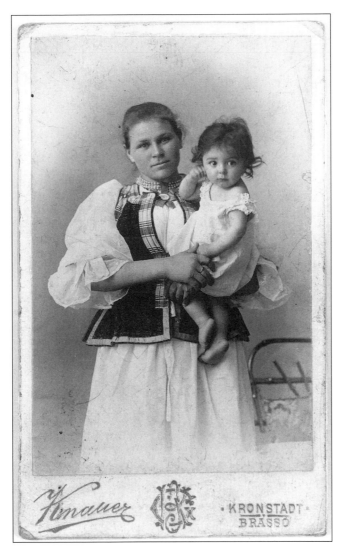

Gyula Halász, one year old, with his nurse, 1900 (© Gilberte Brassaï)

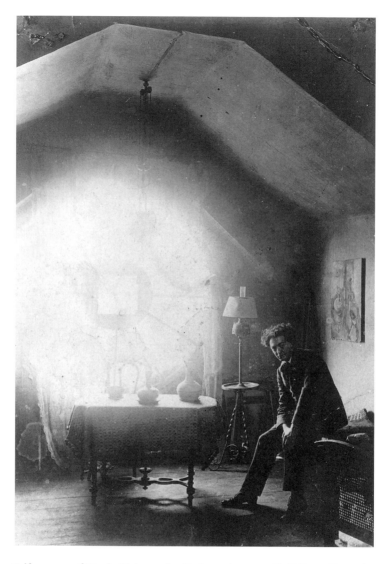

Self-portrait of Gyula Halász in his Berlin atelier, 1921 (© Gilberte Brassaï)

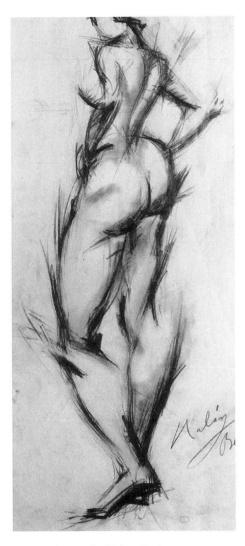

Drawing by Gyula Halász, Berlin, 1921–22
(© Gilberte Brassaï)

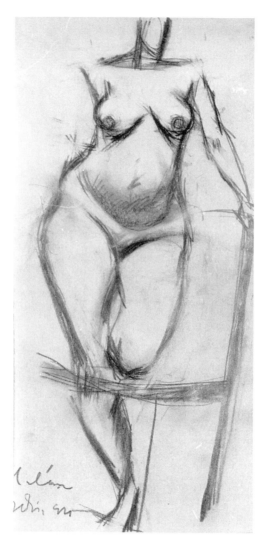

Drawing by Gyula Halász, Berlin, 1921
(© Gilberte Brassaï)

Left Portrait of his mother by Gyula Halász, Brassó, 1923 (© Gilberte Brassaï)

Below Drawing by Gyula Halász, Berlin, 1921–22 (© Gilberte Brassaï)

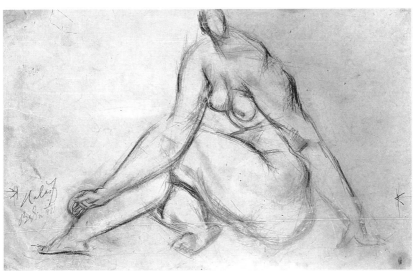

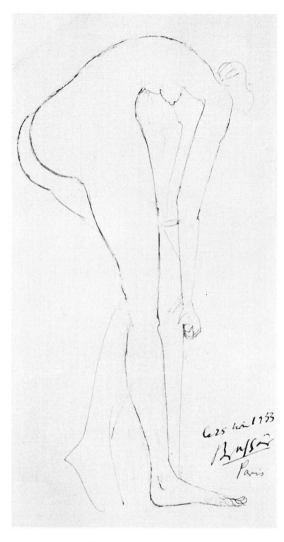

Drawing by Gyula Halász, Paris, 1933 (© Gilberte Brassaï)

Woman in a Coat with an Ermine Collar, Paris, 1929
(© Gilberte Brassaï; print courtesy Museum of Fine Arts,
Houston)

Pont Neuf at Night, Paris, 1929 (© Gilberte Brassaï; print courtesy Museum of Fine Arts, Houston)

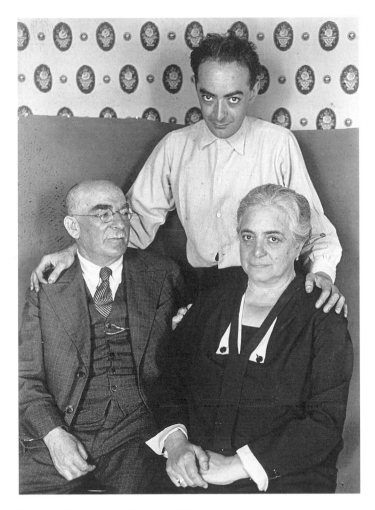

Brassaï and his parents, Hôtel des Terrasses, Paris, 1931
(© Gilberte Brassaï)

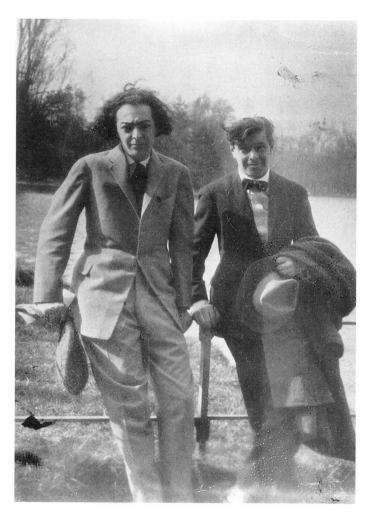

Brassaï (left) and Tihanyi in the Bois de Boulogne, Paris, 1924
(© Gilberte Brassaï)

Brassaï in his hotel room transformed into a darkroom, Hôtel des Terrasses, Paris, 1931–32 (© Gilberte Brassaï)

Desk in the apartment on rue du Faubourg Saint-Jacques, Paris, 1935
(© Gilberte Brassaï)

The First Boat, Paris, 1930 (© Gilberte Brassaï)

Parc Montsouris, 14th arrondissement, Paris, 1931–33 (© Gilberte Brassaï)

Nocturne, 1930 (© Gilberte Brassaï)

Cactus, Monaco, ca. 1931 (© Gilberte Brassaï)

Paris, 12 February 1925

I'm writing by the light of my push-up, push-down Mazda lamp at the splendid round table (with wheels) in my little room. There is a pleasant warmth radiating from my stove, which has a long chimney and is stretching out on its four legs and purring like a cat, although it isn't very cold outside. I have not regretted this move at all. Everything is sparkling clean, brand new, no dust, no animals, and no odors, which is rare in Paris, and I believe even Louis XIV didn't sleep in a more comfortable bed (though he no doubt slept more) than I do. I will start working here, heaven willing, by the second anniversary of my arrival in Paris; for the time being I am still engaged in the art of cooking. The neighborhood is relatively inexpensive. I eat a lot of oysters and drink milk and wine. I still have half of the bacon. It is excellent either raw, over beans, or in ham and eggs. Great acquisitions at the market: potatoes, flour, lard (or rather coconut butter), wine vinegar, oil (for salad), tea, cocoa, sugar, lemon, and some new pots and pans, of course—absolutely dangerous if the Hungarians in Paris get wind of it. It is even possible to wash clothes here, if I want to.

I endured the troubles of moving for three days and three nights. My former landlady, Mme Segas, shed crocodile tears. She was so sad to see me leave, even though I brought the wrath of the concierge and the landlord down on her through my disorderly life—sleeping by day, walking by night. I was truly touched by her giving me a farewell *déjeuner* using her last pennies. And what a *déjeuner* it was! This was the best *entrecôte de Bercy* with roasted onions and white wine that I have ever had. I'm only sorry about the place, but moving away from Montparnasse will perhaps be beneficial for my work. I have been drawn too deeply into the magnetic atmosphere of the

cafés and, whether I wanted it or not, I would always stumble into someone and end up spending my nights in the cafés instead of doing my work. Now I live eight minutes from the Rotonde. There are a lot of ateliers around me—all of them owned by other people! Csáki, the sculptor, lives on my street (he's been living in Paris for twenty years and he has made a good name for himself by now). Bertalan Pór and Gyuri Feny (the son of Miksa Feny) all live close by, as does Mattis-Teutsch, but nowadays I seldom get to see him since he works at the workshop until seven in the evening (it's good for earning a living, but why is he in Paris then?).[86]

I could tell you about several all-night Montmartre outings to the "Mère Catherine" and other similar places. The most beautiful part of these is walking home through Paris at dawn, through the swarming market-hall, over one of the bridges on the Seine, through the Luxembourg gardens in the full radiance of blooming flowers. And the conclusion: the third or fourth cup of coffee with the freshly arrived milk and the still warm, flaky croissants, with the papers hot off the press and still smelling of ink.

My day today: I slept badly, yet I got up at seven. Perhaps the first time I have woken up so early in Paris. I was invited to the afternoon show at Madeleine Vionnet, the biggest fashion salon in Paris. I took Mrs. Vajda with me to this rare spectacle as a fashion adviser. She's the wife of the director of the Vígszinház in Pest.[87] You can imagine how a pageant of the most beautiful models in Paris, wearing ravishing dresses of silk and velvet clinging to their naked bodies, can drive a man crazy. I even had the special luck to see, through the occasionally opening door during quick dress changes, the pomegranate breasts and the plum bottoms. Afterward, since I was already on the Champs-Elysées, I interviewed the press director of the world exposition.

Mr. Móricz has already contacted me twice. He writes that he is satisfied, "but" ... I have to send an article twice a week and one of them must

contain an interview. I will answer him now, but I can send him more only if I get a raise. In any case, I am asking Dad to let me know privately how satisfied they are with the articles I have sent. Last time, I sent a survey of the French press, before that an article from the journal called "The Romania of the Bratianus."

Paris, 4 April 1925

It's two o'clock in the morning. I have escaped the din of Montparnasse. I have also closed my window so I wouldn't hear the rumbling of the city or the love songs of the cats; I even covered the redness of the night with my curtains. Only my blood is still throbbing for the beautiful Oliva from South America, who just stuck a bouquet of violets into my buttonhole at the Dôme and hinted that I could count on her favors again.

I would like to tear myself completely away from the atmosphere of Paris, which is holding me captive to the last blood cells and nerve fibers of my being. Will I succeed? Will I be able to tell you all that I want after such a long, long silence? All right, I am ungrateful and heartless, and — I am writing this in anguish — you believe Paris is distancing itself from Brassó, but I wonder if you understand what is ailing me, and, if I tell you, if you will understand that my feelings and my affections have not changed. I know it is hard to recognize worth, and only few believe in it until it is crowned by success, but the fact that you, my parents, could still be so pusillanimous is such a blow to me that even now it paralyzes my brain. Why am I re-proached instead of encouraged for being in debt in difficult times, "for more than a year of vain efforts in Paris," "for [my] best years wasted after so many others"? I know, it is your great love for me: the selfishness of your great love. But am I to sacrifice the meaning of my life and give up the struggle (without which nothing important has ever been achieved) for the sake of the tranquility of my aging parents? As if my character, which has flourished demoniacally, could be diverted by some small, insignificant blunder, as if I could simply say farewell to the thoughts that have carved out my face and are more real than anything else in me. Oh, that business of

getting into a staff position at the paper, or some other job, secure "at last," this domestic happiness with a good place to live and good food to eat—this is death for me! Understand this at last, if you have not understood it so far: in that case the Montparnasse cemetery is at least closer. If you really love me and do not place your love of yourselves and the peacefulness of your own lives first, why must you lasso me around the neck with the bitter suffering you endure on my account, and why is every one of my steps made more difficult by the "inconsolable" face of my mother and her grieving heart? If it is truly me you love, *trust me blindly*—I don't wish for anything else—since, unfortunately, you are unable to *see* me now. Encourage me with faith if the struggle is hard and don't try to move me and demoralize me by condemning my fate. Believe me, no financial support could be worth the spiritual power derived from your faith: my love desires and craves it. What use does a flower have for the love that plucks it?

Do you understand me? I would offer the sight of my eyes, the power of my faith, and the concrete pillars of my house of cards to keep you from either "aging" or being "inconsolable." But you would be buying your tranquility, and, if it were true, your happiness at a dear price indeed if you buried my dreams in exchange for physical closeness. Well well! How faint-hearted and impatient you are, how you incite me to rebel against my fate; I understand this, as a great part of me is also rebelling against it, but I have long imposed silence on that voice. I have long renounced what is quiet and undisturbed, what is small, mediocre, and ordinary. I want to live my own grand life and I have taken on this responsibility with all its risks; one has to be able to make sacrifices for a grand life. I don't need this boating along the river-bank, no matter how idyllic, beautiful, and, most of all, calm and secure it may be. Let them have it who can be satisfied with it. I want the ocean with all its crests and troughs. If, envying the joys of distant shores, I sometimes say "at last," it certainly will not mean that I have finally reached safe shores, heavens no! It is by controlling the elements that I am in my

element at last, one with the ocean. Let *this* be what you hope for me, what you think about me — it will be easier for me. If you are impatient, if you, whom I love the most, want to get me to dry land by any means, how can I overcome the obstacles?

I cannot repeat all those things that I have already written in confidence in my earlier letters. My God, so many efforts in vain! Life is not easy here in Paris, especially with this blood and temperament, with these eyes and this host of spirits. It is not easy when you can pursue success — the kind of success that will satisfy my hunger — only through the trenches of personal contacts, because, unfortunately, you were not born with a bag of cash on your butt. The work of art may be invisible for now, but it *exists*. This year in Paris neither was squandered nor was without results. I've been disappointed more than once, even when I had expected financial rewards, but there was nothing that could attack my faith and the confidence I have in my values and my ability to succeed here. But why should I be impatient and why should I approve of *your* impatience? Just because silly coincidences have pre-empted some cheap successes that I had been expecting? "La vie, c'est le courage!"[88] And so it is through all the disappointments.

<div align="center">*</div>

I have not had much luck with the German papers so far. I'm still at the mercy of my two press extortionists: Werner Sinn and Herschel, the Paris correspondents for the *Lokalanzeiger* and the Leipzig newspapers. No matter whether I sell them "raw material" or a ready article, they of course submit it under their own names. They are exploiting me and I have to put on a good face about it. Moreover, Sinn sometimes even cheats me: he holds back one or two of my articles under the pretext that he has to read them. A few days later he gives them back to me, claiming that he knows the material already. Thus he doesn't buy it. But he probably uses it anyway. Unfortunately I have no way of checking up on him.

<div align="center">*</div>

Many people, adventures, events, good days, and bad days have passed by during the weeks of my long silence. My diary could only vaguely mirror the "pace," which is so fast that an actual "diary" is out of the question.

28 April. Floresco and I are packing in the atelier. He is now leaving Paris after three years. We are transferring the trunks here and there. Farewell coffee will be at Vigier's. I have promised to come pick him up at 6:30 in the morning and accompany him to the station. Café Dôme. Oliva, the beautiful American woman. I have been craving her for weeks—but from a distance, since she is always surrounded by people. Tonight she is alone. I sit next to her. The Swiss woman comes and sits next to me on the other side. Oliva pulls me away. I have 20 francs with me. Medina asks for 5. A green sealing wax falls out of my pocket. "Why is it green?" "Couleur de l'espérance!"[89] "And the blue?" "Platonic love!" "Mine is the purple red," she says. It's two o'clock in the morning. We have had three *fines à l'eau.*[90] Taxi. Oliva is taking charge. El Garou, rue Pigalle! We're devouring each other. Over the Seine. "A propos, *have you money?*"[91] "Only 15 francs." I pay for the taxi. Fashionable dancing in Montmartre. Champagne for 120 francs. Everyone wears dinner jackets. Two bands: one French and one Argentine. My God, how will we pay for the champagne? Oliva is ravishing. I shouldn't worry. She'll take care of everything. We drink. We dance. The maître d' comes with the bill. Oliva is laughing. She signs it and instead of money places her visiting card there. "Let's go!" Taxi. He is asking for 25 francs. Let's take a hansom cab instead. One is just coming. Home to Montparnasse. It is dawn. Oliva is in my lap, intoxicated by champagne and cognac. She's tearing at my hair like a kitten. *"Multe, multe dulce . . ."* Horse and coachman are dozing off. Avenue de l'Opéra; the Seine; Montparnasse; 9, rue Campagne première. We give the last of our money to the coachman.

Firewood is piled up in the fireplace with paper underneath it. I light it. Sofa. Couch. The fire is burning. Oliva's hot and dazzling thighs on

the puma's fur. You're beautiful, Oliva, your blood is hot. Your father is Italian, your mother is French, and you were born in America. The day is breaking . . . the fire has collapsed. Have sweet dreams in your spider-web nightgown, Oliva! "Diable. Tu es le diable!"[92] I get my gloves and my hat. Six times she asks me to return to her arms for farewell kisses. "Cordon, s'il vous plaît!"[93] The street is bright. I am cold in my light jacket. Cats are crouching in the shadows of dustbins. A few houses away Floresco is getting ready. We are packing. Taxi. Leaving Paris is no small thing. "I have been struggling to succeed for three years. What have I achieved?" On the way to the Gare de l'Est, self-assessment, self-examination, and reproaches. On the boulevard Sébastopol our taxi almost collides with a truck filled with vegetables. The train leaves the station. Adieu, Silvio Floresco! He was a curious, silly man but a good friend to me. In bed by nine. I have 2 francs that Floresco gave me to buy May Day lilies of the valley for Mme D.-B.

30 April. Lunch: half a liter of milk, half a pound of bread. Tihanyi's exhibit. Article for Sinn. Off to Medina's. His money has not arrived. Bread and butter. Off to Herschel's. I get 50 francs out of him instead of 100. A letter from Mme D.-B. "Adorable 'aide-fourbi,' que le Ciel de la Montagne Blanche vous bénisse! Dimanche, je vais avec ma fille adorée faire une fouille dans mes malles. Venez ce jour-là vers 4 heures."[94]

10 May. Only now can I continue the letter, and I feel that I am still only at the beginning. This is my punishment for the long silence. Phillips, my friend from London, was here for ten days. He was attached to me like a sheepdog. He came at a difficult and hopeless time. Therefore, these ten days were soothing to my nerves as well, since I, too, was living according to his good old phlegmatic English rhythm, and the healthy eating certainly did not hurt either. Now, back in London, he's announced his next visit in June. In him I have found a friend I can always count on. Then Mme D.-B.

got back from Nice. Her enchanting company means a lot to me. I was very happy when she told me how much my French had improved since the last time we met. Tihanyi. He has an exhibit now, after almost two years of waiting. A Polish musician named Sliwinsky has furnished a very beautiful place for music publishing and exhibitions, and he opened it with Tihanyi's exhibit. A catalogue is enclosed. Unfortunately it won't be as much of a success as had been expected. Reviews can be obtained only through personal connections, and sales can also only be achieved this way. It is a good thing that the preface by Marcel Sauvage (a well-known French poet) has created a sensation by its novelty; besides many French papers, the English papers and the *New York Herald* have picked it up. It is certain that there are very few paintings in Paris at the moment (among the works of living painters) that are better than Tihanyi's. Of course appreciation and recognition of value, and particularly being fashionable—that is something else again. It means precious little here that the papers in Budapest are filled with news of the great Hungarian painter's Parisian exhibit. I deem it important that André Salmon, who has supported Picasso and Derain, has expressed a sincere interest in and love for the art of Tihanyi and has promised a long study in one of the journals. In any case, this would mean a lot. Tihanyi, though without financial problems, lives economically on the 30 to 35 dollars he receives from home every month. It is true though that he pays 400 francs for his room. Our friendship is longstanding and unchanging, and will remain for life. Mattis-Teutsch has also popped in, struck by the exhibit fever.[95] An exhibit like this, however, means something only at home, for here there is neither an audience nor any reviews. For most painters, except Mattis, whose paintings would never be accepted in Paris, success can be had only with a lot of money (in the big and renowned galleries, where the fee is 5 to 10 thousand francs for two weeks) or through a network of connections. Lies spread at home about the success of a hypothetical exhibit I had in Paris could never compensate for an actual failure. What are such

vanity plasters good for? In any case—I believe it's not the first time I'm writing this—I am getting more and more disgusted by everything that smells of glue and turpentine. I hate painters and salons. None of it has any meaning anymore!

<div align="center">*</div>

I have written just about everything that I had to write about in this letter. Believe me, I would write more, and more often, if I did not always have to "prove myself" and if I didn't know that by revealing the struggle of a hard day or the lack of a hoped-for success I was only causing sadness and I was sapping my own strength with a weapon pointed as if at my fate that I had put into your hands. I am the first to want to bring happiness to my loved ones, but I cannot do so at the price of sacrificing my own life. The wisest thing would be not to write anything until I had something to tell that would please you. But even the heart-stirring voice of a siren could not make me give up the pace.

PS: Regarding the trip to Paris. The set price of 26,000 lei is correct. The trip there and back with the visas comes to 11,500 lei. That leaves 14,500. This includes 70 francs for daily expenses (counting about 15 francs for the room) and Dad's expenses, but at least six applicants would be needed. I have inquired several times about visa discounts, etc., but they know of nothing, aside from the 50-franc coupon that gives you half off the price of the French round-trip railway ticket and a discount on the entrance fee to the exhibit. As soon as I find out about better discounts I'll write you. Dad can definitely count on me in this enterprise.

Paris, 22 May 1925

You must have received my long letter by now, and perhaps, along with all the disquieting news, I was also able to give you some comforting news, some faith, and a little love. Do you believe me?

Now I am sitting here in the small café where I generally write, at eleven o'clock in the morning, an unusually early time for me. I slept with one franc on my table, and the worry that my landlord might catch me again as I was leaving and ask for the rent, which I had promised to pay for certain two days before. Once, in a similar situation, he pulled the dirty trick of taking my key off the hook on the board, and only after a quarrel was I able to stretch out in my bed again. However, around ten o'clock my chambermaid woke me up with two letters (the current maid is a big woman and a mother; the previous maid, Mady, became a professional cocotte and disappeared into the night with six pairs of my stockings taken away for mending). Twenty-five francs fell out of one of them. In it Herschel, one of my jackal editors, announced that "der Ausstellungsartikel mit 2 Zeichnungen von Ihnen ist erschienen"[96] and that the remaining 100 francs would be forwarded the day after tomorrow. The other letter is in the characteristic bold handwriting of Mme D.-B. "Dimanche c'est la vente à la pension de Jacqueline. Si vous venez, nous dînerons ensemble."[97]

There are no words to describe the kindness of Mme D.-B. Her interest in me is no passing fancy, and I know that it is through her that the gates of success will open. If ever there was a woman in my life, aside from Grete, in whom I was able to find, in faith, an echo of my being, then she's the one. Mother and daughter are clinging to me; I can physically feel their confidence pushing me forward. We have been together quite often in recent

days, and these evenings spent together, after splendid *dîners* amid the tongue-loosening and spirit-freeing haze of good French wine and champagne, are truly unforgettable. She is a Frenchwoman with the magnificent French culture running through her veins who knows all the behind-the-scenes secrets of Parisian social life and the ways of success, who talks to me, approaching middle age but still full of youthful vigor and spirits. She's refining my French and my manners so that I will not embarrass her in front of other people. A tuxedo would be more important now than anything else. In the midst of constant financial instability, the question of what to wear often poses a real problem. Little Jacqueline's eighteenth birthday was on Sunday. The young girl is studying at the most expensive institute in Paris and what she pays per month — 3,800 francs — would be enough for me to live on for half a year. We had some refreshments in the atelier. M. Spada (the nephew of the Italian prince Spada), his wife, and their two charming daughters Loulou and Didy — they are studying at the same institute as Jacqueline — were invited. We had dinner and spent the night together in Montparnasse. I suggested the Dôme instead of the Rotonde, to which Jacqueline responded, "It's not very nice of you, Soliman, not to want to go to the Rotonde. Wasn't that the café where we first met? We were on our way back from Enesco's concert and dropped into the bar for a drink. You were playing on the Tourbillon there. Floresco pulled your hair. We invited you to our table and I asked you to play for me, too. Then I gave you 50 centimes." "Yes, but I have lost all 10 sous." "This is not entirely true because you did win 2 sous. They're in my bag. It was a quarter to one." That is when I realized how much this little girl had fallen for me. I'm invited for lunch on Monday and for *souper* on Tuesday, after Mme D.-B.'s concert. I have hardly any money. We took the metro to the Trocadéro. Editor Sinn is beginning to complain that he has no money. Together we read the article about French cuisine I had written on an empty stomach — I have become an expert by now, as I'm also an expert on starving. The article

will, of course, be published under his name. After a lot of bargaining I sell
it for 80 francs. Off to the Spadas' for dinner with the good feeling that I
can pay off at least one week's worth of rent in arrears, and thus I will be left
alone for a while. We are on the terrace of a café near the Étoile. The Arc
de Triomphe is marvelous, with all the swarming cars, arc lamps, and flood-
lights in the pleasant spring air.

27 May, Wednesday. A telegram came from Floresco on Saturday. He is
coming to Paris for a few days and he wants to stay at my hotel. I had prob-
lems with what to wear for Marianne's concert. I had to borrow some shoes.[98]
In the evening Mme D.-B. introduces me to many of her acquaintances at
the concert. After the concert there is a *souper* at the Spadas in the company
of a princess. (I have no idea who she is. They have told me her name but
I forgot it.) It just came back to me: it's la Princesse de Fancigny-Lucinge.
Count Chapdelain, who is working on the plans of a jet airplane, is also
with us. We go to the most fashionable night club, the Boeuf sur le Toit,
which is frequented by Jean Cocteau. Champagne costs 200 francs. At three
o'clock in the morning Floresco and I walk home to Montparnasse.

Paris, 4 June 1925

I am hereby sending my charming picture, taken in the shadow of Tihanyi's masterpieces, so you won't think that I am as skinny as a skeleton. Two women from Hamburg, and Sliwinsky, the Polish composer, are with me. I am also sending you an issue of the *Neue Leipziger Zeitung* with two of my drawings in it. I am also the one who wrote the article for that idiot Herschel.

I'm well, really well at the moment, because I've taken a bath and I can pick up my underwear and shoes from the laundry and the shoemaker. Mme D.-B. takes me everywhere, introduces me, and I myself am often surprised when I am in the company of marquises and countesses. Through what miracle did I end up all of a sudden in the middle of the best Parisian circles? If only I had money and a suitable wardrobe. Just patience! And confidence!

Paris, 4 July 1925

I have some good news to share. All the months of strenuous work in Paris are beginning to pay off. If you had seen me when I made my début in Parisian society on Thursday!

Pierre Duchesne Fournet, this wealthy Parisian arts patron who has the most beautiful Indian collection, gave a tea party in his palace on the avenue du Bois de Boulogne (opposite Anatole France's villa) to which, through Mme D.-B., I was invited. What glamour! An enormous hall with the most beautiful Indian statues all around, walls and armchairs with oriental carpets and the orchestra upstairs in a hidden corner of the balcony. The buffet is in another room with all kinds of delicacies. The most elegant women and *tout Paris mondain.*[99] "M. Gyula Halász, *le grand peintre hongrois,* from whom I have ordered my portrait."[100] My lady introduced me to several influential people.

We drove along the row of stars on the Champs-Elysées. Marianne, in her flower-patterned summer dress, hugged me, tears rolling down her cheeks: "You will be famous, it is written on your forehead . . . I only ask for one thing, that you don't forget me, your loving friend."

Exhausted and always short on time, I can write only in a hurry (unfortunately, it is mostly at the expense of my sleep). My days are loaded with events, and with the intricate web of my soul being ground between six millstones I sometimes think I am going crazy.

This condition, with all its volcanoes and whirlpools, tragic by nature . . . The friends demanding affection . . . (Tihanyi grumbles if he doesn't see me; Floresco, who now lives in my hotel, is unlucky; Medina, the German journalist, is looking for me to tell me about some good news or about

his gaming loss of 600 francs. By my behavior I have deeply offended my friend Mattis-Teutsch, who has always been lovingly attentive and ready to help me; I couldn't even say goodbye to him on the day of his departure because I was pursuing my editor for money so that I could send something home. Now my friend Phillips has arrived in Paris for a stay of four to five weeks. I can spend hardly half an hour with him now and then — I have already turned down three of his invitations.) Oh, and the small everyday problems along with the problem of what to wear. I always have to dress impeccably now; I have to shave every day, I have to complement my wardrobe with dickeys, cuffs, velvet stockings, and neckties. Moreover, there is a good opportunity to earn money with Werner Sinn, my editor. I received 100 francs instead of 80 for my (partly invented) article about cocaine and opium dens. He was so satisfied that I now have to write about literary cafés, then on what a day in the life of a *femme du monde* looks like.[101] I can also draw some pictures to accompany Medina's articles for the *Film Courier* for 60 francs apiece — I am enclosing one in this letter. It's just time, time, time?

I read your kind letter and the news from home with great joy. Forgive me if I was unfair; I know well why this was the case. I will come home yet, I will rush to you, and not at all like one would go to the Montparnasse cemetery. I wish only that I might come home when I want to, and the way I want to.

Enclosed is the photo of Mme D.-B. in the folk costume of Brittany and of her castle in Langoz. Beyond the trees is the ocean, where I have been invited in September.

Paris, end of July 1925

I am happy to have been able to bring you some joy with my last letter. Mme D.-B. left for Loctudy with little Jacqueline yesterday morning. I have to get a proper wardrobe together by November so the issue of clothing will no longer hinder my visits and invitations. Thank you for your kind help in seeing to it that the tuxedo problem was resolved.

Floresco is leaving for Romania in a few days. He is also going to Brassó to discuss his autumn concert (Transylvanian tour) with Klingsor's. He is a very kind and good man, despite his many bizarre traits. He has always been a true buddy of mine. Be kind to him.

I am doing well, I'm just feeling the effects of the German monetary crisis: they pay for the drawings and the articles only with difficulty and after much delay.

Outstanding people whom I could rely on spiritually in the most critical moments of my life are crossing my path with miraculous regularity: Tihanyi, while in agony I searched for my identity in Berlin; and here in Paris, on the eve of my struggle for light, Mme D.-B., this remarkable woman. It wasn't just a coincidence either that I withdrew from Mattis-Teutsch, for example (whom I needed very much at a certain time in my life): a higher inner need demanded it, as he was eating away at my energy with his depressive personality. Life is eternal sacrifice. One's feelings protest in vain against the separation and alienation, but the forces of nature are more powerful. Closing the gates in front of the dejected ones is an *obligation* if one has one's own goals to pursue.

Marianne, with her infallible intuition, knows better than I do what role she has assumed in my life. She wrote this in one of her poems: "I

praise my fate for it has placed me as the lantern of a sanctuary into the vaults of your life, to disperse its dimness." The spiritual power I have found in the faith of an exceptional being means much more to me than the fascination with fame and social status. Marianne claims that she has waited for me all her life, and knew that she would meet me. This is not a mystical Breton legend. Her statement is proven by a poem she wrote a few years before we met . . . to me:

> Tu es l'essence même de ce que j'aime
> la raison d'être de mon amour
> la plante sauvage et drue
> autour de laquelle, comme un volubilis
> s'enroule mon désir . . .
>
> Là, j'ai "épousé" la forme future, que
> Dieu te destinait dans sa sagesse
> Et là, tu as su que ma forme mortelle
> serait pour tes yeux une source de délices . . .
>
> Oh, c'est là que nous nous sommes vraiment
> "connus" et maintenant — quand et
> où, peu importe! — nous n'avons pu
> que nous RE-CONNAÎTRE.[102]

This poem — "We Recognized Each Other" — is exactly like one of Goethe's most beautiful and profound lyric poems; not only the poetic notion but even the titles of the two poems are nearly the same: "Wiederfinden." Well, Marianne did not know Goethe's poem at all. Regarding its form, Goethe's poem is of course more accomplished and concentrated. But it is an interesting coincidence.

Paris, 26 August 1925

I went to try on the tuxedo this afternoon. A friend of mine, a German correspondent, accompanied me to the tailor as an expert. It looks like it will be perfect. It is relatively inexpensive, 550 francs. My drawings now appear regularly in the *Film Courier* of Berlin; four have been published already and a fifth is on its way. They will also start appearing in a Berlin literary journal that is just starting (*Literarische Welt*), as well as in the *Leipziger Zeitung* and the *Prager Tageblatt*. Money stays in my hands barely long enough for me to touch it. The next moment it disappears into the hands of the landlord, or I need it to get my underwear back from the cleaners, or my suit, in which I had a lining put after waiting three years to do so. I ought to buy some shoes, however, and I don't have a coat either. I have received 60 francs for an article I wrote for the *Periszkóp* of Transylvania. Now the editor of a French art magazine, Marcel Hiver, would like to publish it in French. I wonder if Floresco has arrived? I have not received any news from him since his two letters from Vienna.

Paris, 18 October 1925

I am writing you, slightly thinner, but finally in a better mood. Yesterday, after weeks of privation, I was able to eat lunch at a restaurant again. It was as if I had returned from the ice fields of the North Pole. After several warnings, the patron threatened me, as I arrived home last night, that if I didn't pay at least 200 francs before noon the next day, he would throw me out of the Hotel Max's. You can imagine how well I slept! However, the events of the night of the first of October repeated themselves. And not only in feverish tossing and turning but also in the marvelous and fortunate story-book ending.

I have been listening for weeks to someone shuffling up the stairs around eight o'clock in the morning. This is the Spanish girl. This one is the tenant in No. 38. These steps might be encouraging but they stop at the fifth floor. Finally, someone is on his way upstairs with slow, thudding steps. The sound of the steps becomes louder and louder. Forceful knocking. It's either the patron, who wants to throw me out, or the postman with the money. And it is indeed the postman! Two registered letters with money. I give him my last franc for a tip and triumphantly tear open the red-sealed canvas envelopes. Thirty gold marks fall out of one of them, forty Austrian schillings out of the other: the former is worth 150, the latter 120 francs . . . Thus, my being thrown out has been postponed for a while again . . .

But let me tell you of my dream of the first of October. The patron gave me the key for the room only after a lengthy quarrel. Medina had accompanied me and waited outside so that in case I got thrown out, I wouldn't have to spend the night in the street but could sleep at his place. I dreamed of the

room key all night. I saw myself sneaking down the stairs. The Hotel Max's looked somewhat different: there was a pub underneath it. The patron was sitting at a table with several bearded men. I wanted to sneak out without his noticing me. But he saw me. He greeted me in a friendly manner, the same way he began greeting me again yesterday after I paid him. Pointing at the bearded man, he said, "These here are your compatriots. They know that you are an honest man, and they are ready to help you out in your momentary financial difficulties. They would like you to paint a Madonna portrait for them. If you accept, they will gladly pay your back rent." Of course I accepted! Completely calmed down, I fell back into a deep and re-laxing dream. I was awakened by an infernal knocking. The dream was, well, only a dream. But who was knocking? The patron? A postman? It was Kiss! Kiss, whom I saved from starving to death during his miserable days in Paris. I hadn't seen him in a few weeks. He probably lost his job and wanted some money again. I burst into laughter: "You couldn't have come at a worse moment." "Why? What's the news?" "The news is that I owe the hotel 350 and if I don't pay 200 before noon, I will be out in the street." He then took out his purse and from its inner, its innermost, compartment, where he had kept it in safety, he pulled out 5 dollars, then another 5, and put the Yankee banknotes down on the bed: "I didn't come to shake you down! Now I work at night and I wanted to see how you were doing be-fore I went home. I have a little money saved. I don't need it. You'll give it back when you can." There was knocking again. It was the chambermaid with a note from the *patron*. "M. Halasz, je vous prie de débarrasser la chambre pour midi si vous ne pouvez pas me verser au moins 200 francs. L. Charanel, le *patron*."[103]

It is since then that I believe in dreams . . . I shaved. I went downstairs and, threatening him with my bamboo cane, I scolded the patron. So is this the way he treats his tenant of eight months? He should know that I get

money irregularly and that I am at the mercy of my editorial offices. All right, since he insists, I'll exchange my dollars, and I whisked out the ten dollars triumphantly.

What could I have written during those penniless days, those days of starvation? Would a letter have been more pleasant than silence? Sometimes I didn't have a single franc to send a letter for four or five days, and if I had had one, I would rather have bought half a pound of bread and a half liter of milk with it. It is fortunate that there is nothing the wisdom of human nature makes you forget more quickly than hard days. I assume that the human body also possesses this good quality. On the day following weeks of privation, well-fed and with a Havana cigar in my mouth, I see the days of privation as a "Lindewiese cure" that has been stretched out too long.

The beautiful plans for the autumn have been cancelled. Mme D.-B. has begged me again to go to Loctudy for a few weeks. It would have cost me only a postcard, and she would even have sent me money for the trip. But I have never asked for or accepted money from her even in my hardest hours. On the other hand, I didn't want to expose her to the indignation of relatives and acquaintances. By the way, Marianne has sold her castle in Langoz. But she kept the beautiful one in Métairie and the fields that belong to it. So she will be settling down in Paris. She will be buying or renting a house or an apartment and I will have to help her with it. It is somewhat a question of my own home as well. She wants to spend the winter months in Nice with Jacqueline. Also, how could I leave Paris just when, after all my efforts, I finally have the direct contact with the German papers that I've wanted for so long? The *Neues Wiener Journal* sent 40 schillings (120 francs) surprisingly early, twelve days after my article, "Pariser Spielklubs," was published. They pay very well. The first success of my press campaign. My article about the Teutonic Order will also be published in

the *Tägliche Rundschau.* The new *Literarische Welt,* for which Thomas Mann also works and which is already publishing my drawings, will also publish my article on Anatole France, under my name. It will pay 50 gold marks, that is, 250 francs. Another four or five German papers have my articles (*Königsberger Hartungsche Zeitung, Badische Landes Zeitung, Prager Tageblatt*). I'm surprised to have been able to sweat out so much with all the missing calories.

I will return to my dream of the first of October. Apart from my compatriots getting me out of the fix (Kiss), the order for a Madonna portrait was also in it. Well, a few days later an old Dutchman visited me. I have known him for half a year. Have I written about him before? He is a former consul, and though he is seventy-one, he is youthfully vigorous and lively. One night he was talking all sorts of nonsense. He is a member of a secret society and they are looking for a young woman who has disappeared in India and who is the mother of the future Redeemer. If they find her, he will forward me the picture of the Madonna and I will have to paint her portrait, for which they will pay me 1,000 francs. But for this purpose I'll have to rent a separate room that no one else is allowed to enter except me. Five or six years later, when the son of the "Madonna" is twelve years old and enters the world as the new prophet, I myself will be famous for the painting as well! I didn't believe any of this crazy story, though the old Dutchman otherwise gave evidence of a lot of practical wisdom. He left and I never received the photo of the Madonna. And now I've met him on the street: he was just coming to see me. He shook my hand. They had found the woman in India, and he has come to Paris to give me the photo according to his promise. I will have to make a sketch of the "Madonna" by Saturday. For this, he is paying 100 francs. Then, in great secrecy, he handed me the photo along with a lock of hair of the future "Christ." I will have to wear it on my breast until I have finished the painting. At the same time he handed me the

100 francs. For me, the money of the mysterious "Redeemer" was really a redemption! The Dutchman has deposited the 1,000 francs for the picture in a bank. He'll return to the Netherlands, but if the secret society likes the sketch they'll write to the bank and it will advance me 500 francs. Should I believe it? A strange dream . . .

Paris, 13 December 1925

I thought I would be able to send a typewritten letter this time, but that has failed for the time being. Hotel residents need the guarantee of the *patron* in order to rent a typewriter. Though my *patron* came to the shop with me and said every good thing possible about me, even that I pay on time, he did not want to assume any responsibility. Should the machine get stolen, he would have to pay for it. Now I'm reluctantly waiting for the return of Mme D.-B. She will do this favor for me. My dinner jacket is near completion. My tailor received me cordially: the tailors in Paris are used to these absences of several months. As a reassurance: those who have not seen me in a long time are saying that I look good and also that I am elegant. There are beige gaiters (*guêtres*) on my legs and a yellow (inherited) silk scarf around my neck, and, according to the nuances of the weather, I wear either the short, brown, checkered overcoat inherited from Floresco, or a new gray raglan, or the white rubber-cloak; round plush hat; and, in my hand, a delicate bamboo cane with a silver ring, which I also inherited, and with which I gesticulate like Charlie Chaplin. And a great event! I had my hair cut short. Until now I've been *à la Ninon* and now *à la garçonne!* At the barber's, I watched without pity as the long locks fell under the scissors. If one sees the hordes of artists here in Montparnasse day after day, with all the ostentatious attributes of those kissed on the forehead by Genius, one grows to hate everything that may give rise to suspicions that one belongs to that company, from the wide hat to the bow tie, from the Samsonian hair locks to the mournful shirt.

If I were listening to my reason, I would never pick up a paintbrush again, I swear. Whether I can help it is a different question. If I can't, it will

be a sign of weakness. I realize this whenever I see those succeed who do not deserve it or when I'm secretly nosing around for an atelier. At this moment there's nothing more important than striking the article-iron while it is hot, since this provides me with a regular income now. The *Leipziger Tageblatt* is coming out with my third article now and I have received the honorarium for the first one: 25 gold marks. This is slightly less than I had expected: 150 francs instead of 200. The chambermaid has just brought in a letter from the *Königsberger Hartungsche Zeitung* in which they inform me that they have published my article. Now the only upsetting thing is that I still don't have a typewriter and I have to run around and spend a lot of money to have everything typed in German.

I received a long letter from Floresco in Bucharest. He had lunch with the Romanian minister of education, and his job, as he writes, has been permanently assured now. I think he has been appointed professor at the conservatory of Bucharest.

Paris, 19 December 1925

Unfortunately, I cannot send anything other than good news for Christmas. It is likely that, from the first of January, I will be the Parisian agent for one of the big German photo agencies for a fixed salary of 100 gold marks. My writer friend Medina introduced me to the director of the agency. I have made him take a multitude of photos, from a cease-fire wagon to me jumping clear of a car on the rue de Rivoli. My task will be to obtain from Parisian photographers the pictures that Germany is interested in, and to have a photographer take pictures for the commissioned articles. But Gaudenz (that's the name of the director) would mostly like me to learn photography so that I can provide these pictures myself. He returned to Berlin last night. Before leaving, he took a few pictures of the "notables" gathered in Tihanyi's studio: Tristan Tzara, the leader of the dadaists; Liesler, an architect from Vienna; Hans Richter, film director; Medina; Tihanyi; some beautiful women; and myself.

Now I have to hurry and look for a photo of Henri Barbusse as well as obtain the commissioned picture of the European woman champion in stenography.

Paris, 2 March 1926

I am to go to Nice for two weeks on the fourteenth of March. I have given notice that I will have left my room by the fifteenth. I have sold the interview with Iorga to Sinn for 150 francs, and now I will get the same amount for the Merezhkovsky interview. By the way, I had to draw a picture of the prominent Russian writer for the *Literarische Welt* as well. I would have liked to rest in Nice and I wanted to receive an advance of 400 francs from Sinn on the articles to be written (which I think I will have ready while still here in Paris). He accepted the plan with great pleasure. I have several acquaintances in the south and I am not in danger of losing thousands at the roulette tables.

On Saturday, I looked at an atelier for rent out in Bellevue-Meudon, near Rodin's studio. It's perfectly located. A 5-meter glass window looks down from the hillside onto the Seine and the Bois de Boulogne. A kitchen, bedroom, and another small room. It's furnished, with electricity and running water: 350 francs a month. If I didn't continually have to run errands in Paris, I would have rented it without hesitation.

I hope I will be able to draw some portraits in Nice for the German literary paper. There are a lot of famous French and foreign writers down there, such as Rudyard Kipling.

Paris, 10 March 1926

It seems that I have begun my third year in Paris very auspiciously. My income this month exceeds 1,800 francs. Why don't I come home then? Because a hiatus would disrupt everything while the journey to Nice will improve everything. I believe that when I return after two or three weeks, tanned and refreshed from bathing in the sea, the renaissance of my Parisian life will truly begin. As I wrote before, I will have given up my apartment as of the fifteenth of March and I have not looked for another one for the first of April. Suppose I stay on the Côte d'Azur for another week in April or, if the drawing and article-writing business turns out right, take a mountain trip as well? I am really yearning for some fresh, snowy mountain air. I will leave all my belongings here, in the basement of the hotel. I am writing by hand because my Remington typewriter was shipped home yesterday — in three pieces! Fortunately, I am not the one who broke it. Early in the morning, barely had I handed it over to the man from the firm who had come for it, and no sooner had he closed the door behind them, than I heard a terrible noise. Slipping on the waxed stairs, my man, and with him the machine, rolled down an entire flight of stairs. Though I wasn't responsible for it, the event was embarrassing. I went to the firm to offer my condolences. They were the ones who reassured me: I shouldn't worry! This is a risk the firm has to deal with. Anyway, the Remington was insured ... So this way, perhaps, they may even make a profit out of it ...

Paris, 18 March 1926

Still in Paris. Instead of leaving on the fourteenth, I will get on the road
only tomorrow evening after a five-day delay. I have been held back by this
"Count Kokotzoff business," partly awkward, partly funny. Someone else
would write a short story about it, I will preserve it for posterity just this
way. For three days, the fate of my entire trip to Nice as well as the fate of
my article-writing enterprise depended on whether Kokotzoff was alive or
dead. First I had to investigate, then to lay siege, until last night I got the
greatest potentate in the former tsarist empire to capitulate. What actually
happened was that in an inspired moment, thinking of the 150 francs that
I would get for the interview, I invented an interview with Count Kokotzoff
(the former Russian prime minister and finance minister), which Sinn re-
ceived with shouts of joy, and which was published in about fifteen German
papers. A whole week had passed and I thought everything was fine, when
all of a sudden Sinn asked me for Kokotzoff's address because the editorial
office wanted it. Frightened by the prospective catastrophe, which would
immediately result in Sinn's getting fired from all his papers, I announced
that I myself had bought this interview from a Russian and I didn't know
the count's address. Since the interview contained descriptions not only
of the count's beard but also of his apartment and the engravings hanging
on the walls, Sinn was desperate for me to find the count and get his per-
mission, after the fact, to publish the interview given to the "Russian." Of
course he didn't suspect that there might be more serious repercussions than
a refutation — that is, if the count were no longer able to refute anything
because he was no longer among the living! Would the Kokotzoff case be-
come the prey of German satirical papers, with the title "Interview with the

Deceased Count Kokotzoff," etc.? Fortunately, the interview was not mere fiction. For the most part, it contained statements he had made that were published in the *Echo de Paris* two years ago. You can imagine the suspense! I was especially worried about the advance for Nice and the fate of my trip. I was talking to everyone I knew in Russian circles. Some of my informants stated categorically that the count had died. Much to my relief, I finally found out that he was alive. I even obtained his address: one of the palaces on the avenue Marceau next to the Étoile. Then another obstacle arose. Recently a Belorussian general disappeared from Paris without a trace. Thus my count was also afraid of a Bolshevik attempt and no one was allowed to approach him in person. After I rang the doorbell, a male voice behind the unopened door asked me to write to him. In answer to that, I drafted the perfect diplomatic letter by weaving together all the flowers of French phraseology, a letter that would have moved even the heart and liver of Rasputin. I described the tragedy that would befall Sinn and his family if the count refuted the article. I received the count's long-awaited answer the day before yesterday: depending on the German article, he will make a complete refutation. I sent him the article on the *pneumatique* and he received me in person last night at seven. He gave me his word that he would do nothing about the matter until I returned from the Riviera. He did not have an opportunity to study the article, but he would correct me, give a *real* interview about the fake one. Sinn, to whom I immediately handed over the address of the count, felt relief from the nightmare and promptly paid me.

After I gave up my room on the fifteenth I had to wait for the favorable or unfavorable outcome of the Kokotzoff case in a daily room. This waiting has made me so impatient that I don't want to stop until I get to the roulette table in the casino in Monte Carlo. In revenge, I will test my luck. I will visit Marcel Sauvage, the French writer, who has invited me to Cassis-sur-Mer (near Marseille), only on my way back.

Adieu Paris! Next time from the coast of the Mediterranean Sea.

Nice, 29 March 1926

My dear ones, I have been able to write only postcards until now. I have
been here for almost ten days, and since then, as if to mock all the praises
I have heard about the sun in Nice, it has been raining almost incessantly.
Instead of getting sunburned, I am just burning up! It is a meager consola-
tion that it is snowing in other parts of France, and that it is freezing in
Paris.

Nice and its surroundings are ravishing even when it is overcast. Para-
dise must have looked something like this, as the beauty of the flora makes
you forget the many manmade contraptions and the bad taste. On my ex-
plorations, I delight in the palm and orange trees, in the giant cacti, in the
geraniums that grow to the size of bushes on the bare rock walls; here, the
tropical plants get along well with mountain pines. This is the first time
I have ever seen the sea, and in its most beautiful form! I drag myself out to
the pier and watch the fishermen — they sit around on the rocks for hours,
huddling under their umbrellas. I go up to the castle, or to Mont Borou
(I have just come back, soaking wet), from which you can look out over the
shores of the Riviera to the sea. Right now the rock-lined coast is being
pounded with gigantic waves. The color of the Mediterranean Sea is such a
surprisingly translucid green here that one wonders whether it is real. I can
write little about the sun, simply because I have hardly seen it.

At this moment I don't yet know, and I don't want to know, how long
I'm going to stay. I would like to finally see the famous Nice sun. Due to the
beastly and totally depressing weather I have not yet been able to visit either
Cannes or Monte Carlo or Menton. I would also like to make a short trip
to Grasse, the city of flowers and perfumes. Everything depends on what

I can afford and for how long. Presently I am staying at a hotel for 12 francs a day. But I hardly have any money left and I keep going to the post office nervously, storming the *guichet H–K* at *Poste restante* to see whether help has arrived from some part of the world.

Today, as a fortunate conclusion to the Kokotzoff case, I received another letter from the count. He informs me that although there is a lot of *fanfaronnade* (contrary to his modest character) about his name in the introduction — the introduction is not my work but that of the stupid Sinn! — he will not refute the interview and asks that I "persistently believe in his high esteem for me." [104]

Nice, 7 April 1926

My dear ones, you are worried, aren't you, and you don't know whether I have been swallowed by the sea or by the perils of Monte Carlo? Fortunately, I still have the money to mail this letter without being in danger of starving to death. But I fasted throughout Lent, and on better days I have lived on figs, dates, and oranges — out of necessity, since tropical fruit is the least expensive here. Being completely penniless on the rainy days here in Nice was depressing. But the weather has been glorious for the last ten days and, for lack of a better alternative, I spent these days lying on the beach in swimming trunks, sunbathing and resting, and I am so sunburned that I look like a Moor. It would be difficult to tell you in detail how I got myself into this embarrassing situation. But everything is fine again, and the same thing happened to me that happened to the sons of the father in the Gospel, who, though they did not find any treasure, dug up the whole vineyard. Well at least I was forced to get well rested. Yesterday and the day before I even swam a little in the sea. The thing that bothered me the most was that I have not been able to write to you for two weeks. I received your postcard, and now I'm waiting for the money sent to Tihanyi so that I can pay my rent. Nice is beautiful. I'm just beginning to really enjoy it now. If my money arrives today, tomorrow I'll go to Cannes to interview Colonel House. I have discovered a number of interesting personalities and I've had an elegant business card made for the interviews.

Nice, 15 April 1926

My vacation in Nice has been appropriately adventurous and foolhardy. Foolhardy because I wanted to live on money that was not coming in and on notables who could not be found. It would have been wiser to play in Monte Carlo, but you need money to do that! I could have made a living by drawing caricatures if I didn't have to be afraid of acquaintances popping up everywhere. The other day I was just about to draw on a fashionable *plage* when I bumped into Count Bourgault de Coudray, the nephew of Mme D.-B., who knows me well from Paris. (I've been invited to his place many times for *diners* and music parties.) It would have been awkward if he had caught me working here as a caricaturist for a few francs.

Of all the tragicomic adventures, I would only like to recount how I was thrown out of the hotel. After my money ran out and I did not get anymore, I lived on credit. First I pawned my silver watch. But when my debt exceeded 100 francs, my *patron* said that if I didn't pay the following day, adieu! The following day he was willing to hand me the key to my room — and on a cool night the room key is the key to heaven, leading to bed! — only if I also handed over my suitcase. By the third day I would have been in the street without the silver watch and the suitcase! In the evening I went back to the hotel without money. Getting thrown out was inevitable now. That, or I could persuade them to give me another deadline. I listed all my excuses for the *patron*'s wife. She would talk to the *patron,* I should come back an hour later. It was eight o'clock. My God! They led me to a table set for dinner. The wife was cooking and baking in the kitchen. The little girl placed a pillow on the armchair for me to sit more comfortably. The *patron* uncorked good Italian Chianti wine. Nero, the dog, licked my hand. There

was no denying that I had not had a single bite all day. The Italian dinner was excellent. They insisted I eat two extra eggs as I had probably skipped lunch. By the end we all got drunk. The *patron* was cheering Mussolini and the king of Romania and he embraced me. I was so touched that I drew caricatures of everybody, from Nero the dog to the old grandmother. Not only did they not throw me out but they also gave my suitcase back, and the following day they moved me to a better room. Now they are patiently waiting for my money to arrive. It is a surprising turn, worthy of a novel, isn't it!

I have received 250 francs from Mr. Phillips, my English friend, who found out about my fate in Paris a few days ago. This amount enabled me not only to pay my rent, but also to concentrate on my articles and interviews again. The Phillips money came so unexpectedly that I was wondering whether I should risk the remainder of it on roulette.

Nice, 20 – 22 April 1926

I had several embarrassing disappointments in front of the *guichet H–K*
of *poste restante*. It was obvious that some mistake or accounting error kept
them from paying me the money Tihanyi sent. My rent has become over-
whelming again and I may have to wait for weeks before I am able to
wriggle myself out of the swamp of financing my vacation. The clerks at
the post office already know me very well: though several hundred clients
come day after day, they know my name by heart. For the past month I have
been their most faithful client between eleven in the morning and five in the
afternoon. Oh, these moments in front of the *guichet!* "To be or not to be!"
Registered letters and those with money are listed in alphabetical order on
a page. To avoid cheating, the clerk always covers the list so that the client
won't see it. But often enough they misread the name and one doesn't get
the remittance. This has already happened to me twice. I was in wretched
poverty and starving while my money was at the post office. The same exact
thing has happened again now. Angered by the negative response, and with
a speed fueled by despair, I pushed aside the piece of paper covering the list
and I noticed my name under *K,* instead of *H.* Kalász instead of Halász!
Acknowledging the mistake, the clerk took out four letters from letter-box
K. First the telegram: "1,000 francs are waiting for you at my place. Come.
Lajos." Then a postcard from Dad. Then a check for 170 francs. In my
bogged-down state I really appreciate your being able to send this money.
The law of bogged-down carts, however, is that all of one's efforts just make
them sink deeper and deeper. I will heed your advice, including the admoni-
tions. I deserve them. But believe me: it was only a tiny rock that bogged
me down, and the enterprise didn't turn out as well as I had expected or

told you. It rained unceasingly for eight days after my arrival. I received the money that I had been counting on with much delay, partly due to the mistakes of the postal service. This is why I could not rent a room by the week, which would have been much cheaper, and had to hold on to the one for 12 francs a day. After my arrival, I immediately ferreted out the addresses of some of the dignitaries who deserved an interview. In Nice I found Archduchess Stephanie. Dr. Voronoff is nearby, too, as are Venezilos and Grand Duke Cyril. Colonel House, a friend of Wilson, is in Cannes. But my deteriorating financial situation did not allow a return trip to Cannes. I also wondered whether he spoke German or French and if I would have to go to Cannes several times before I could catch him. By the time the sun came out again I had long since been in a fix, amid worries about bread and butter and accommodations, in a way more wicked than in the Sahara or in the jungle . . .

Here are some entries from my diary. Things like this are written only by hopeless arctic explorers.

Good Friday, 2 April. Yesterday (no mail) — up to the castle with a pound of bread. I also buy an orange. Lunch. Sunbath. Post office at five. For dinner the rest of the bread. In the evening I meet Barroi, the actor, on the promenade. We talk for half an hour on the beach. He takes off to have dinner. I come home hungry. I go to bed at ten.

Today I put on my light suit and my only clean shirt. (In the evening I washed my gloves and stockings.) I have thirty-five centimes. I don't eat anything all day, only graze on the hillside below the castle, being totally weak. From home only a postcard and *no money.* Nothing from Sinn. It will be several more days before I receive any money, if at all . . . The wife of the *patron* has become grim today. She is pestering me. What is going to happen? (My soap ran out, my cologne broke, my powder is exhausted, and I don't have any clean dickeys left. Man, do something!!) It's half past eight in

the evening. I'm looking for Balogh but can't find him. Mrs Nacher. Pension. The beautiful Russian woman. The boy from Vienna. They have finished their dinner. I wish they at least would offer me wine. No, I have to dance. (Energy for this, also!) To home, famished. Today I have not had a single bite! By the way, today is Good Friday. The idea, however ridiculous, calms me down.

Easter Saturday, 3 April. Bright sunshine. I sleep feverishly. I'm tormented by hunger. My dream: I've purchased the wrong train ticket but I am sure the cashier is at fault. I am so angry that I go back to the station and make a row. Cars are honking terribly. I assume it's already noon but it's only ten. The Promenade. I don't dare to draw. Post office. A registered letter from Sinn. I open it trembling . . . He returns my article instead of money. Catastrophe. I creep away as I can't pay the 40 centimes to the clerk. What is going to happen? Hunger. I take a walk and want to draw. On the Promenade. A frog-swallower. I draw a gentleman. I step up and show it to him. He laughs and goes away . . . I pack my clothes and sneak out of the hotel. To the pawnshop. It is closed. I ring the bell, along with three Englishmen. Nothing. Back with the parcel. I have eaten only a pound of bread and an orange in three days. This is Lent. I go to Balogh to ask for a franc so that I can redeem my mail tomorrow. Sinn's letter comforts me, though. In the kitchen at Balogh's while he is out, I cut off a small piece of bread. I feel ashamed to ask for a franc . . . I walk there and back. I want to draw . . . Post office. A letter! But not from Tihanyi. Like a wolf trapped in a pit, I'm handed a branch that would rescue me, but it is dry and breaks half way up: I fall with a crash. Hunger. How long am I going to hang in there? If I were lying on a bed it wouldn't matter that much but I'm up all day long. Negotiations with my landlady. They are good people. What should I do? The leather camera case! But where should I sell it? I don't even give it a try, I'm lounging around and suddenly find myself in old Nice. I forget

145

about everything in its labyrinth of narrow alleys. Easter Saturday. Joints, brothels, and shops full of people. Easter milk loaf with an Easter red egg inside. I don't know how long I am loafing here, nor where I am. Hundreds of bats are flying close overhead. The jumble of an unrecognizable Italian dialect. Finally I end up at a fair. A fortune-teller. Roulette by candlelight. Sweets stalls, a shooting-range . . . I have fifteen centimes. What could I buy? The cheapest orange is twenty centimes. I think of stock cubes, I wonder if they have become more expensive. Finally I buy a Stollwerk caramel for 10 centimes. This is today's menu. Almost forgot: I also find an orange half trampled down. I wash and clean it and eat it on the beach, and I almost *steal* a can of milk. The cans are on top of one another in a pyramid. If I entered the gateway and stretched my arm I could just reach the one at the top. They wouldn't even notice me. The street is deserted. But from the windows? By the time I return, they are already taking the goods in (fortunately!). I return home dead tired. Negotiations with the patron. Tuesday noon is the last deadline. This is dreadful, because money can't arrive by then and if (a big if!) Tihanyi sends the money on Monday it cannot get here before Tuesday at five. What will happen *tonight*, though? On the verge of starving to death. I'm surprised that I can endure so much. I shave. It gives me energy. To Balogh. *Coffee.* Although terribly hungry, I go to bed calm. If money arrives on Monday or Tuesday I can resolve the situation without delay.

Easter Sunday, 4 April. I slept well. Nasty awakening. To such an Easter Sunday. It is one o'clock in the afternoon. I linger to and fro on the Promenade. (How come I still have strength? How come I don't look worse? However, if somebody looks at me, I get frightened.) I still have one sou. The little magician. They are singing Valentia. A lot of beautiful women. I don't think of drawing. But I would like to sell the camera case. At last

a Hungarian street photographer. "Why don't you buy the case? Five francs." He doesn't consider it too expensive, but as I asked for 5 francs he gives me only 3. They are in my hands. He asks what I am. A draughtsman. "Then you have your livelihood in your own hands! There is a Hungarian here, Kondor is his name, he makes hundreds in Monte Carlo and Cannes and he can't even draw, he is just impertinent. People don't even know what he does before he has emptied their pockets. Sir, you might earn tons of money. Just select a better-off gentleman and he will no doubt give you 5 or 10 francs . . . Two have already given it back? The third won't. Somebody will give you 20 francs. You're still running around with the case while you could have earned ten times as much." I have to try it. But now: *I have 3 francs in my hands.* I will eat. I don't even feel hungry or tired anymore. I hurry towards the fruit market. Half a pound of figs for one franc, two oranges for fifty centimes. I attack them on a bench under the cacti. This is the resurrection of my stomach, empty for three days. I munch carefully, enjoying all the flavor of the fig. Pressed café au lait in a bar. Hotness penetrates my stomach. It's excellent, I get quite drunk . . . Only the starving healthy stomach knows this ecstasy: EATING! I sit on a bench. I would like to do something, but I can't do anything. I draw a German. I go over to him — he doesn't want a good caricature. It's true that I ran away before they got a good look at it. It's getting dark. Adieu drawing! So there's no dinner either. Caramel for two sous. I find an onion. I eat it, without salt, with due disgust (it would not have been bad with bread and salt, quite a good sweet onion). My mood is good. Now to Balogh, I hope to get a coffee and to dare to ask for one franc.

Easter Monday, 5 April. Ten o'clock. Still hungry. With the smell of the onion. I couldn't find Balogh last night. To the Promenade. I manage to get another two francs for the case from the Hungarian photographer. Half a

pound of figs in the evening. There's nothing at the post office, but I pay back 20 centimes (I still owe 40 to the other clerk). Café au lait (70 centimes). At one o'clock the photographer gives me more instructions. I should be brave. I leave the Promenade in disgust and go out to the beach. I can't resist it. I get swimming trunks and I swim into the sea. I lie in the sun till five. Now I'm going to draw. I do draw, but the blockhead doesn't buy it. I walk with an Austrian boy. It's nine o'clock. Balogh gives me five francs. Let's get into a 4.50 restaurant at once. Soup, fried fish, scrambled eggs with pommes frites, a tangerine, and red wine. Tomorrow is Tuesday. What will happen at the hotel? And what will they think *at home?*

Tuesday, 6 April. Post office — nothing. It may come at five, though I can't stand it any longer ... The pawnshop is open! I take a bath and a swim. In the afternoon to the pawnshop with the blue suit. I am wearing the light one. Half an hour later. They don't take it. They give me another address but they don't take it in there either, only jewelry. Hunger. Heat. A big parcel under my arm. To the beach. (I don't dare go home.) I sunbathe for half an hour. Back to the first pawnshop. *25 francs!* On the beach: oranges, dates. Article for the *Brassói Lapok.* Post office at five. Forty francs from Tihanyi! Dinner in the evening. Twenty francs to the *patron* and I tell him that money is coming. I write at the café. I sleep terribly.

Wednesday, 7 April. I write to Tihanyi. I go back to the hotel. The weather is beautiful. I redeem my business cards for ten francs. Once more, I hardly have any money left. Tihanyi promised to send a 50-franc advance on the check the next day. In the afternoon I am searching for addresses.

Thursday, 8 April. Has Tihanyi deceived me? No mail. Has the check from home not arrived yet? Half a pound of dates and half a pound of bread ... that's what I have in my stomach tonight. In the afternoon the *patron*'s wife

does not want to give me the key. But she is fundamentally a nice woman. In the end she does give it to me. I lie in the sun all afternoon. The *patron* says it is the last day. I have a fever from getting sunburned. It's cold. The barometric pressure has fallen. Is it going to rain again?

Friday, 9 April. A terrible day! Today I ate only two small carrots that I took from the gutter. And that's not all. A postcard arrived from Tihanyi instead of money, and he wrote it yesterday, Thursday, instead of *Tuesday*. What is going on with my check? I have to leave the hotel. After some bargaining I can stay today but tonight I will have to give all my belongings to the *patron*. Now I'm packing. What packing, my God! I am dying of hunger! I haven't had a bite either yesterday or today. I pack this diary. May it rest in peace. They push me out into the street . . .

Saturday, 10 April. I drew a big question mark in my diary for this day. The worst thing is that I won't be able to shave my two-day-old beard tomorrow morning. I don't even have any soap left. As to what happened in the evening — instead of being thrown out, an invitation and a splendid dinner. I have already written about that. Now that I've got the diary back, I make a note: the photographer gave me an additional five francs for the case. I wanted to draw again, but I always stumble into acquaintances from Paris, and that keeps me back.

Sunday, 11 April. I don't eat anything till eight at night again. I'm just on the verge of entering a café and, come what may, ordering coffee and a sandwich and perhaps trying to draw when I bump into a Hungarian painter. After many lies about our wealth it turns out that he doesn't have a penny either and he would like to draw, too, but he does not have the courage. Encouraging each other, we enter one of the big cafés on the avenue de la Victoire. We order coffee and pastry. Some people are playing pool behind us. I

sketch them and send them the drawings by way of the waiter. A big laugh. And money from their pockets! Thirty francs. What a success! We split the proceeds. I immediately go to a bar and wolf down a sandwich and hard boiled eggs with beer.

Monday, 12 April. A registered letter from Tihanyi with a check for 230 francs. Right to the bank. Even by wire it takes four days to cash. This morning a meeting with the Hungarian painter. He's got tasteless but attractive silhouettes. They're not made by hand and cut out by scissors, as he states, but mass-produced at a factory. It doesn't matter as long as people like them. On the money left from yesterday we are going to Monte Carlo, where he will no doubt sell them. But he has a new idea. Our hair is too long, let's go to the barber first. The barber is shaving me and asks whether we like his freshly painted shop: "Very beautiful," says the painter, with shaving foam around his mouth, "but something is missing from the walls." "What's missing?" "Some kind of beautiful picture. Clients often wait here and the empty walls make them bored. But you're in luck, I'm an artist and I happen to have what you need for the walls." He stands up, unwraps a silhouette, and puts it on the wall. The barber is enchanted. So is his wife, whom he asks to come out. "What's the price?" "Oh, it's not expensive. I'm just getting back to Paris, I can give it to you really cheap, at half price. What a job, though! To cut it all out with scissors!" Refreshed and galvanized with 40 francs in our pockets, we start out for Monte Carlo. The weather is fabulous. This is the first time I've been in these parts. The road is wonderful. The painter has gone to the hotel to sell the other silhouettes. I'm walking in the park. What vegetation! I admire the spreading roots of the ficuses and the air roots descending from the heights to the ground. And the palm trees, the blooming scarlet and pink camellias. Finally, I sit down in front of the casino. I have made an appointment there with the painter.

One does not notice it at once, but after sitting there for a few hours it is noticeable: there's an unbelievable tension on the balconies. There is an old Spaniard next to me on the bench. A young man comes out of the casino in haste and tells him, "Please, give me the other 500 francs." The old man takes the money out of his pocket and counts it out: "What happened? Have you lost it all?" "Yes, I have lost it. But right now a winning streak is coming!" And rushes back into the casino. At last the painter is coming. He's sold a silhouette with much difficulty. He leads me to a small Italian pub. View of the sea. An Italian singer: memory of Sorrento. Fried eggs. Salami. Bread. Red wine. The painter gives me five francs. Back to Nice.

Wednesday, 14 April. Early in the morning I meet the silhouettist again. We have to glue together some more silhouettes and frame them under glass. Then back to Monte Carlo. Though he's running up and down till evening, the painter cannot sell a single silhouette. Back to Nice. We go to a bar, in case we can draw there. Soon we realize that this one is for homosexuals. A handsome blond boy is showing nude photos of himself to an old man. He kneels down and kisses his hand. We flee. Perhaps we'll have more luck in an elegant tavern. I draw the *patron*. He gives me two francs. I can come back tomorrow night if I want to draw. There will be many clients.

Thursday, 15 April. I shave with the soap stolen from the café. I'm a bit thin. The painter has disappeared. He didn't come to meet me at the time we had agreed upon. I still have one franc and 50 centimes. Figs for a franc. I lie on the beach till five. In the evening I find a half-rotten lemon, an apple, and two good oranges at the fruit market. I eat them in the park. I go back to the tavern where I was yesterday. It *is* true there are a lot of people. Unfortunately, there are many of my acquaintances as well. The actor Barroi and his colleagues who played in the film *Carmen.* And the director Jacques

Feyder is here, too. I drew his portrait for the *Film Courier*. How could I start drawing here for a few francs?

Friday, 16 April. Two hundred fifty francs sent by Phillips. I rush to the bar. Milk with rum and two brioches. One hundred twenty francs to the *patron!* Letters to Tihanyi and home. At last a decent lunch for 5.50. Soup. Fried pigeon. Potatoes. Artichokes. Omelette with ham, apple. I write articles. I buy soap, shoe polish, paper, pencils, etc.

I hesitate about whether I should tear up these pages. Please, read them with as much indifference as I am now, as I transcribe them. All this is *memory* by now. And thanks to heaven, everything, even the worst things, lose their sting when they migrate to our memories.

I will return to Paris in two or three days. I've set up an interview with the American senator, Thomas, and I will try to set one up with Colonel House. On my way I will stop in Cassis-sur-Mer to visit with Marcel Sauvage for a day or two. Thank you for the support you gave me during my difficulties.

Paris, 29 May 1926

Mme D.-B. and Jacqueline have just returned to Paris with greetings and parcels from home. They recalled the pleasant hours spent in Brassó with much joy. Originally I tried to talk them out of this visit, but now I am happy that you could get to know these nice people. They talked about my family with great sympathy: about Mom's eyes and her compote, Dad's delicate diplomacy, Bandi's smile, and Kánka's masculine features and intelligent hands. Thank you for receiving the ladies so kindly. They are so nice to me that it is only up to me, and they do for me whatever I want. We had dinner together on the evening of their arrival. These days I'm drawing the portraits of Madame Marianne and Jacqueline and we will write to the count who had earlier commissioned his portrait.

My new hotel and my room are very good. I have a telephone and I can receive anyone I want. My room can be described as ideal. It's so big that I can also paint in it and the view from the window is the most beautiful I have seen in Paris, with chimneys and a multitude of houses and the Eiffel Tower, which shines through the fog at night with the changing marquee lights. Perhaps the only problem — if it's a problem — is that the sun shines right into the room from eleven in the morning till seven or eight at night, when it sets blood red amid the train smoke of the Montparnasse railway station, and in the summer the heat may be unbearable.

Paris, 12 July 1926

I've been preparing to write a little bit, to my heart's content, for several weeks. "A little bit," even if it takes twenty pages. Believe me, I live here like that thief in the story about the musicians from Bremen who didn't know where to hide, for the donkey kicked him at the threshold, the cat clawed him from the ashes, and the crab pinched him in his towel . . . It makes no great difference if you are pursued because you are likable, and it is to you whom everybody confesses their grief and misery. Then comes the difficulty of making ends meet, which, thank God, is difficult only insofar as I have to work to make them meet. After that, the social connections, which can be sabotaged by the least thing once you start having them . . .

To begin somewhere: when I finally manage to get home one way or another to the hotel room, with which I'm still on a honeymoon, first the kindly, fat Russian *patron* stops me downstairs, and I have to discuss with him, if nothing else, the likely increase or decline in the dollar's value. By the stairs, the *patron*'s younger brother, who is dying of boredom, stops me, and even if I am strong, it takes at least five minutes to turn down his request to play only two games of chess. Let's say it's nine in the evening. In slippers and swimming trunks (the heat is getting unbearable) I am finally sitting on my part meant for sitting. Of course, there's a knock. Of course, it is the half-lunatic German baron, von Roncador Rengersdorf, Edler von Nonnenfels, who, unfortunately, lives across the hall in room number 28. I cannot be too cruel to him; because of him I have earned some money with commissions (for example, I got him a ticket for a naked ball and I charged him 150 francs more). I can only hustle him out in ten minutes. He is as boring, well situated, and stupid as my English friend, Phillips, is (may God

keep him in England). All right. Roncador is out. Ten minutes later there's another knock. It is either Dora from no. 29, Vilma from no. 26, or Gina from no. 44. Dora is a German girl, the other two are Hungarians from Pöstyén; Vilma is the photographer who did my portrait in Berlin. Unfortunately, I could not prevent them from moving into my hotel. Fortunately, since Dora and Vilma make love to each other and, frankly, Gina's charms don't exactly excite me, I have been able to keep a several-kilometer distance from this harem despite my closeness to it. It is, however, a good excuse for me to listen to all their laments in the name of comradeship. At eleven I have to run downstairs, because Madame Marianne is waiting for me. If I can't spend the whole evening with her, I can give her at least half an hour, which will turn into two and a half, and it does not make much difference that I spend two pleasant hours in the Petit Napolitain café, which is still French, not Americanized yet, and has a family atmosphere, and where one evening — the irony of fate — Mihály Károlyi was playing chess[105] with an Armenian medical student at one table,[106] while next to him the cousin of Queen Zita,[107] a Bourbon-Parma princess who plays chess here at night, was playing with the youngest of her chauffeur sons (all three of her sons are chauffeurs). It's only natural that at two o'clock in the morning, heading home alone past the terraces of the cafés, I run into Medina, whom, let's say, I haven't seen for a week, or Tihanyi, with whom I must spend a short half hour — sometimes we don't see each other for days or even weeks, as I hardly ever frequent the cafés of Montparnasse these days. My life has changed a lot in this respect.

Let me be novelistic, as I live so much in a novel that it's impossible for me to see through all the developments. Tomorrow morning — I should have done it four days ago — I'll have to leave my visiting card with all the families I shall be with in Brittany, as it looks like I will spend August in Loctudy, and although there are numerous obstacles, I am accepting the invitation. I have just selected the names from my notebook: the comtesse de

Carfort, the vicomtesse de Somyèvre, the comtesse Bourgault de Coudray, etc. Under the address of the comtesse de K. I find, much to my surprise, the handwriting of Marianne: "Pour le 14 juillet triomphe!"[108] God knows when she wrote it there—what does it mean, though? She will give a *goûter* on the fourteenth of July to present the portrait I drew of her. Countess K. will also be there. What does that woman want from me? And what does Marianne want from me by way of her?

Countess K. was born a Romanian princess; she is twenty-six years old and her French husband died a year and a half ago. I've written about my invitation from Henri de Rothschild to the château de la Muette. Marianne, before leaving for Brittany for a few days, made it my duty to go there without fail; later she would tell me why. So I went. But there was a comic prologue to this visit. The previous day I had washed my deerskin gloves, and at the advice of one of the maids I laid an electric light on the bed and put the gloves on it to dry. When I returned home two hours later, my room was full of smoke and soot. Not only did the gloves burn up, but so did the bedcover, the blanket, the two bedsheets, and the mattress all the way down to the middle. The three maids were darning at my place till three in the morning and I continued patching the bedsheets and the blankets till five in the afternoon. The bedsheets were changed yesterday; they have not noticed anything yet.

So at five in the afternoon, all decked out and in new gloves, I got on the metro and got off at the station closest to the château de la Muette, to which I was taken by a taxi. It's only natural that there were beautiful women and beautiful clothes. I met Countess K. for the second time. As she is mourning, she didn't dance, but we talked for half an hour. After Madame Marianne returned from Brittany, I gave her an account of the Rothschild afternoon and she said, then everything is fine, but I should know that the countess is "in love" with me. Since then the three of us have had lunch together five or six times. Countess K. is a classic, cold beauty: a mystery

so far. Madame Marianne said that this woman would be my most useful helper. "Not only do I allow you to court her, but I command you to do so. You have to mingle in her circles, I'm no longer young enough for this, I'll remain the 'foundation.'" I don't know whether the countess really loves me or just pretends to. She said she would come to Loctudy when I was there.

Marianne's affection disarms me and it hurts when I happen to be strict and unjust with her. However, sometimes I think I will go mad. I have only one life and I can't divide it six ways. How am I supposed to "mingle" in society when I should be spending this time earning a living? That's why I told her explicitly that if she does not excuse me from the parties and the dinners that last till midnight, then my traveling to Brittany is out of the question.

My cousin Kornél dropped by amid the never-ending line of Paris visitors just as I was becoming desperate over all the things I miss for lack of time. He rightfully demanded that I spend two days with him. Therefore for two days and two nights, from dawn to midnight, I strolled around with him until I collapsed. Of course he didn't like anything I showed him. To him, everything is more beautiful and better at home. What does a man like this travel for?

Loctudy, 27 August 1926

You must be waiting impatiently for my letters from the Breton coast. It was a hard decision to come here and it was even more difficult to leave Paris. Perhaps I would still be in Paris if I had not received 700 francs from four sources on the last day. I wanted to arrive in Loctudy with a decent wardrobe, and to leave everything behind in my hotel in such a way that I wouldn't have to waste a lot of time finding a new room, moving, and settling down upon my return. There was a big rush, but I managed to arrange everything in the best way.

I was surprised and hurt that you found my relationship with Marianne "disturbingly abnormal." You have never known me to be selfish to the point of being with a woman for months without a true attachment to her. What the nature of this attachment is, I don't know and I cannot define. One doesn't know what a person has meant to one until one has lost that person. I evidently love this woman despite the great age difference; conceit and vanity play some role, as does, perhaps, even my ungrateful passion for exploring life in all its nooks and crannies. I may even propose, as a thesis, that every young man of my age who takes life very hard (despite appearances that may be deceptive) can be satisfied only by the love of a woman. There are too few good friends and too few honest feelings for you to push aside an outstanding being, who throws herself at your feet and offers everything as a pledge of her love, only because people take offense at anything unusual out of jealousy, viciousness, or silliness, or, as in the present case, they see something abnormal in what's normal, in the name of God knows what model and morality.

I left Paris at seven in the morning on the fifteenth (two weeks ago Saturday) with the two Siamese cats in tow. Little Jacquo, bronzed by the sun and sea water, was waiting for me at the station in Quimper (nearly the westernmost corner of Brittany). It was eleven at night when we arrived in Loctudy. The roads were covered by a strange fog two feet thick, the car lights fell on Bretons dancing in clogs and folk costumes. The strong smell of the sea, the trees, whose branches start from the bottom, and the lighthouses blinking from four or five directions at night: these were the first impressions. A huge dinner was waiting for me, made mostly of local specialties and a giant, freshly caught lobster.

I have been here for over two weeks and it would be difficult to write about everything. The beauty of the ocean is inexhaustible. The sun, the atmosphere, the high and low tides, and the play of the moon provide a continually changing decor. There's never a repetition. I feel as if I have been on board a ship for three weeks and were on my way to Java and Borneo. A few days are not enough to get to know the ocean. I experienced the big ebb and flow at full moon. At that time the sea comes right to our house and later withdraws 4 to 500 yards. Then one can walk with dry feet on the seabed and wander on the granite rocks covered by exuberant seaweeds in a thousand varieties. All varieties of big crabs and sea spiders under the caves of the rocks, and starfish, different mollusks, and plantlike animals, hermit crabs in snail shells, and the small cuttlefish that squirt dark liquid in desperate effort. I stroll on the seabed for hours with a net in my hand.

I could write a lot of funny things about the people and their customs, and I will do so if I have time. Nevertheless I have to emphasize that my interest in these people is, I could say, almost a *scientific* one. French society is a bygone world, which, like a plucked flower, continues to live in the vase with its customs, tastes, and lifestyle, perhaps unique in the world today.

There was a party at Coadigou Castle, where I was invited as well. At

the castle they are preparing for a wedding. Elisabeth, Jacqueline's cousin, will be married to the son of Lucien Simon, a well-known painter and professor at the Beaux-Arts. Marianne invited Lucien Simon in Paris mainly to show him my drawings and the portrait I had made of her. I was a bit wary of academic eyes, though when I considered enrolling at the Beaux-Arts, I was thinking of him as a teacher. I was very surprised that Lucien Simon was delighted with my work and he flattered me by comparing my drawings to those of Michelangelo. Elisabeth is a beautiful and charming girl and her fiancé is very nice. Yvonne, Marianne's other daughter, and her husband, Baron André H., who is a lieutenant in the garrison in Coblenz, were also present at the party.

I feel fabulous. I've gained weight. I exercise daily on the sandy beach for half an hour, swim for half an hour, then I rub myself down, and, after taking a shower, I have a good breakfast with milk and butter. In Paris my "secretary," Alfred Perlès, a boy from Vienna, handles my correspondence and my article business with the German papers. I had intended to return to Paris in the middle of September. Elisabeth's huge wedding, however, is scheduled for the seventeenth and I was asked to stay. I probably will, too. After that I would like to look around Brittany. I'm mainly interested in the prehistoric menhirs and dolmens and the wonderful Romanesque churches and Calvary crosses.

Paris, 8 October 1926

I have been waiting for the promised photographs of the fairy-tale wedding
party at Coadigou Castle. The pictures would have made it easier for me
to report on the weeks I spent in Loctudy and the people there. They are
late. Now that I've witnessed the lives of the aristocratic families of Brit-
tany, I can comprehend what a risk Marianne took by inviting me in spite
of the expected gossip and intrigues (which my "likable" personality could
overcome only in part), and how much she put herself on the line for me.
My suspicions were well founded when I hesitated to accept the invita-
tion to Brittany, considering the probable inconvenience I would cause the
family (as for me, I had nothing to lose). Marianne reassured me by asking
whether I knew her as someone who could not bear the consequences of a
decision. She introduced me to a lot of people. One of the families invited
me for dinner in Audierne.[109] We were to have spent the night in their home
and then they were to drive me to the famous "Pointe du Raz" the following
day. Because of the intrigues, however, the invitation was withdrawn over
the telephone with some lame excuse. Still, many other people received me
very cordially, such as Elisabeth's father, who soon made friends with me,
as did his wife, to the extent allowed by her rigid character, which exhausts
itself in formalities. The young couple, Elisabeth and Paul, went to Biarritz
by car for their honeymoon. They became good chums of mine. Elisabeth is
a very relaxed and genuine person. Countess K. also attended the wedding.
This cold beauty is all falseness and insincerity, and I remained as reserved
with her as possible. Geo de Villermarqué—his full name is Geo Hersart
de la Villemarqué de Cornouaille—the last descendant of the reigning

families of Brittany, displayed a great liking for me and saw in me the foreign journalist to whom he felt obliged to show all the beauties of his homeland. He took me on two day-trips by car.

I can write about the D.-B. family only with the greatest delight. I had a truly marvelous time in the company of Marianne and Jacqueline. Yvonne — Marianne's other daughter — is blessed with an abundance of charm and refinement, which she reveals both in the way she dresses (organizing the irresistible charm of her femininity) and in the childlike simplicity and sincerity of her manners. Her husband, André, is the most amicable Frenchman I've ever met. There is no artificiality in him, and therefore one never has the feeling (as one does with most French people) that even in the greatest intimacy there remains a wall that is impossible to penetrate.

Unfortunately, despite the overwhelming success of the Loctudy vacation, I had as little opportunity to paint as I did to write for the newspapers. Back in Paris, I made drawings of the participants in the international film conference for the *Film Courier* in Berlin. I recovered my good old room at the hotel, which I have furnished so that I can now use it as a studio. I also had my big old basket, containing all my painting materials, brought over from my previous hotel. I have to admit that my situation is a bit embarrassing as, in spite of being a painter, I do everything but paint. Nevertheless, I have no reason to regret the long and involuntary pause.

Paris, 5 February 1927

Good news would fly to you if I did not always have to fear censure. I know how doubtful is the joy of tidings when the news itself is not joyful. It is unwise of me to break the silence. Now I will stay in Paris for good, whatever the circumstances, and why should I provide you with weapons against this firm resolve of mine? I can see that Paris is further from Brassó than I thought and also that there are many things organically connected with my ⸗ life that you will never understand.

I earned a total of approximately 2,700 francs in December. Sinn, whose best articles I ghostwrite, thus enhancing his reputation as a journalist, always interferes with my life in Paris in a decisive way, either as a savior or as a wicked demon. Now that he's become the Paris representative of the Rhenish German newspaper concern, the richest German newspaper company, he wants interviews and articles from me, offering fees so high I could hardly believe them. He paid five hundred francs for a Caillaux interview! [110] Three hundred for a five-minute conversation with Monzie, 200 for Rakowski, [111] and 200 for Tristan Bernard. [112] Encouraged by all this success, I charged 2,000 francs for the visit to Nikolai Nikolaevich, which Sinn ordered from me for the Christmas issue of his papers. He offered 600 immediately and 600 for my drawings of the castle directly from the *Verlag*. The drawings were not published. So the second 600 francs were reduced to 200, but I still received 800 francs for a single article! The possibility then arose of Sinn's *Verlag* hiring me with a monthly pay of 1,500 or 2,000 francs starting the first of January. I don't know whether I make this happen, but it seems that whenever I begin to stand firmly on my feet, chance sends an avalanche down on me. Sinn had taken ill in Düsseldorf and could not do

anything to further my cause. His wife received me in despair: her husband's condition had worsened; he had blood poisoning. He had left no money for me. The articles had stayed here, too. His wife and I were trembling with fear that Sinn might die, and with him my hopes. Oh, those trips to the Trocadéro! (Sinn lives in that neighborhood.) How much joy and how much disappointment I have experienced in this place! Thankfully, Sinn is feeling better. He's returned, although he is still sick. He hasn't brought my salaried job with him. I'm seeing him the day after tomorrow. I might still have the chance to come by some money . . .

Sunday evening. In the midst of my troubles, everything has been topsy-turvy for two weeks. However hard I try to direct my thoughts elsewhere and to brace myself with cold showers of masculinity, there is no way I can get this beautiful creature out of my head. Her big black eyes, her snub Parisian nose, continue to smile at me from the Butte-Chaumont, in her moleskin coat and the pretty beige dress whose simplicity and elegance are her essence. I'm ashamed to confess: I am in love. I have been experiencing all the excitement of this foolish passion for two weeks now. A fortnight ago, despite all my doubts, she showed up, a little blushing, but with the self-confidence of a modern girl who is able and willing to make her own choices. I met her entirely by accident, and Madeleine promised to come to my place instead of taking her Sunday morning stroll in the Bois, so I could draw her portrait. And, indeed, she came . . . She was supposed to return last Sunday. The week crept by. It dragged so much that I wrote a foolish letter asking to see her again sooner. The response to my letter arrived on Saturday. Saying only that she had been unable to reply earlier and that she couldn't come on Sunday, but that I shouldn't doubt her sincerity. Another week to endure. And the added uncertainty of whether or not she would come on Sunday. By Friday I was such a fool and so restless that I went to the Butte-Chaumont and found number 13, rue du Rhin. I know very little about

Madeleine: her father is of American origin, her mother is French. Number 13 is a fine-looking building with an ornate entrance; the inhabitants are obviously wealthy. I kept watch in front of the gate for an hour, hoping to see the lovely creature. Anxious that my first letter may have ended up in her parent's hands, I wanted to ask the concierge to hand another letter to Madeleine. Suddenly I caught sight of a familiar silhouette through the fog and the drizzling rain. Too late. She'd already walked through the gate. I went after her. The concierge handed her the evening mail and she climbed the stairs. I called her name. She turned around. "For God's sake, what are you doing here? What if they see us?" I handed her the letter across ten steps and over the the railing. I asked her, "Are you coming on Sunday?" "I will certainly come, you can count on me." Now it is one o'clock and Madeleine hasn't come . . . Did I mess everything up with my stupid haste and my visit? I write all this in shame. Wasn't it I who offered the same advice to Tihanyi a few days ago, in a similar situation, and shouldn't I now apply it to my own case? "Your letter reached me at such a critical moment," wrote Tihanyi, "and it convinces me so strongly of your friendship for me that I would deem it ungrateful not to acknowledge it in writing. Anyway, if your letter had reached me an hour earlier, I would have been much stronger during one of my most critical hours. This is why I came here, I admit that now. I couldn't have anticipated a better ending, only a nicer one. But it doesn't matter anymore. Don't worry about my tranquillity, I'll never be calm as long as I am really alive. I hate this, but of course this is a different kind of restlessness: a stimulating one, that gives life to me and my work. It's to be feared that I'm lost, although I don't want to believe it. You'll get a clear picture of this matter at home. Tita is a strange woman. She possesses great spiritual strength and subtlety, which deserve respect, but she's a woman — not a logical mind. I'm entirely logical in love, but I can see this in my deeds only when it is too late — as it is now. This offers me some

tranquillity. I only wish this feeling of calm didn't dry up my brain." Tihanyi has been in love with this girl for six months and he traveled to Nice to clear up the situation. "You could not possibly believe Tita's gentleness," Lajos wrote in his first letter from Nice. "I could see by the second day that I hadn't come in vain. I'm a lot more attracted to her now, and she deserves all my trust. I don't know how this Spanish girl acquired this incomparable refinement, I've never seen a woman with such self-control and such an ability to deal with other people. (Do not assume that this is simply a bias resulting from my love.) Tita is sad. God only knows what troubles her. They are very well-off and live in a very nice flat. I'm a guest every night simply because I want to be with her . . . I'm really so well, as if God had taken me a little into His good graces. I'm not even trying to be any luckier in love: the friendship of a pure, good woman is so far assured." By the time my letter arrived in Nice, what I had foreseen had taken place: "My first letter was overflowing with happiness," Tihanyi wrote. "It would be both nicer and more pleasurable if you believed I still felt this way. However I'm pursued by misfortune on this otherwise beautiful trip. Tita and I sit in silence for hours. She hasn't wanted to talk to anyone. But she's the only person from whom I can expect a sensible word and some guidance. And relish for life. I'm fine but as you can see I am suffering, willy-nilly. Perhaps one day you'll know the true story of this six-month affair of mine, which, despite all its hopelessness, gave me a relish for life and much joy that may make up for all the pain. There's no space to write about this now. It is sad, though, that I am prevented from speaking."

I am attempting to apply all the wisdom of my letter to Tihanyi to my own case, but in vain. Passion does not want analysis but gratification. In vain am I proclaiming that man carries his love in his own rib cage, himself creating women, with all their faults and whims, and that he can expect nothing in return but what he himself has given. I'm saying it in vain. I keep repeating it in vain. Nothing can extinguish my burning restlessness at this

time. Madeleine did not come. Despite her promise. Where did I make the mistake? Tomorrow and surely for the entire week I'll be awaiting her letter of explanation. I confess in shame that nothing is more important to me right now.

<p style="text-align:center">*</p>

It makes me happy that I could share with you (being indiscreet and asking for discretion) something of Tihanyi, who has become such an intrinsic part of my life. I can't describe our relationship any better than in a few lines I wrote to him once—two years ago if my memory serves me correctly—after we had had an awful row. After angry letters in which I scorned Tihanyi instead of my own poverty and he scorned me instead of his deafness, he concluded his final letter as follows: "I never change in my love for you—and I'm not about to now!" And I: "You are my life's strongest pillar of support and even if you were not beside me, I could never imagine you being far away. Our relationship was built on a strong foundation, which time cannot erode. I cannot picture a situation in which my feelings for you and your cause will change. I have never betrayed you or your cause, as you are the first to realize. Both in Berlin and here, I followed you around with a rake and tried to smooth the paths you'd torn up with your pickax, because one needs everybody, and those who are no longer friends are enemies. I'm happy to have been able to say all that was necessary. I wish you understood!" The present situation differs from the one two years ago only in that Tihanyi can now make himself understood in French quite well and no longer needs an interpreter, like at first. And there's always someone who is more than willing to help him. My role as an *interprète* is restricted to the most confidential of conversations. You will have read about his successes. Although the Hungarian press did exaggerate considerably (since in reality Tihanyi is not so well-known in Paris yet), he is definitely one of the greatest painters of our age, along with Rousseau and Picasso, and as a person he is unequalled by either. This is, by the way, not the first time I've expressed this opinion on

paper, although I'm not expressing it with anymore conviction than I did when I first realized the worth of his cause and attached myself to him. What made me happier than his success in the press was the more telling success of Tihanyi's having sold one of his pictures to an American for $650 (to be paid in installments over four months), and that now he can work with greater peace of mind, as he has to use all the money he receives from home just to pay the rent on his atelier (700 francs).

<center>*</center>

I assume that you don't disapprove of my friendship with Mme D.-B. as much as you did even in your latest letters. Anyway, I am the type of man who sets his own rules. It is entirely without relevance to me whether or not, since the time of Adam and Eve, a twenty-eight-year-old man has ever loved a woman who is almost fifty. But allow me to edify you with a few examples. Liszt was twenty-seven years old when he fell in love with the fifty-three-year-old Bettina von Arnim. And what about Balzac and Goethe and Ady! I am not saying that every youth of twenty-seven feels the kind of desire that can cause the spiritual resources of a fifty-year-old woman to burst into a twilight bloom. However, such a desire is not unnatural. It shows a richness of character, which, besides all its other love objects, seeks and finds satisfaction in the soul of a mature woman. "I have your best interests at heart, I love you," wrote Bettina von Arnim to Liszt, twenty-six years her junior. "Time has watered me with its fertile rain. The hidden seeds of the most powerful will are sprouting and shooting within me. Be pleased!" And Liszt loved Bettina more than the captivatingly beautiful Charlotte de Hagen and the other young Charlottes who were madly in love with him. You don't know enough about my relationship with Madame Marianne not to misinterpret it. She loves in me only what I could become (but am not yet), and is jealous only of that which is harmful to me. But believe me, I quoted the illustrious examples only for the sake of

understanding. The life that manifests itself in us is unique, so unprecedented that it bears no comparison.

Tihanyi and I spent Christmas Eve in the Medinas' family circle. On New Year's Eve we were at Mme Marianne's in the company of little Jacqueline, the lovely Elisabeth, and her husband, Paul. They're very likable creatures. They've invited me several times. But I can give very little of my time to my acquaintances. I've entirely renounced visiting salons. I have accepted only a few *dîner* invitations, from Count Bourgault du Coudray and Count Chapdelain. But the ice is broken and if I wanted it a society career would be wide open to me . . .

I saw all my acquaintances from Brittany again; they were crowded in a room at Mme D.-B.'s concert last night. When the Kreutzer sonata was being played, Heinrich Neugeboren from Brassó turned the pages. We are on friendly terms; he's staying at my hotel, too. I introduced him to Marianne as a composer, although their notions of music are poles apart. Neugeboren is a talented composer, although he's extremely stiff, roundabout, and unsociable. He considers Marianne a very original pianist, especially in her performances of Beethoven's sonatas. Beethoven is his idol. Jacqueline has grown up be a beautiful girl. Our relationship is a playful one, as if she were my younger sister. She views me as her "milk brother." I've never considered marrying her. But the possibility has been raised on a few occasions, sometimes jokingly, sometimes seriously.

Paris, 26 February 1927

The superb bacon, cottage cheese, quince jelly, and halvah have arrived, pristine and still bearing fresh Brassó pollen.

The day before yesterday, I sold a picture for 1,000 francs to an art collector friend of Mme D.-B.'s (it was a picture of the small Teleki castle in Hídvég). This served as financial encouragement for me to return to painting. I'm hunting for an atelier at the moment, I'd like to find one in Montparnasse if possible. Mme D.-B. has offered me furniture of hers that is presently stored in a warehouse—beautiful armchairs and antique wardrobes. However, I don't want an expensive atelier.

Paris, 26 March 1927

Let me first tell you of the K.'s visit. Once more, my playing guide was met with ingratitude. Even though I spared neither time nor energy trying to ensure that their stay was as pleasant as possible, I feel I haven't been able to give them a good time and haven't been able to prevent them from being disappointed and leaving with bad feelings. But I am accustomed to this failure with visitors to Paris. A dozen extra mishaps also contributed. The Eiffel Tower received us with a shower; the Cluny museum, with its gates closed (due to renovation work); the Luxembourg Gardens, with a biting wind and an inhuman, flowerless dreariness. Her ladyship's primary desire, to see Josephine Baker, could not be fulfilled either, since the opening night of the new revue at the Folies-Bergère had been postponed. I wanted to take them to an elegant party on Sunday evening and obtained tickets to do so. But her ladyship lost the key to the two suitcases containing their dinner jacket and evening dress. (The husband's reproaches, the wife's sobs, and a vehement squabble followed, which my presence could do nothing to assuage.) Of course, we had to get a locksmith to open the suitcases. To look for and to find a locksmith in Paris on a *Sunday night!* Goodness gracious, I had to endure this drudgery, too!

In May I will be in a new atelier on the rue Servandoni. It's being wallpapered at the moment and shelves are being built into the walls. I indicated the balcony of the atelier to K. from the place Saint-Supplice.[113]

Mme D.-B. and Jacqueline are settling into their new apartment. We are often together. They invited me to Loctudy again for the summer, from August 15 to the end of September. I accepted the invitation in principle. I might be able to paint there in the summer. I was pleased by a remark Tihanyi made to Bölöni: "Halász has come to his senses, he has become a painter again."

Paris, 12 April 1927

My dearest ones, you really made a wise decision regarding the date of your visit to Paris. May is the most beautiful month here, and, of course, you aren't disturbing me!

My atelier is nice but small. I'm just about to move. I'm likely to move on the twenty-second as not everything is ready at the moment. I regret leaving the comfort of the hotel behind, but on the other hand I am taking enormous pleasure in the new atelier, its brightness and cleanliness; the balcony is six meters long and two meters wide: it will be perfect both in the winter and in the summer. The rue Servandoni is completely Italian, not only in name but also in its shape.[114] It is a narrow, quiet street with high walls. Few cars ever stray there; neither does the sunshine, though. Nevertheless, my atelier catches the sun from midday to sunset. I'm enjoying the proximity of the Luxembourg Gardens already, it's entirely green and bursting with flowers. I cross the garden every day on the way from Montparnasse. You will have a good time in Paris. Mme D.-B. and Jacqueline are looking forward to seeing you again.

Loctudy, 10 September 1927

I'm still writing from Brittany. This summer has, indeed, been washed out.
But we still have had a few bright days. Anyway, the "awful" days are the
most beautiful here and the storms are enchanting. One can do anything
in Loctudy but work. No sooner do I sit down to produce something than
a car comes chugging by and I am taken somewhere. I even participated in a
three-day cruise on a fifty-ton yacht. It was fabulous! Beautifully furnished
cabins; every last nook and cranny is cleverly utilized. The kitchen and the
dining room are on the upper deck. There are eight beds, hot and cold wa-
ter; the *Oasis*'s crew consists of a steersman, a cook, and two sailors. Our
ship's host was a factory owner from Nantes, an ex-airforce officer. He and
his wife are both nice, pleasant people. I might stop by in Nantes on the
way home since they have invited me to do so. They must have considerable
wealth to afford such luxury. Marianne, Jacqueline, Yvonne, her husband,
André, and I were the guests. We were lucky to have excellent weather. We
had great meals and drinks—even I concocted an onion omelette in the
yacht's kitchen. I had such a great time that I wasn't even seasick, although
the waves were high. One night we anchored in the phosphorescent sea off
the Glénan Islands.[115] There are a lot of sea crabs and spiders here. This is
where the famous Prunier restaurant of Paris has its "containers" carved
into the granite, full of sea crabs. I would have liked to have stayed longer on
board the *Oasis,* and I lingered in a pleasant daze for a long time after the
cruise. I'm going to stay here for another week; Elisabeth and Paul Simon's
daughter 's christening will take place on Tuesday—I was at their wedding
on the same day last year.

Paris, 6 November 1927

My life is relatively peaceful. The apartment has worked out. I was afraid of the cold, but the stove provides so much heat that I am constantly having to turn it off. I've completely renounced going to the cafés in Montparnasse. Sometimes I go seven or eight days without seeing Tihanyi. I don't see Mme D.-B. too often, either. I'm occasionally in the company of her daughter, Yvonne, and Yvonne's husband, André.

Paris, 28 February 1929

If I abandoned my Christmas trip, I had an imperative inner reason to do so. To leave Paris, now that the fruits of my four-year labor here have ripened, and to return home empty-handed would have been a crime, and after the first joy of our reunion would have broken my heart. Now I not only have hopes but positive results to tell you about, and I don't have only *prospects* of earning well, I *am* earning well. I am a regular contributor to the *Kölnische* and the *Münchner Illustrierte* and on friendly terms with the editors of both. I made 1,800 francs with two articles last month and more than 2,000 francs for two articles and two photographs this month. With my experience, my sources of photos and connections, compiling an article is child's play, and the opportunities for publication are almost limitless . . . So if I don't stop now I can easily make about 5 to 6 thousand francs a month. Of course, the money I've earned so far already had a place to go—I immediately had to invest part of it in the "business." As soon as my financial position is strong enough, I will buy a good portrait camera so I can take my own photographs and become independent not only of the photographer but of Paris as well.

What shall I write about myself? Where shall I begin? I gave up the apartment on the rue Servandoni in time, thank God; I spent the summer in Loctudy and, upon my return, I stayed in the atelier on the rue Campagne-Première for two months (until the D.-B. family came back). Now I've succeeded Tihanyi in the hotel on the rue de la Glacière. I have a very good room here (400 francs) and I don't expect to change my address anytime soon.

Tihanyi is in New York. (Have you received the farewell photo taken

at the Gare Saint-Lazare? Bölöni in a fur coat; Steinsberg, the engineer from Vienna; Müller, the Swiss art collector; and his wife; and the wife of Kertész, the photographer, are also in it.)[116] He had a lot of trouble upon his arrival: they detained him for two days because of his deafness and asked for 500 dollars as a guarantee. Then for three weeks he had problems with his pictures. Now he's fine, though, under the financial protection of a few rich families he knows, and he may well become successful.

Paris, 4 December 1929

I'm so overloaded with urgent requests for articles that I barely have time to catch my breath. I'm not writing this as a complaint but merely as an excuse. If you have my success at heart—and I know and feel that you do—you must be happy that my affairs have taken a turn for the better, and you have to make, after so many others, this minor sacrifice of patience. After a year-long effort, plenty of disappointment, and some difficulties that were almost insurmountable—I would have needed 15 or 20 thousand francs to get this business off the ground and to keep it going as it is now—I managed to canvass the entire German illustrated press, and even the French, as you will have gathered from my photographs published in the latest issue of *Illustration,* which is devoted to Clémenceau. I'll explain the mystifying and incomprehensible mechanisms of this profession next time. But I can tell you now, based solely on the facts and without any exaggerated optimism, that Brassaï articles are much sought after in Germany these days, and even my remuneration has been raised. The *Münchener* pays 200 marks for a page, the *Frankfurter,* 175, and twice that for a double page. The *Frankfurter (Das Illustrierte Blatt)* has bought two of my articles ("Verschwundener Sport" and "Exotische Fotokünstler"), and I'm delivering "The Priest of the Girls"—I'm working on it now—by Christmas. What I sold to the *Münchner* is a photo report from the war of 1870 (for 400 marks) and "Weekend on the Trees." The Essen *Wochenschau* has two of my articles ("Das Deutsche Paris" and "Polling the Animals"). I made five drawings to accompany the latter, which are actually the first drawings of mine to appear in an illustrated magazine, as Dugó is not me but the painter András Szenes. My Berlin "secretary" (Ilse Steinhoff, a wonderful, lovely girl, who has already

sold several articles of mine and takes the necessary steps when something —
mainly money, of course — gets stuck somewhere) has two of my articles:
"Paris Dog Cemetery" (with drawings) and "How Sardines Lose Their
Heads" (also illustrated with photographs and drawings). I have also sold
the articles "Dancers from Java" and "Coiffure at a Crossroads" for the *Köl-
nische Zeitung* supplement entitled "Mode und Kultur." The *Hamburger
Illustrierte* has bought "Sonntagsfotografen" with photographs and my
drawings. Right this minute I have to deliver "The Priest of the Girls" to
Frankfurt and the same article in French to *Vu,* the second biggest Paris
magazine after *Illustration. Vu* also bought "Dog Cemetery" in my own
French version (my first article in French!). Before Christmas I have to
write "The Modernized Church" for the *Berliner Illustrierte* (they placed
the first order!). I'm preparing this article — like several others — with the
photographer Kertész, who also took our picture on the terrace of the hotel
on rue Servandoni. I urgently have to deliver two articles to the *Kölnische
Illustrierte* as well: "Back to the Tent" and "Visiting the Father of Cinema
(Lumière)."

You can see from this short list — which is incomplete — that business is
going well. The amount due (counting only the fees for articles that have
already been bought) comes to 16,000 francs, not an insignificant sum.
However, you can also get an idea of the difficulty involved in financing
these articles, since 150 to 200 francs were invested in each, and they are
paid for only upon publication, which may take several months. Thankfully,
I now have so many articles due to be published, and I'm in contact with so
many papers, that I can avoid the unexpected, which could easily mean —
and unfortunately often does — that of three articles not one gets published
within a two-month period. I have a considerable collection now, full of the
most interesting documents, like the picture of Clémenceau on horseback
that was published in *Illustration.* I want to buy a typewriter to replace the

one I'm renting. Then I'll have to buy a Leica camera, which costs approximately 2,500 francs. Only when I have all this can I free myself of Paris and travel wherever I want, including home of course, without endangering my livelihood. The most important thing is that I'm well connected now. Paris was an unavoidable necessity in order to achieve this, but only this. Subjects worth reporting on can be found elsewhere and if one has the necessary equipment they can easily be captured. So the hour of redemption is near, even if it is not quite here yet. Again I cannot come home for Christmas — for the fifth or sixth time? I'm asking for your patience once more. I know how much you both love me and miss me. Let's not speak of what it means to me to be separated from my parents, my home, my siblings and relatives, the taste of my favorite dishes and Mom's caressing love, how much all this hurts and how much your reproaches sting me when I feel I'm innocent in these matters. I want to dwell on this all the less since I believe and fervently wish that the moment will soon come when we can talk about all this in person.

Look, I've written more than I was going to after all, and I promise I'll write with further details again soon. Please don't leave me without news in the meantime. I need it more here. And please don't grieve, if at all possible!

Paris, 11 March 1930

Dearest Mom!

Look, I haven't forgotten about your name day after all, and aside from my best wishes and my kisses, I am sending you my promise to give you news more often and in a more detailed way from now on.[117] As I wrote and as I'd expected, the New Year started really well, and I earned close to 5,000 francs in January. It is true, February brought only two thousand, but I have great hopes of being compensated now, in March. I really needed the Christmas present because barely 1,200 francs arrived in December; thanks and gratitude for your help.

I've mainly been producing articles with drawings lately, and my beauty queen caricature was a roaring success in Germany (the text, unfortunately, arrived in Frankfurt too late). I was pleased when a Dutch paper, *Het Leven*, from Amsterdam, contacted me (they had my address sent over from Cologne). They asked for the beauty caricature and "The Priest of the Girls" for publication and they would like to have everything I do for Germany. The Madrid *Estampa* has also asked for material; they bought two articles. The beauty caricature, which I threw onto the train, was unfortunately lost, but it will definitely be published in a Rio de Janeiro newspaper (*A Noite*). Its Paris editor sent it in. The Dutch and Brazilian papers offer huge financial rewards as well. I had one of my articles published in the Vienna *Bühne* as well; you may even have seen it. They wanted more material, although they can't afford to pay a lot, so I can't send anything.

I'm still living at Tihanyi's hotel and not, as you mistakenly thought, in

his former atelier. The latter costs 1,100 francs per month and I couldn't afford to pay that much for accommodations: my room, as I wrote, is 400 francs per month. Tihanyi is still trying to make some money in New York; he has had several exhibitions, although his success has been more moral than financial. I think he'll come back in June.

Jacqueline got married; her wedding took place in January. Of course I attended the splendid occasion. Her husband is presently in the military; after his tour of duty he'll serve as a colonial officer. As soon as he's taken his exam, they'll go to Indochina. By the way, I rarely see the family nowadays (once a month). I came by a camera. I've been taking photographs for the past few weeks, and the results, as you can see from the pictures enclosed, are encouraging. I wrote an article to accompany the photos of boats taken in the Luxembourg Gardens entitled "Naval Disarmament." I managed to sell it, so I will soon be able to consider buying a more serious camera.

Paris, 24 January 1931

I received a note from my Berlin publisher — Mauritius Verlag — to the ef-
fect that they won't send my check until February 10. Here I am now with
all the trouble of the rent, the installments for the typewriter, and the bills
of exchange I signed for the camera. The German crisis came just as I was
starting to earn a decent wage, and the 3 or 4 thousand francs a month looked
guaranteed. Newspapers tightened their budgets and started reducing their
fees and their use of freelance reporters. This is what pushed me to sign a
contract with Mauritius Verlag and ensure that my articles are published
through them. I get a guaranteed advance of 200 marks each month, for the
period of six months for the time being. The publishing house takes 35 per-
cent of my fees — only for those articles, of course, that I cannot place
directly.

I'm glad to have mastered the art of photography and to have amassed
the necessary equipment. It took a considerable amount of time and energy,
but I will slowly reap the rewards. I haven't given any of my photographs to
the periodicals yet. The *UHU-Magazine* published my article "Die ersten
Momentaufnahmen die die Welt sah" [118] in its September issue. A consider-
able number of my drawings have come out, too, for example, in the *Chicago
Tribune,* a copy of which I am enclosing.

Mme D.-B. is on a tour around the world. I believe she's in China at
the moment. She's going to Tahiti from there, across the Pacific islands and
the Pacific Ocean. She's to be back in a year. Jacqueline is in Syria with her
husband. She's had a baby boy, who is healthy. Her husband, however, lin-
gered between life and death with appendicitis for two weeks. Tihanyi is
facing serious hardship. It's no longer possible to sell any pictures. He's not

getting any assistance from home either because the Balaton café is doing badly.[119] I don't know what's going to become of him. There are fewer foreigners in Paris as well. Sári Z. has left for home. She was dreaming of a great career and expected me to play the fairy-tale prince. I introduced her to my painter friend, Vince Korda, who has more time for Don Juan-like services. He receives a nice allowance from his director brother, Sándor [Alexander] Korda. I have installed a laboratory in another room at the Hotel Glacière, and I'm going to get an enlarger soon.

Paris, 27 July 1931

Even I have been affected by the German crisis. I should no longer rely on
Germany. Luckily, I am prepared for this possibility. I will endeavor to en-
sure that I earn my money here in France and I conclude from the results
that this will work. I've completed several portraits, which I've sold for
100 francs here, 150 or even 300 francs there. I've also sold a few photos to
French magazines. I took a photograph of Oskar Kokoschka, the greatest
German painter alive, who lives in Paris. In him I have found a very good
friend. He sings my praises to everybody and sends "customers."

Loctudy, 18 September 1931

I managed to escape from Paris only with great difficulty, and ten days later than I had thought. I had a number of interesting and advantageous jobs in sight, but I really thought I could use two-weeks' rest and that I would make back on the swings what I had lost on the roundabouts. By the way, I have a reliable secretary trainee — I left him with plenty of tasks to be completed during my absence. My work has become easier since your departure, partly because I now have the essential equipment and partly because I am becoming more widely known. Tériade, the art critic for *L'Intransigeant,* is going to discuss my photographs in a long, detailed article. He encouraged me to organize an exhibition as soon as possible, and he will offer his support. I'm planning to do so in either October or November, and I hope I'll be able to win over one of the larger galleries without incurring too much expense. I will probably rent an atelier upon my return to Paris, or at least a laboratory, which would make my work both easier and faster. I can see that there is as much work as I could possibly want. Antoine, the king of hairdressers, was delighted with my photographs and paid 600 francs for photos that he was really entitled to for free. He has already brought me a client, the daughter of the car-factory owner Voisin. The photos are beautiful and they might get me new clients from these circles.

It rained for three months, but now the weather has changed and I got a nice tan in the few days I've spent here. However, it is uncertain how long this good weather will last. The sea is cold, but I still bathe every day. I also think that I've gained some weight. There's a lovely girl here, Jeanine, who is also a guest, and with whom I often go rowing; yesterday, we went to a nearby island by fishing boat. I'm going to return to Paris with her in a

week's time. Her father is the director of Gaumont Film, she's going to introduce me to him when we get back. About my financial matters: July and August turned out well, I received a 1,000-franc advance from the *Paris-Soir*, and I'm due to get the same amount upon my return. They were satisfied with the illustration for the novel, although I had to do the entire thing in one day. I'm going to do the next illustration, too. Mauritius is one month in arrears in its payments to me, I'm expecting the August check to arrive here. I'd be extremely grateful if you could send me 200 francs for security — not more by any stretch of the imagination — in a check to me here in Loctudy so that I can cash it at a local bank. I'd like to do one or two articles on my way back and if the Mauritius money does not arrive I will lack sufficient funds. I think I'll stay here until the twenty-fifth. I'll write more next time.

Paris, 5 November 1931

This is not the long letter yet, but it's a letter all the same and it contains some good news. The best French art publishing house has decided to pub- ⸜ lish my collection of photographs taken of Paris by night. I'm going to discuss the terms and conditions with them tomorrow and may well receive an advance if we come to a mutually agreeable arrangement. Having returned from Brittany (I'll come back to this topic later), I immediately compiled my collection (about a hundred photos mounted on fine paper) because I thought it was time for me to display my work to potential publishers. First I went to see Lucien Vogel, the editor of *Vu*.[120] He was delighted, sat down immediately, and wrote a letter to Peignot, the editor of *Arts et Métiers Graphiques*, who received me at his home that very night. He asked me how come he hadn't heard of me yet. I answered that I hadn't wanted to show my work to anyone until I felt it was worthy of being shown. (The self-deprecatory stratagem worked perfectly, as you shall see from the results, since I managed to ensure both a higher fee and higher esteem.) He asked me to give him three photos, which he'd place in the next issue of *Arts et Métiers Graphiques*. (This is the most beautiful and expensive periodical in France.) I then showed him twenty from my *Paris Nocturnes* series, proposing that he publish them in a collection entitled *Paris de nuit*. He liked the idea. He said that had there not been a crisis, he would have immediately accepted the book for publication; things being what they were, however, he asked that I give him some time to consider the matter and requested that I not show my work to any other publishers in the meantime. I replied that I'd be very pleased if he published the book, on account of both the publicity

and the quality of presentation, but asked him not to delay too long in making his decision since it was in my interest to have the collection in print as soon as possible. He said that two weeks would be sufficient for him that I should call him around November 5. Meanwhile I took another twenty photos under and above bridges, in the Tuileries and on rainy streets at night (these are among the most beautiful pieces of my collection) to impress Peignot further, should he still be hesitant. I called him the day before yesterday and he gave me an appointment for yesterday at noon. He received me by saying that he had already written a letter to me and that he had decided to publish the book. The only question remaining is the matter of payment. The price of the book will be one hundred francs, a few exclusive copies will cost 500 and 1,000 francs, and the first edition will have a print run of five thousand copies. Therefore, he will earn one hundred thousand francs even if the book is not a success! I am convinced that it will sell, though. I'm going to ask for 12.5 percent of the first edition and 6 thousand in advance, or 12 thousand should he not pay me royalties. He may want to bargain although I don't believe he will. This is a colossal achievement for me; I've managed, with my first book, to grab the best publishing house, and, if Peignot's predictions are fulfilled, the book itself will be a great success in terms of both the photographs and the presentation. This book will be the first in a series and will be followed by several other publications for which I'm also likely to receive a commission. (We've discussed two further books so far: Paris markets and Paris streets.)

I've been working extremely hard during the past few weeks: I had to dispatch articles to an English-American agency, five for England and sixty for America (that is, more than two hundred photographs). An article ("Antoine the Hairdresser") was already published in the October 3 issue of the periodical *Sphere* (London's counterpart to Paris's *Illustration*). Today I just sold six photographs to a fine-arts periodical in Buenos Aires called *Sur*

and was consequently introduced to the circle of American millionaires financing it. Grasset, the largest book publisher in Paris, bought four copies of Ribemont-Dessaignes's portrait; now it can be seen in the shop windows of Gallimard and other leading bookshops, accompanying the writer's latest novel. Grasset also commissioned me to take portraits of the writers Morand, Mauriac, and Maurois; he requires twenty-five or thirty of each for the advertising campaigns of their new novels. Tériade proposed that I should start taking photos of the great French painters in their workshops (Picasso, Derain, Matisse, Braque, etc.) and then compile a nice book.

P.S. Tihanyi, as you will have read, was attacked and quite seriously injured on his way home one night. He's now recovered and the stitches have been removed from the wounds he sustained to his head.

Paris, 4 December 1931

Once more, I'm thanking you for your nice letter in a hurry, between taking pictures and developing them. It seems that I did not overstate the extent of my success; on the contrary, it will be greater than I thought. Paul Morand, the famous writer, is going to write a foreword for the book, which will be very nicely presented. Interest in the book is evident; a German publisher has already bought the rights to publish it in Germany. The twelve thousand francs is a nice sum, it has to be said (in France no one has ever earned a similar figure for a photo collection before), although I could have earned more with royalties, or even with a flat fee if I had asked for fifteen thousand. But my guiding principle was to satisfy the publisher as well, in order to encourage him to collaborate with me in the future. The work is tiresome as I have to run all around town, roam in familiar and unfamiliar neighborhoods; nevertheless, I do this gladly as I want the book to be really good and all the photos sensational. This is the only way to achieve the success I expect. Half the book has already been assembled (I've just brought the new material, made since our contract, to Peignot, who was very happy and said he'd be pleased if the rest were of the same quality). I'm enclosing an issue of *Illustration* and an article from *Nouvelles Littéraires* concerning the published material in *Arts et Métiers Graphiques*. Similar sample photographs from *Paris Nocturne* will come out in *Illustration*, on the same fine paper, when the book is released, and there are negotiations about simultaneously exhibiting the Nocturne series in Paris and New York in February. The first exhibition, which features six of my photographs, will open in a gallery in ten days (as I might have told you before). My unbiased opinion is that my material is the best and that reviews will deal with my work in great detail.

Paris, 28 March 1932

The bad weather brought me back to Paris, so you may well receive my letter at the same time as my postcard. As I wrote earlier, the book of photos has only now been completed, at Easter instead of New Year's. The two months turned into four, and even now I'm not completely as free as I want to oversee the plating process personally. The delay may seem a bit strange since I reported ages ago that the book was done except for a few photos. Yet the explanation is simple: the more pictures I took, the more adept I became at the technique of night photography (and I can claim to have made history in this field) — and I realized that I could do this and that better and, what is more, that I could do subjects we hadn't even thought of before. I could almost say that as the material grew — and I now have enough material for four or five beautiful books of night pictures — the number of chosen pictures decreased. It sometimes took me several nights to pick out the photos most representative of the rotary press, the naked baker, the couple of lovers, the cats in love, the policemen on bicycles, the backstage world of the Folies-Bergère, the Tabarin, the brothels, the boulevard, the Concorde, prostitutes, phantoms of the night, etc. etc . . .

My publisher, the editor Jean Bernier, and Paul Morand completely agree with me that what we would lose in time (and this was my loss only) we would make up for in the beauty and unity of the book. One could object that I pushed myself too hard and as a result lost what would have been my profits from the 12,000 francs, as the work took four months and I had to hire an assistant. Yet my guiding principle was that if the publisher made great sacrifices for the book (he had invested nearly one hundred thousand francs!), then I, too, was obliged to make every effort, since what I lost on

the swings I would make up on the roundabouts. These "roundabouts," aside from the expected success, refer to the several hundred photographs that I can sell immediately after the publication of the book, and from which I can make as many as ten interesting magazine articles.

Right now, as I mentioned before, I am negotiating with another publisher (Éditions Albert Lévy) that would like to publish a book of 240 photographs featuring four cities in Provence. I asked for 20,000 francs although I'd do it for 15,000. I hope he makes up his mind soon. Then I can spend a few months in the south, which would be the best compensation for all my night work.

Paris, 1 April 1932

The decisive discussion (though not the last one) on *Paris Nocturne* took place today; the final content of the book was decided upon. I was pleased and relieved to realize the fruits of four months of hard labor and even happier to find that the only problem is in determining which of all the beautiful pictures to sacrifice, since only 64 can be in the book. This was my noble revenge upon my publisher for his single indiscretion. Otherwise he has always been most loyal to me, paying before the deadline and several times inviting me for dinner. (In fact, I had dinner with him again tonight.) That indiscretion did cause me some embarrassment on one occasion. About six weeks ago, I learned that behind my back Peignot had asked several other well-known photographers to shoot night pictures. The results were meager, as I later saw from the material, and my colleagues were in a less-desirable position than I because they had to work for nothing while I was getting paid. Still, I had to take energetic measures, and I told Peignot that while I was in no position to prevent him from commissioning others, I had to insist, in accordance with our contract, that only my pictures be included in the book, except for the Opera ball, for which he had been unable to secure an authorization for me. Thus I nipped the maneuver in the bud, which was entirely to my advantage as, after seeing the others' material, Peignot was forced to admit that in me he had found the only suitable person. My noble revenge, then, consists in his dilemma of which photos to dethrone. With great difficulty he has pared down the material to eighty pictures, and twenty more have to be eliminated. Another obstacle that had stood in the way of the book's early publication has been successfully removed: it occurred to my publisher that with all the delays the book would

be published in late May or early June—that is, in spring, yet there was not a single spring or summer picture. We have solved this problem by leaving two blank spaces for two pictures of a spring night, to be taken in about ten days to two weeks (there are buds on the trees already). Thus I am confident that the book will be out in June at the latest, which would be important from the point of view of success—otherwise it would be better to delay it until October. The advertising campaign, as I wrote earlier, will be lavish, with about 150 of my night pictures on exhibit in Paris and New York at the same time. Currently we have a photo exhibit at the Julien Lévy gallery in New York, from March 15 to April 15; I am represented by six pictures.

Paris, 12 August 1932

In my last postcard, I dropped only a hint that I might switch over to film-making. Now this is a done deal. First, Jean Tedesco, director of the Vieux-Colombier, offered me a camera to experiment with as I wish, and then Alexander Korda invited me to assist him at the shooting of his next film (to begin on September 1).[121] I am to take pictures of the cast and selected scenes and to learn the job of a cameraman because he would like to hire me as one. I hesitated for three weeks whether or not to accept this lucrative proposition — he offered 1,000 francs a week to start with — for

1. I wanted to leave Paris for a vacation of two or three weeks;

2. my book is coming out in the beginning of October, and my exhibition, sponsored by de Monzie, the minister of education, is opening then, too, and it is in my interest to exploit what I anticipate to be a great success;

3. in accordance with my second contract, already signed, I have until the end of November to make the photos, for which I am getting 2,000 francs a month, with the first installment received on July 20.

In the end, I couldn't resist Korda's friendly and loyal offer, which takes the final shape of 1,200 francs a week for the first three weeks, 1,500 for each of the next three weeks, and 2,500 if I agree to do the next film as well. I can have an assistant and a laboratory technician, and I will have free time to look after my personal business. They will buy all the equipment I need and, of course, cover all my expenses. If my passport were valid — I found it, it had slipped to the back of the drawer — I would have left for London today to shoot the film being made there. Korda promised to arrange for my passport so he can take me to London. The significance of the offer can be seen, on the one hand, from the extremely large number of applicants (willing to

work unpaid—such is the enticement of working for the movies) and, on the other hand, from the fact that the Korda group, which possesses enormous capital and is backed by a group of English financiers, is recruiting the best of the French film industry. Currently they are negotiating with René Clair, the foremost French director. I am now in a position where others come to me for recommendations, while I myself am recommended by my work. As I can see from the correspondence of my publisher (Arts et Métiers Graphiques) with foreign publishers (in Berlin, London, and New York), my book is going to be a world success. It is estimated that ten thousand copies will be sold in Germany alone, to which have to be added ten thousand in France and seven thousand in England and America, for a total print run of more than twenty-five thousand for the first edition. My maiden interview, conducted by an American journalist named Miss Watterson, came out a few days ago; her interview about me and my work appeared in several American newspapers. I was taken aback when she asked for a picture of me, since I don't have one, at least not one that is suitable. If you received the periodicals I sent, you can see the way in which my photographs are presented. Unfortunately I was only able to send you copies of the French papers; I have but a single copy (if any) of the foreign ones, and I need these for my collection. My third book, of which I have written to you, will contain nothing but small photo stories, humorous and tragic, such as "Un homme meurt dans la rue." [122] I have eight or ten such stories already.

I'm still writing from the rue de la Glacière, but I won't be here much longer. I will probably rent a large atelier with a comfortable laboratory. I will be able to afford it. In addition to the 5,000 francs due from the Korda group and the 2,000 due on September 5 (an installment for my second book), I am expecting 200 marks from Germany, 700 francs from Holland, 3,000 francs from the Julien Lévy Gallery in America, which is organizing my New York exhibition at the end of October, and 3,000 francs from Paris-Magazine.

It would be a crime to leave Paris at this point, when success presents itself in such a tangible form and compensates me for the laborious struggles of those long years. I have a feeling that all the pending and embarrassing affairs will be easily resolved as soon as the question of money is no longer a hindrance and my success becomes more permanent and widely recognized. As far as the near future is concerned: I am busy now and will be particularly so after September 1, so a trip to Brassó or Pest is out of the question. That's all for today in this suffocating, sweltering heat, which has lasted for the past few days.

Paris, 31 August 1932

Just a quick note until I can write a longer letter from Fontainebleau, where I'm going for a five-day vacation. The shooting of the first film (*Coup de vent*), with Adolf Menjou, starts on September 12 and will last for six to eight weeks. So a trip home is out of the question both in October and in November. I have to stay here, moreover, because of the publication and exhibition of *Paris de nuit.* It would be a great deal wiser for you to come to Paris in either October or December. The only difficulty is that I am so busy. I'm in the studio by eight in the morning. This means that I have to get up at six and I'm not home until seven or eight in the evening, utterly exhausted. Still, the few hours that we could spend together every day would be better than nothing, so I suggest that you take off. I earned 4,000 francs in July, nearly 5,500 in August, and my September income will be over 10,000. So I won't have any financial problems and you can witness my success in October.

Barbizon, 3 September 1932

I've managed to get away from Paris. I spent two days in Fontainebleau and moved on to Barbizon yesterday. I could set aside only six days for the vacation, so it wasn't worth traveling any farther. The Fontainebleau woods are beautiful and the pension — in the middle of the woods — is pleasant. I can really rest up here, too bad I can't stay longer. After the exertions of the past few months I could have used at least two weeks' rest. Maybe I can make up for it in the winter. Unfortunately, when I return to Paris more work than ever before will be waiting for me. The first Korda film will begin shooting on September 12, as I wrote you earlier, and I have to obtain all the necessary technical equipment by then. At the same time I should be printing the pictures for my New York exhibition.[123] Julien Lévy, the owner of the gallery, is right in pressing me. This exhibition is very important for me and I will get up to 3,000 francs for the photos. I should also show some new material to the publisher of my second book — the second 2,000 francs are due on September 5 — but I have hardly been able to achieve anything. How can I complete this book before the end of November if I'm totally absorbed by filmmaking? The fate of the two books and the New York exhibition mean more to me than the Korda film. Their offer came at the worst possible moment, so to speak, and I hesitated whether or not to accept it. But Sándor Korda was so insistent that I finally agreed. Should I be sorry I did? I can now match the great salary I'm getting from them with other and more interesting work. As for the films they have programmed, they do not conform to my concept of a good film in any way. According to my original plans, I was going to switch over to film only at a later stage, if at all, and then autonomously, with my own equipment. But now the die is cast.

Regarding your visit: come in October. I'm sure you'll enjoy witnessing the success of my book and my exhibition. You may have seen the article and photograph that appeared in the August 21 issue of the *Prager Presse:* "Der grosse Photoreporter von Paris: Ein Besuch im Atetlier Brassaï."[124] This is the tribute that Miss Watterson wrote for several American newspapers. Well, there will be more of these stories soon: a whole legion of French journalists have asked for interviews in connection with the book.

Paris, 18 September 1932

I spent a couple of extremely beautiful days in Barbizon. An American painter friend of mine, Karl Holty, picked me up and brought me back in his car. I looked at a lot of ateliers, but not one was satisfactory. Monsieur Robbe, the *patron,* and his daughter, Gilberte, are doing their utmost to make me stay in the hotel longer. I temporarily solved the problem by renting a second room (across from the first) that I intend to use as a laboratory.

Sándor Korda is a very nice man. He has wholeheartedly taken me into his good graces and often invites me to lunch. In general, I'm held in great esteem by the company, and my judgment is respected. My idea and photograph were accepted as the trademark for the company: upon the mast of a sailboat a flag inscribed with the word *Production* flutters in the wind followed by five smaller flags bearing the letters K-O-R-D-A, which flutter together for a while as the boat's siren wails. (They gave me 1,000 francs for this.) In response to Dad's question: the Korda company is the French branch of the English company for which Lajos Biró works.[125] They work in Paris and London simultaneously; unfortunately, they are too rich to produce good films rather than merely entertaining ones. Good films cannot be made until the big companies and big stars collapse and are forced to move out of the studios into the streets.

The publication date of my book has been delayed once more because of my publisher's vacation and unfinished negotiations with the foreign publishers. This time it is scheduled for the end of October, although the book is finished and printing can start as soon as the print run has been settled. This is no longer of great significance to me. I should focus my attention on the second book and see that it is better than the first.

Unfortunately, things are going badly for Tihanyi, as they are for other renowned painters. (Even big-time art dealers are going bankrupt one after another.) He lives for the most part on the support offered by the Korda company. Once in a while someone buys a picture from him. Mme D.-B. is in Brittany. Jacqueline, whose young husband died in Syria, is going to get married again soon. The famous general Pechkov, Gorky's son, is going to marry her. My friend Medina got married to a Hungarian violinist named Rózsi Réti and they had a baby girl. I haven't seen the photographer Kertész for several months. He divorced his first wife and now lives in seclusion with his new wife.

Parisian Angel, 1931 (© Gilberte Brassaï)

Graffiti, 1933 (© Gilberte Brassaï)

Brassaï photographing for the film *La dame de chez Maxim's* directed by
Alexander Korda, 1932 (© Gilberte Brassaï)

Group of friends, after the exhibition of "The Ten," Chez Leleu, rue Royale, Paris, 1934. Back row: third from left, André Kertesz; holding bird, Christian Bérard (called Bébé); unknown woman; Lajos Tihanyi; Elisabeth Kertesz; Émile Savitry. Middle row, far right, the photographer Ylla. Front row, second from right, Maurice Tabard. (© Gilberte Brassaï)

Mihály Károlyi, former president of Hungary, in exile, Paris, 1930s
(© Gilberte Brassaï)

Oskar Kokoschka in his atelier, avenue de Reille, Paris, 1931–32
(© Gilberte Brassaï)

Hans Reichel in his room at the Hôtel des Terrasses, Paris, ca. 1931 (© Gilberte Brassaï)

Composer Edgard Varèse, Paris, 1931 (© Gilberte Brassaï)

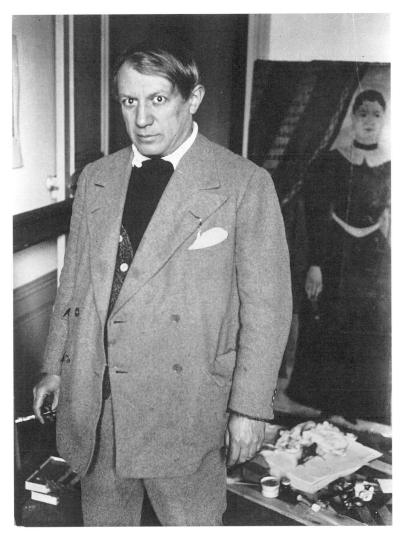

Brassaï's first portrait of Picasso, rue La Boétie, Paris, 1933 (© Gilberte Brassaï)

León-Paul Fargue, Paris, 1933 (© Gilberte Brassaï)

House of Illusion, rue Grégoire-de-Tours, Paris, ca. 1932 (© Gilberte Brassaï)

Girl on the rue Quincampoix, Paris, ca. 1933 (© Gilberte Brassaï)

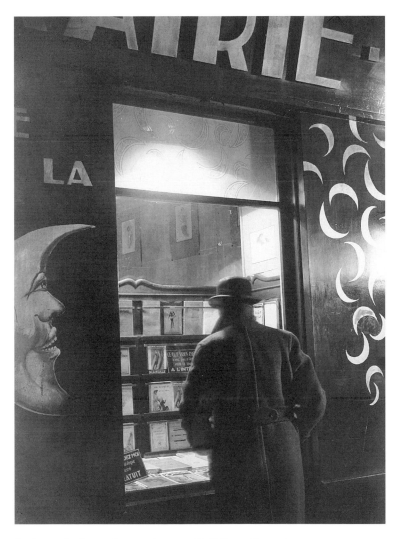

Bookstore "La Lune," Paris, early 1930s (© Gilberte Brassaï)

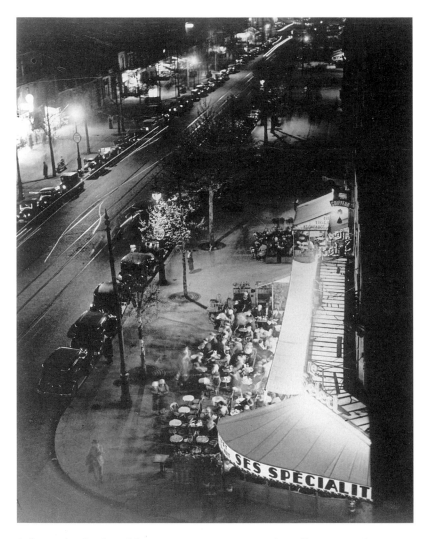

Café Le Select, boulevard du Montparnasse, Paris, 1932 (© Gilberte Brassaï)

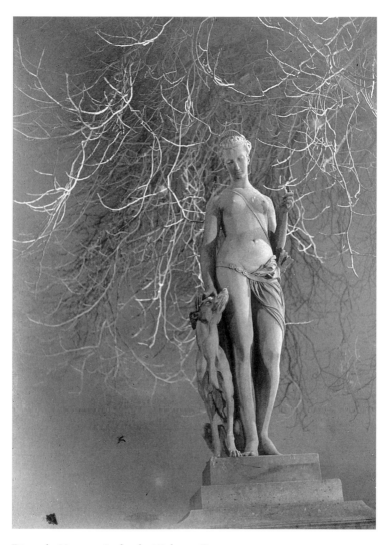

Diana the Huntress, Jardin des Tuileries, Paris, 1931–32
(© Gilberte Brassaï)

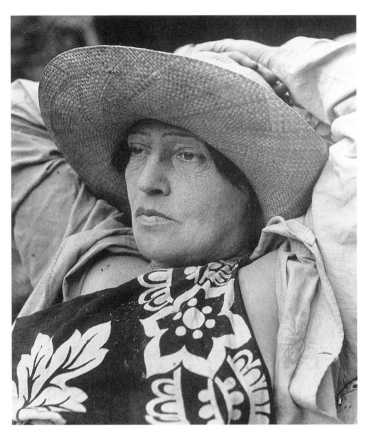

Madame Marianne D.-B., 1932 (© Gilberte Brassaï)

In the Louvre, Paris, 1934 (© Gilberte Brassaï)

Soiree on the Île Saint-Louis. Misia Sert, Antonio Canovas del Castillo, Helena Rubinstein, Gabrielle "Coco" Chanel, and Serge Lifar at Helena Rubenstein's apartment, 1938 (© Gilberte Brassaï; print courtesy Museum of Fine Arts, Houston)

The Negro, Les Halles, Paris, ca. 1935 (© Gilberte Brassaï)

Notre-Dame, Paris, ca. 1944 (© Gilberte Brassaï)

Paris, 29 September 1932

Shooting for the Korda film has been delayed.[126] I was supposed to start work only now, on September 26, but I cancelled at the last minute, giving up three weeks' salary. I have many interesting commissions, along with the pictures for my second book, that I can now do in the three weeks gained.

Paris, 9 November 1932

I have been working in the studio since last Friday. The first two days were horrendous. It reminded me of my time in the military, what with getting up at seven o'clock and assembly at half past eight. (I have to travel through most of Paris, from the rue de la Glacière to the rue Francoeur and along the northern side of Montmartre, so I usually take a taxi.) First they shot a short film, which had to be finished within three days. So we worked until ten every night. That is, from half past eight in the morning until ten in the evening, with a lunch break of one hour. However, I was not finished at ten. I was left with the trouble of developing. I was completely fagged out after two days, although I adjusted to this regime by the third day — we even worked on Sunday! — and now I'm determined to go through with *Dame de chez Maxim's* as well, until the middle of December. The machine that I had Korda purchase is beautiful — it cost eleven thousand francs — and it is a lot of fun to work with. As far as lighting and the motion picture camera are concerned, I have learned a great deal and I'll be a trained cameraman in six weeks. Actually, I have very little work to do. The film photos are taken by another photographer. I need to capture only what appeals to me, as if I were making a camera report about the film. Developing and printing are not my task anymore either. Now I see that only the first few days were difficult, when everything was still new.

I'm enclosing the Sunday issue of *L'Intransigeant* with an entire page of pictures announcing the release of my book. Maurice Raynal, an art critic and close friend of Picasso, and another art critic named Tériade, who are in charge of the art section of *L'Intransigeant*, invited me to write an article

about photography. I have done so. The article will come out next Sunday. My contract with Korda takes effect on Friday with a salary of 1,200 francs per week. I hope that the film will be finished by mid-December. Then I will either interrupt the contract for a few weeks or be released for a week or two while preparations for the new film are under way.

Paris, 10 November 1932

Tonight (Thursday) is practically my first night off. Tomorrow is the anniversary of the cease-fire and even the Korda group was forced to take a break. For the first time in a week I can have a good night's sleep — it may be my last chance for we're going to work every Sunday in this frantic operation until the film is finished.

My work so far has been very successful. I have been relieved of the burden of taking publicity and technical photos as well as those taken of the sets after each scene. They might even publish a collection of my pictures as part of the film's advertising campaign. It is an amusing piece, with costumes from the 1900s and beautiful English and French stars. I'm also learning English since there's an English version. As each scene is rehearsed and shot five times, this is a veritable Berlitz school. I can immediately test my knowledge with the English actors and especially with the actresses. In a few days I learned the technique of directing and all the functions of the cameraman so well that if I had to step in as a cameraman I believe I could stand the test. By the way, I'm constantly next to Sándor Korda, who often asks me for ideas about shooting. I've chosen Maurice Raynal's son, Raymond Raynal, to be my assistant.

Paris, 4 December 1932

This is the first Sunday in four weeks that we're not working in the studio. And not because we couldn't take it any longer, either. Rather, the equipment had to be serviced. Nobody knows yet how long it will take to shoot this film. There are rumors about January 10, although it may well be longer because of the outside shots. We're also going to the beach for a few days, perhaps to Nice. In any case, I'm going to remain with the company until the completion of *Dame*. After mid-December we'll get to the easier part of the job, with breaks of two or three days, though I will continue to get my salary of 1,200 francs a week, which will increase to 1,500 francs starting next week. However, after *Dame* I shall definitely quit since the completion of my second book of photos is more important to me. Physically, I can't stand this studio life much longer. It is like being aboard a submarine, the difference being that it is hotter in the studio and the air is stuffier. One cannot think clearly after a twelve-hour submersion. As for the financial aspect, I'm losing as much as I'm gaining, if not more. I've neglected all my newspapers and agencies for lack of time, though I now have contacts in Belgium, Holland, London, and New York. Don't worry about a thing! My book, *Paris de nuit*, came out two days ago, with great success. I'm bound to get plenty of new offers. I've just been in the city. The major bookstores have filled entire windows with displays of the book. There are phenomenal crowds everywhere. Many people have bought it. A lot of bookstores sold all their copies the very first day. I'm going to send a copy home tomorrow. Unfortunately, the front cover has been slightly

marred by the red letters, although after the first thousand copies these were replaced with letters printed in white and silver; these look better.

I reserved the same room for Mom and Dad as last year, and I reserved one for Bandi, too, so we will occupy (almost) the entire floor.

Nice, 16 May 1933

I'm just warming to the notion of being on vacation; I'm bathing and sun-bathing every day. I'll go to Marseille on Thursday, spend the night there, and will be in Paris Friday night. The exotic garden of Monaco is not the one we saw on the side of the Prince's rock, but the one opposite, on the side of Condamine, overlooking Monte Carlo. I'm sorry we missed it. It is a wonderful garden! I had never dreamed of such a variety of cacti. One needs permission to take photographs there, and I will get it tomorrow. So I might be able to offer some interesting material for the third issue of *Minotaure*. The first issue, with my Picasso photos, is probably out already, since the newspapers are heralding it as a major artistic event. Today I bathed and had lunch with the dancer whom I had told of my stay here. It turns out that not only did she stay at our hotel for a few months last year, but in the very same room I am in now. I visited Matisse but unfortunately found only his wife at home. He left for Tahiti on May 4. So I'll have the perfect op-portunity to come down here again, maybe in August, after completing the *Book of Love*. I'm hard pressed for time and want to take the last photos upon my return. I'm enclosing an issue of the *Éclaireur du soir*, in which I came across a quote from Dad's Heine article, and two postcards of the ex-otic garden in Monaco. The periodical *Voilà* has started a *Paris de nuit* se-ries with photos that were not used in the book.

Paris, 7 December 1933

If I'm not mistaken, I left you saying that I was planning to stop in Marseille for a day ... I ended up staying in Juan-les-Pins because of an American girl and returned to Paris directly. For the most part I've been working for *Minotaure* and on the material for *Paris intime* — that will probably be the title of the book. There are a few pictures still missing but it is nearing completion and will be published in March. I would like Pierre Mac Orlan to write the accompanying text. I have the feeling that it will be at least as good as *Paris de nuit*. Possibly even better. The double issue 3–4 of *Minotaure* will come out within a few days, approximately 180 pages long. It will contain many photos by me — among other things, sixteen pages of the workshops of the best French sculptors: Aristide Maillol, Brancusi, Lipschitz, Henri Laurens, and so on. I myself wrote an article about the drawings on public walls (graffiti), of which I've taken many pictures. Its title: "From Cave Walls to Factory Walls." Unfortunately, I was involved in an embarrassing affair at *Minotaure* at the last moment. One night I took photos of the blond girlfriend of the publisher, Albert Skira, and sold one of the pictures to *Paris Magazine.* This in itself was not a problem since I had been authorized to do so. But the photo appeared in the December 1 issue as an illustration for an article called "Love in the Taxi." Scandal: crying girl, protesting, outraged parents. Skira pulled it from the paper, despite the fact that everything had already been typeset and paged. It would have been the first time my name would have appeared next to the names of André Derain, André Breton, etc. Although Skira admitted I was innocent and assured me of his friendship, he claimed that his hands were tied: he had to give the girl's parents and acquaintances the impression that he had broken

off relations with me. This happened yesterday. I immediately sent him a *pneumatique* expressing my regret about what had happened, but I said that if he removed my article from the paper, I would end my association with *Minotaure* and withdraw all the pictures I had intended for the periodical. Tériade called me this morning. The affair has been settled, he said. My article will be published. This whole business aggravated me because I also had to take a firm stand with *Paris Magazine,* my main source of income. Yet I know that in both cases it is they who will give in because they cannot do without me.

There are several more book projects in the works, but neither the album of nudes nor the collection of cacti has yet been contracted. Financially I'm in the same position as I was when you were here: I earn enough, but spend more. Conditions are not deteriorating, although the invasion of German emigrants, and the fact that photographers and photo agencies are so well organized, so impertinent, and so unambitious, have an effect upon everyone.

I was glad to receive news of Kánka's wedding. I would like to send him a telegram if you will give me the address in Kolozsvár with the date of the ceremony.

Paris, 2 October 1935

In Paris once more after Brussels, Antwerp, and Bruges. Actually, I was dispatched to Brussels on a photo assignment. Pleasant, but a very beautiful city. But as long as I was in Belgium, I wanted to get to know Antwerp, the great Belgian port city, and Bruges, whose beauty captivated me for an entire week. And now I am back, once again up to my ears in the Parisian rush. Under much better circumstances, I must say. I no longer have to dash down four flights of stairs twenty times a day to answer the telephone; it rings right here on my desk. The only noise is the twittering of the birds since my rooms look out onto the garden of the Observatoire. The laboratory is comfortable (I sacrificed the kitchen for this purpose), the bathroom is spacious with hot and cold running water, and, in regard to the furnishings, I'd rather send some pictures later.

It is of course difficult to give an account of everything after such a long silence. My financial condition has improved since January, my name has become frighteningly well known, and the camp of followers has increased. An important and secure source of supplementary income, for the past ten months, has been a barbers' journal, every issue of which is filled with my photos at a rate of 3,000 to 3,500 francs a month. They were also the ones who sent me to Brussels, in the same way they packed me off to Marseille a month ago. I extended the latter trip by two weeks, spending a few days in Toulon and a week in a vineyard outside Toulon owned by the parents of my colleague Savitry (a very congenial French boy whom I hired a few months ago as my assistant).

Paris, 17 October 1935

I'm extremely busy with piles of orders to be filled. I've been commissioned to do all the reporting for *Votre Beauté* in addition to *Coiffure*. I shot some publicity photos for the Hutchinson rubber factory (rainy, snuffling, stormy pictures), for Mon Savon, the Tobis film association, the Oréal hair-care company, and so on and so forth. Presently, my most encouraging connection is with the American magazine *Harper's Bazaar* (the biggest American fashion magazine, the rival of *Vogue*). They would like to publish two full-page photos by me every month for three thousand francs. This deal has been delayed for a whole year, through my own fault. I took the first photo for them a few days ago: couples coming down the steps of the Opera dressed in evening attire. If my connection with *Harper's* proves fruitful I will be able to raise the rates, for it is better to earn more with fewer pictures. My second collection, *Paris intime,* has been stuck with the publisher. He paid my fee but he has insufficient funds, or so he claims, to publish the book. I have now been given carte blanche to offer the book to any other publisher. In its present form the book won't lose its relevance for many years.

And now I'm going to answer Dad's questions: my apartment costs six thousand francs a year, central heating included, but I have to pay for hot and cold water, electricity, and telephone separately, plus one hundred francs a month to the concierge for cleaning. Altogether, the apartment costs me 1,000 francs each month. I have two large rooms, 4.5 by 5 meters, both with a balcony and an excellent view from the sixth floor.

Tihanyi is doing fine, but has a hard time making ends meet and relies

mainly on the Kordas. Alexander Korda has become one of the most influential people in the film world. He is still inviting me to London; his latest offer was that I should go to Arabia with his brother Zoltán Korda (also a film director), where, in January, they'll be shooting a film about Colonel Lawrence, an English officer who led an adventurous life. Vince Korda had a baby boy. He married a nice English actress, but he is exceedingly busy since he makes the sets for most of Korda's films. Medina's wife, Rózsi Réty, is now performing in the new show at the Casino de Paris. The reason I left the hotel is that I could no longer cope with the lack of space and I was unable to receive guests. But I remained on amicable terms with the patron and his daughter, despite the fact that the hyposulfite ate entirely through the walls of one of my rooms. They occasionally come to see me and ask about Mom and Dad. Dobó tried his luck in London first but was unsuccessful. He left for America a few days ago. He has a rich uncle there who'll help him and who paid for his passage.

Paris, 5 December 1935

I would have replied to your kind letter a long time ago had I not been busier than ever this month. One photo assignment after another, almost without a break. Suddenly I was in such demand that it was as if I were the only reporter in Paris. I can't begin to list all the things I've photographed and all the commissions I've had to turn down in the past few weeks. Five series of pictures for *Votre Beauté* ("Dans les salles de culture physique"), the first of which came out in the Christmas issue; one series about Georges Carpentier and his nightclub for *Adam,* a men's fashion magazine; a series about the opera ball for *Vu* and one about the nightlife of Les Halles; a series of photos about the fashion ball for *Le Jardin des Modes* (the sister magazine of *Vogue*). If you add all the pictures for *Coiffure de Paris* the picture would still be incomplete since neither the private requests nor the material to be sent abroad nor the material for the exhibition (a major photo exhibition will open at the Louvre on December 20) are included. Besides the underworld and nightlife, I am now photographing high life (for example, an aristocratic hunt at the castle of Hénonville the day after tomorrow) with the same passion, because all walks of life interest me equally. Now that a perfect whole is slowly emerging from the pictures I develop day after day (light and shadow, front stairs and back stairs, the 500-franc banquet and the cesspit), I have to admit that I must truly be what an American writer, Henry Miller, called me: "the eye of Paris." You see, even if it took a lot of struggle, I have wrested from fate the opportunity to give my talent free reign after all, although success and popularity come at a price: a permanent address, responsibility, social status, are precisely the bugaboos I have abhorred all my life. In addition to my colleague Savitry, I've hired the

unemployed Kiss; he is the purchasing agent, photo courier, and telephone girl. Sometimes there's so much work to do that we even need a third person, and the flat that seemed so spacious a few months ago is now slowly proving to be insufficient. But now, although I occasionally yearn for my penniless freedom and friendless solitude, I cannot turn back, all the less since I think I'll soon be able to earn a lot of money and be freer than ever. Then I will get around to a visit to Romania, perhaps in connection with a book that I could write about Transylvania, indeed, all the more easily since I became acquainted with Cesianu at a party a few weeks ago. It was the evening party of the diadems at the ambassador's residence, the entire diplomatic corps was present, and as I was photographing various groups, a gentleman stood up and introduced himself: Cesianu, a member of the Romanian government. He asked me to send a few copies of the picture to the embassy, which I, of course, was happy to promise and to do, although I have yet to pay a personal visit.

Chamonix, 4 September 1936

My dearest Bandi! Let me seize this opportunity, while I am here in the mountains, to give you some news of myself. I did an assignment in Grenoble and I treated myself to a two-week vacation in the Haute-Savoie. The sun was just setting as my train pulled into the Chamonix Valley. Peaks, one higher than the next, climbing into the sky: then Mont Blanc, blanketed with snow and ice.

I came to take a rest, determined that I would take only short walks. However, the old mountaineer blood has not been completely extinguished. Everybody here walks wearing spiked boots and is equipped with pickaxes and ropes, and there are glaciers and hair-raising peaks of twelve to fourteen thousand feet towering over us. The day after my arrival I, too, had a pair of spiked boots on — they must have weighed at least six pounds — and after two hours of climbing reached one of the glaciers (glacier des Bossons). The sun is so blinding here you can't survive without dark glasses, and you need crampons attached to your boots like skis. If you should slip, it's horrible to imagine where you would fall; there are extremely deep fissures in the ice. Recently, I scaled the mer de Glace, at a height of 2,200 meters. This is the largest glacier in the region. I also traversed it, with the aid of a guide of course. Encouraged by my success, I decided to ascend Mont Blanc — 4,808 meters! Although it is tiring, it is not as difficult as other peaks. Six of us were roped together and, having successfully traversed the frozen cliffs and whirls of ice of the "glacier des Bossons" with the guidance of our leader, we reached Grand Mulet, at a height of 3,067 meters. This is where we had to stop for the night in order to ascend Mont Blanc the fol-

lowing day. I must say, I arrived at the shelter utterly exhausted. For three hours we had to cut our way with ice axes through crevasses, since there were no paths whatsoever; and the pyramids of ice often collapse with great crashing sounds. Fortunately, the sky became entirely overcast. So we had to give up our plan to scale Mont Blanc the next day.

Paris, 11 May 1937

I'm taking this opportunity to give you a sign of life. I'm well but horren-
dously busy. Business and fame are getting to be too much for me. In recent
weeks I handed in my resignation to *Coiffure de Paris* and I gave notice to
my two useless colleagues (Savitry and Kiss). I realized that I needed to
change course, that I wanted more quiet in my life. Thus I strengthened my
American and English connections, above all. I am counting on your put-
ting a visit to Paris on your agenda. Do not come in the summer, though,
but rather in September. The heat is unpleasant here, and it is likely that
the exhibition won't be completely finished by then. I am definitely counting
on your visit and will cover all the costs of your trip and your stay. Neuge-
boren can also testify to the security of my financial position. Will you
promise to come?

Salers, 23 August 1937

I hope you received my news from Vichy. I stayed there longer than I had anticipated. Not that I was particularly enticed by the spa life, similar to that in Karlsbad, but the countryside is beautiful, and since I had a car at my disposal we drove to a different area each day. Thus I had the opportunity to see a couple of glorious medieval French towns: Riom, Clermont-Ferrand, Thiers, etc. Of course I took pictures all along. Harvesting, threshing, herds. Spa life and golfing in Vichy. Through sheer luck I came across the largest French traveling circus, the Cirque Amar; sixteen elephants, eighty horses, twelve tigers, and as many polar bears. I spent a few days amid the hustle and bustle of circus life and took a whole pile of nice pictures. The sun was a faithful traveling companion during my entire journey. I traveled to Chaise-Dieu from Vichy; this is the site of one of France's most beautiful abbeys, at an altitude of 3,000 feet. From there I went on to Le Puy. Now I am in a small village between Aurillac and Mauriac, in the heart of the Cantal volcanoes, at an altitude of 3,000 feet. The beauty of Salers so enraptured me that I decided to stay here for a few days. Every house, every gate, is a work of art. The food is also first class. I'm going on to Périgueux this weekend to visit the caves of the Ice Age man in the valleys of the Dordogne. I'll probably be back in Paris on September 1.

I hope there haven't been any changes in your travel plans and that you'll be in Paris on the ninth. I'm earning a lot of money at present and 100 francs doesn't matter. Don't be overcautious with money. Have a comfortable journey. My decision to get rid of *Coiffure de Paris* (despite the monthly income of 6 or 7 thousand francs) and my two colleagues has been a total success. I gave *Coiffure de Paris* to Savitry, thereby killing two birds with

one stone. Kiss has found a job in Orléans. My income has doubled, even tripled since then. I don't keep accounts, but I easily make 15 to 20 thousand francs a month, and can once again take photos to my own satisfaction. An American periodical, the Chicago *Coronet*, has bought more than two hundred photos from me at 8 dollars each. I have to give three to my agent, though. A proper connection has at last been established with *Harper's Bazaar*. I produced four series worth 8,000 dollars. Through Radó's agency, I sell photos, mainly to advertising agencies, for 4 to 5 thousand francs a month. There are photos for which they are willing to pay up to 800 or 1,000 francs. In addition to French periodicals, there are the sales through my London, New York, and Berlin agents. The stress is proportionate, of course, and I've been feeling exhausted. From now on I'm going to tear myself away from Parisian life more frequently, for vacations of a week or two.

Paris, 1 December 1937

I've lost my best friends in the past year: Tihanyi died. Medina and his wife were deported last spring. Neugeboren has moved to Nice for good. Dobó is in New York. After five months of "married" life, I broke up with my girlfriend.

Tihanyi's illness — meningitis — his death, funeral, and estate, have created much toil and anguish for Bölöni and me. The future of his pictures and his work is our present concern. First we had to rescue them from the clutches of his landlord, to whom he owed nearly 15,000 francs in unpaid rent. And then from the hands of his younger brother — unworthy heir — whose only desire was to gamble Lajos's work away as soon as possible. We managed to save the pictures. We moved them into a new atelier we'd rented for this very purpose. We intend to organize a major exhibition this year and offer the best pictures to a few museums. This cause takes a real man and requires ten times the time that I have. Tihanyi was one of the greatest painters of this age and — curious but true — no one knows, no one is aware.

I'm working almost exclusively for English and American papers. But photography is no longer a labor of love for me and I'm going to give it up as soon as possible. I have great hopes of doing so. I make a good living and I've gotten to the point where I need not accept work that I have no motivation to do. I can do whatever gives me pleasure.

I spent a month in the Alps in August, this time in Pralognan in the Vanoise Mountains, between the valleys of the Arc and the Isère. I climbed a lot and imbibed the sight of mountain streams, cows and goats, and the fragrance of the pine forests. I endured the worrying days of September (Munich), when we were on the brink of war, with relatively steady nerves among a small camp of optimists.

Paris, 2 August 1939

I am still steadfastly hoping for a miracle, though catastrophe hangs over
our heads and we must obviously be prepared for the worst. A good oppor-
tunity to update you on my situation, while it is still possible. Success has
never been able to fool me, and I have never become a prisoner of my own
fame. I've always had to measure whatever I accomplished against what I
wanted to, and *had* to, accomplish. A couple of years ago, as I was approach-
ing forty, all my dissatisfied demons awoke at once. They swept me into a
crisis I had not faced since my Berlin years. It was obvious that, come what
may, I had to free myself from photography. I had always considered pho-
tography to be a mere springboard to my real self but, lo and behold, the
springboard would not let me go. Sometimes I was close to despair. What
was a mystery at the age of twenty and an unrealizable hope at thirty, all of
a sudden appeared as a very close, palpable, constructible reality — but at
what cost! I have been fighting valiantly for three years. I have spread my
wings! The clear view of objects has opened my eyes, and today I can see
into the heart of matters. How can I catch royal game with this dragnet that
is photography?

The ultimatum I gave myself ten years ago expires in one month and
nine days. On the ninth of September, I am to emerge from the dark tunnel
into my renewed life. That I am facing the appointed time with a peaceful
soul, in full awareness of my creative powers, and with faith in myself, is due
to the fact that I never fell into the *trap of my success as a photographer.*

In the meantime the idea, conceived in my twenty-two-year-old mind,
grew into a tree with wide-spreading branches. Such an abundant and fer-
tile tree that its weight almost crushed me. I had found a treasure but I could

not fully possess it . . . I had lived with three languages so long that I finally had perfect command of none. I had to grab the bull, the French language, by the horns. With the same commitment and persistence that allowed me to master the technique of photography, I threw myself into the French language. Descartes, Pascal, La Rochefoucauld were my masters. Now I am well armed, my ideas no longer walk around slipshod; I am sure of myself. I have been writing in French for the last three years. My idea has poured into new territories and discovered surprising connections never before suspected and seen. Everything I have done so far takes on new worth in light of what I am currently striving to accomplish. Now you know with what self-confidence I look into the future. If fate were only gracious enough . . .

If fate will be gracious enough . . . I am still writing in my room, I am still in Paris . . . I don't care about my own fate but I am full of worries about my work . . . I am trying to save my best negatives and manuscripts in three iron cassettes . . . But where will they be safe? I have volunteered to be a soldier, but being forty years old I have been rejected for the time being. Now I have asked to be admitted into the civil defense.

How are you doing at home? Kánka? Bandi? The little boy of Ilus and Kánka? Please, please write! Try to understand me! I know, I have deprived you of much happiness in your golden twilight years. Try to be strong and patient! My fate hasn't cheated me so far, I have no reason to believe that it would abandon me on the heels of its most beautiful promises. Try to rejoice wholeheartedly in the fact that I am your son!

Jurançon, 5 July 1940

I'm writing in the hope that you will receive my letter. I left Paris on the night of June 12 with a rucksack upon my back, accompanied by a couple of friends; and having crossed France, we arrived in the Pyrenees. I'm living in a small room on the hillside near Pau and spend my time drawing and sometimes working a little in the vineyard. I'm awaiting news of events and I hope to be able to return to Paris soon — I left all my work there. I hope you are all doing well. Send me your news to the address below.

Cannes, 2 September 1940

I received your letter (it had been wandering for six weeks) and I'm pleased with the good news. Does the big change that occurred recently have a direct effect on your life? I hope that you and my brothers are able to stay in Brassó. Please reassure me as soon as it is possible.

I left the Pyrenees for the Côte d'Azur a month ago. I've been living in Cannes for three weeks. Perhaps I'll be able to work again here, although the situation is rather difficult. All my belongings — photographs, negatives, and equipment — remain in Paris and foreigners are not allowed to return until further orders. You cannot even correspond with those in the occupied territory. Therefore, I am forced to wait. In the meantime, however, I am able to enjoy the sun and the sea. I'm in excellent health. I swim for an hour every day and I take long hikes with my friends. My financial circumstances, unfortunately, are not too splendid. The little money I have deposited in Paris has been frozen, and it is very difficult to receive money from America, although I'm expecting payments from more than one place. Still, I received fifty dollars back in Pau. I'm going to contact my friends (in the unoccupied parts of the country) before too long. My ex-colleague, Savitry, wrote, for example, and sent me 1,000 francs. I might have to spend the winter here. My concierge notified me in a letter six weeks ago that my apartment was unharmed. But since then?

Do not worry about me, I'm going to manage somehow. I await your letter. My address: M. Halasz, Hotel Castille, Bd. Montfleury, Cannes, Alpes-Maritimes.

Cannes, 25 October 1940

Thank you for your kind letter, which gave me great pleasure, and for your affectionate thoughts. I'm still in Cannes. I'm reasonably well off since (with a lot of difficulty) I have received money from America on as many as three occasions. Unfortunately there's nothing for me to do here, so a few days ago I decided to return to Paris. I would like to rescue my belongings at least — my life's work. This is, alas, a serious decision since I will be cut off from the rest of the world (perhaps from you, too) and I cannot know how long this will last. I'm leaving today and (barring unexpected difficulties) will be in Paris Saturday morning (October 26). I hope to find my flat in order and that I will be able to meet my friends who remained there or who have also returned. Unfortunately, I'm parting with Rado and Savitry (we spent a few days together in Cannes; they live near Toulon) as they cannot return to Paris for various reasons. I have no news at all about the Bölönis. It seems they are in the unoccupied zone. I am also leaving behind my French friends (Jacques Prévert, with whom I left Paris and spent the five months of the exodus) and many acquaintances. Harsányi, the composer, is here, too (Neugeboren stayed in Paris, I believe). I met Hertz, the surgeon from Brassó. Don't worry about me, I have some money and the news coming from Paris is not too bad. If the flat costs too much I'll leave it and move to the Hôtel des Terrasses (if Mr. Robbe is still there).

I'm going to apply for citizenship at the Hungarian embassy. I'll write more on this as soon as I can. In the meantime I'd like to ask you for a favor. Please send me two copies of my mother's birth certificate (in German), I have mine with me. It is sufficient to prove that two of one's grandparents are Aryan. Please find out how you can send it to Paris—through an ac-

quaintance in Austria, perhaps, who could forward it there. In any case, could you please send the other copy to the following address: Emile Dupont Savitry, Villa Provence, Hyères (Var). He'll send it on to me in Paris with someone.

It fills me with sadness that you face such grave decisions, thinking of starting a new life. Would you leave the city that you're bound to in a thousand ways? What will happen to my brothers? Where do they intend to go if they leave B.? Perhaps I'll return to Transylvania, too; I could earn a living from the pictures published in foreign newspapers. All this, of course, depends upon the oncoming events.

Thus I'll leave you for now (and good-bye), and kiss you with all my heart,

your

Gyulus

Andor Horváth

To paraphrase Brassaï, no sight is more inspiring than a meeting between an old artist and his youthful self. The sage remembers his youth across the distance of a half-century with both reproach and forgiveness. How instructive both these attitudes are. To be ashamed of, without condemning, the errors of one's youth after a lifetime of battles won in the name of art; to feel sympathy for that youthful self, to approve of him, but at a distance, as if he were a stranger — this is how Brassaï looks back in his preface and this is where we meet him in the letters.

Early in *Conversations avec Picasso* Brassaï recalls his first encounter with the masters of surrealism: "Eluard reminded me of Apollo: and with Breton, it was almost like seeing Jupiter himself." A satisfying encounter, no doubt. But can it equal the experience of the reader who enters the age via Brassaï's exacting lens, and entering thus, finds it to be Dionysian? Is it a surprise when the author of the letters speaks of himself as "demonic"? The letters in this volume and the notes from which *Conversations avec Picasso* would be written three decades later are identical in fact but not in tone or point of view. The Brassaï of *Conversations avec Picasso* introduces us to a society (the Parnassus of Parisian, nay, European art in the thirties) whose members, even the newcomers, are famous or imminently so. The letters, however, document life before the fame, specifically of Brassaï but generally of the artist in twentieth-century Europe — how art and artist are born. In the hallway to Parnassus doubt is as real as starvation, and the youthful, wolfish appetite longs not only for the fame to come but also for love, life, and all the magic of Paris.

This personal, "demonic" narrative transcends the conventions usually observed in family correspondence and positions Brassaï's circle of intimates

along the path of his career as if they were characters in a novel. In this "essay-novel" the protagonist is both art and the artist. Brassaï's dilemma — "to be or not to be" — is the dilemma of European art during the era. While Brassaï searches for himself, the boundaries of art and the life of the artist are in flux: must the talented make art only to see it turned into merchandise, or must they work anonymously making the art of every day on the assembly line? What was at stake was the notion of genius itself, dating back to the Renaissance. What had been lost by inflating it, by abandoning it?

Brassaï's letters are direct reports from this turbulent front. How typical is his certainty about his calling, the confidence of youth which, however brash, kindles his faith in his own talent? How much like the age, the artist flouting convention and at the same time struggling inside the unlimited freedom that ensues: what happens to the rules of creating a form, which can never be circumvented? [127] In Brassaï's first letters, and in his early work, this struggle is centered around the notion of "experience." Are we mistaken if we read his longing for experience (which only later, presumably by Tihanyi's teaching and example, became a resolve) as an attempt to escape the form-breaking excesses of the artist's inner life in favor of form? Far from denying the existence of form, this creative act aims precisely at grasping, conveying, and recording it. Gyula Illyés seems to support this assumption in his foreword to the Hungarian edition of *Conversations avec Picasso:* [128]

> The task of art, says Brassaï, is not to be real, but to express reality. Since the objects to be captured are entirely impossible to imitate, our task is solely to translate their essence and message into a common language. However, we are compelled to re-create, in some sense, precisely in order to remain faithful to the essence of that which is to be depicted, in order not to betray that essence. . . . This hot pursuit of *similarity* (whatever people may say about it nowa-

days) takes us beyond the "free" realms of imagination and invention. This is what leads the artist to ever new sources of expression. By their very existence, the sources are always exhilarating and inspiring. But how to channel them in the proper direction and on the proper path: this is the major problem. They have to be possessed, utilized and given shape and form. I couldn't put them either into shorthand or in a camera. I had to channel the flowing world between two firm riverbanks. I wanted to depict life, which flows away, in an unmovable form. Both when I was photographing and when I started writing again.[129]

There is no one moment in the letters when the young man who has taken a camera into his hands realizes that what he is producing is art, or that it might *become* art. Yet in explaining to Illyés why he took up photography at the age of thirty he says: "Because I could no longer hold the pictures in me; I had absorbed so many, mainly during my nocturnal wanderings. I had to express them in a different, and more direct, form than the one afforded by the paintbrush." This may be why Brassaï became one of the great pioneers of photography. He did not become an artist as a photographer but chose photography as an artist—an insight that can bring one closer to Brassaï's oeuvre. What can "I could no longer hold the pictures in me" mean but the fact that experience had accumulated such that it demanded a new form of artistic expression? On the other hand, doesn't it suggest that the experience was organically structured from the first and sought to manifest itself as art? I would venture that Brassaï's significance in the history of photography-as-art lies in the fact that this objective means of expression, which constrains artistic freedom, had met its match in him. After all, Brassaï arrived at the medium after working his way through his own consciousness about art to a kind of purity, yet he never forsook his

dialogue with tradition. Isn't Brassaï's greatest achievement precisely to have inaugurated the classical era of photography, that is, to have devised an idiom, a raison d'être for the new art? In an era when the fine arts justified their revolutions (in part) by an extreme subjectivism, and when, on the other hand, photography, still relatively new, had not yet overcome its inherent technical limitations to become a medium for making art, Brassaï's venture is epoch-making the way fortunate syntheses are: he imbues the pictures, recorded with an objective lens, with *his* experience such that they are not merely true to life, not even *primarily* so. Rather, they embody his values as they attain aesthetic status—they are works of art.

Experimenting with photography in the surrealist atmosphere of the thirties, Brassaï raised it to a classical status by emphasizing its ability to make forms when its sister arts were finding their old forms being destroyed. Many of his photos are related, above all, to the visions of the surrealists. Remember, for example, the photograph in *Conversations avec Picasso* of the art nouveau decoration in the Paris metro station. It looks like the figment of a surrealist artist's imagination. Although a modernist in step with his sister arts, Brassaï is also one of photography's first classicists. Like European art from the Renaissance to Postimpressionism, he remained, in principle, true to life.[130] Conversely, however, there is Brassaï's "magic naturalism," which makes his work seem like a kind of manifesto for the arts of his time. After Brassaï had presumably tried a dozen different ways of using a camera (portraits, photojournalistic assignments, art reproduction, "composition," etc.) he hit his stride by capturing Paris at night. Which is not to diminish his other achievements—the portraits, for example, that commemorate nearly half a century of French culture, or the art reproductions, to which modern art and its journals owe a debt. But I presume Brassaï's intuition told him that, although such pictures justify the role of photography in our age, this in itself was not enough for it to be recognized as an art in its own right. The latter could be achieved only if photography realized

its inherent potential, which it did in Brassaï's first book, *Paris by Night* (*Paris du nuit*), published in 1932, and *Secret Paris* (*Le Paris secret des années 30*), published in 1976. He proved that photography, the greatest merit of which is to capture reality as it is, can do much more than merely be true to life; it can create an entire world. Brassaï's other motives aside, his attraction to Paris by night can be understood as an attraction to the realm of light and shadow, where even a recording of reality will reveal aspects of worlds not yet uncovered by the fine arts. Brassaï's light and shadow, however, reveal not only human life in extremis but also the beauty of ugliness, poverty, cheap pleasure, and perversion. Thus does the Brassaï of secret, nocturnal Paris resemble Baudelaire: he draws beauty from ugliness, but without the tension that informs Baudelaire's rebellion; to the contrary, Brassaï's scenes are suffused with a kind of serenity. Brassaï said, "We continuously feel that we are in a different world, outside this world." This is Brassaï's test: an objective picture of the real world as well as an artistic vision of it. In the words of Henry Miller:

> Brassaï has that rare gift which so many artists despise — *normal vision*. He has no need to distort or deform, no need to lie or to preach. He would not alter the living arrangement of the world by one iota; he sees the world precisely as it is and as few men in the world see it because seldom do we encounter a human being endowed with normal vision. Everything to which his eye attaches itself acquires value and significance, a value and significance, I might say, heretofore avoided or ignored. The fragment, the defect, the commonplace — he detects in them what there is of novelty or perfection. He explores with equal patience, equal interest, a crack in the wall or the panorama of a city. Seeing becomes an end in itself. For Brassaï is an eye, a living eye.[131]

What better praise for the young artist's correspondence (now collected for publication but not written as such) than that, with a thousand details, it confirms Miller's words. Miller's portrait of Brassaï matches the self-portrait Brassaï created for his parents. How keen sighted he is, how prophetic, taking possession of a world entirely new to him. Even if they had not been written by a renowned artist these confidential reports, composed in a hurry after all and reflecting his year-and-a-half-long stay in Berlin and his years in Paris, would merit recognition for their documentary value. The letters show us that Brassaï did not choose photography by accident, nor did he become a great artist by chance. Is anyone fooled by the fact that a series of accidents did contribute to the development of his career? There has never been an artistic career in which accident played a greater role than fortunate circumstances.

I know of no other young man who wrote to his family for so many years, so regularly, describing the events of his life in prose of such quality. In the letters childlike sincerity, a strong sense of responsibility, and a cozy informality inform his struggle to accept his chosen role and to persuade his parents to do likewise. What I find most fascinating are Brassaï's crises of identity — how he wrought harmony from them and overcame temptation. And what temptations there were, enticing a young man anxious to find his way in an unknown world in directions contrary to his talent, and throwing up roadblocks. The temptation to offer one's talent for sale and to betray one's talent for a livelihood; the temptation to renounce art for prosperity or because one is disappointed in oneself; the temptation to spread oneself too thin and to sink — the wonderful thing is not that Brassaï avoided all these pitfalls, but that he escaped every one. And after conquering the language barrier and establishing himself as an artist, he faced the biggest temptation of all, that of his own fame. His fame was built by his photographs — in 1978 he was awarded the highest of arts prizes for his photographic oeuvre — yet he remained an acknowledged writer of substance (his two-volume portrait

of Henry Miller, for example, rivals *Conversations avec Picasso*), a graphic artist, a sculptor. Only so strong a personality could so masterfully avoid producing nonart, a hazard especially of photography . . .

Roles and characters! The letters are the theater director's dream of life of the artist. How enormous the distance between the addresses (the most important of whom is surely the father, who sojourned in Paris thirty years before his son and from whom the young man inherited his attraction to Paris) and the characters who unfold in the letters! How many life stories are touched upon in these pages, how many anonymous figures and how many famous ones cross the writer's path—and how many are recorded lastingly not with a carefully drawn portrait but with a rough sketch. The cast of characters is dominated by the Hungarian artists Brassaï met in Berlin and Paris. (They are a valuable addition to Illyés's *Huns in Paris* as well as a familiar counterpart to the pageant of celebrities in *Conversations avec Picasso*.) If only for its portrait of Tihanyi or the revelations about Bölöni this volume is guaranteed a place in the cultural history of this century, which isn't to say, however, that it is a mere snapshot of the Hungarian artists' colony in Paris.

The real hero of the letters, however, is the author who grows from Gyula Halász Jr. into Brassaï before our eyes. He is among those who in 1920 answered an inquiry in the *Napkelet:* "What is true Hungarian literature?" Jen Szentimrei, in his 1921 report on the *Napkelet*'s first year, argues that the "primary merit" of the newspaper was "to have introduced completely new names, young people of strength and talent, most of whom have produced work of increasingly serious value since," and along with Ferenc Balázs, Andor Becski, and Zoltán Finta mentions Gyula Halász. This young man, who occasionally wrote poetry and prose had, however, probably committed himself to the fine arts by that time. We know from his father's memoirs that he was a student at the Budapest College of Fine Arts in 1919.[132] In one of his letters home during the months of the revolution, he wrote,

"The winds of revolution have reached the drawing teacher's school. The whole school is in a turmoil, demanding reform. This reform would not be the kind I had in mind, but it will be sufficient for the time being." Gyula Halász Jr., however, was not satisfied with the struggle to reform the college — he enlisted in the Red Army.

He had just turned twenty-one when he went to Berlin in 1920 to continue his interrupted art studies. Twenty years separate the first letter from the last one in this volume. But the forty-one-year-old man who declares his resolve to return to occupied Paris, the center of his life and work, is no longer Gyula Halász, no longer his parents' Gyulus, but Brassaï, the renowned artist. Brassaï, whom the Hungarian reader has known thus far only as the author of *Conversations avec Picasso*, now offers a "portrait of the artist as a young man" written in his mother tongue, and asks to be admitted, after six decades, into the culture that once sent him on his way as a gifted young man.

✧ EDITORIAL NOTE ✦

Andor Horváth

Brassaï's younger brother, Kálmán Halász, deciphered and organized the handwritten letters. It is thanks to him that a selection was published in *A Hét* in 1977; when he offered the entire manuscript for publication, the editorial office asked Brassaï for his consent. The selection appeared with Brassaï's approval, edited for length by Andor Horváth.

Brassaï examined the letters, occasionally altering and frequently shortening them for the book; most of the passages about the family were omitted, as were financial or otherwise personal references of no concern to the public. Because all the letters were addressed to the author's parents or, less often, to his younger brothers, we indicated the addressee only a few times, in accordance with Brassaï's wishes.

Since even a sampling of Brassaï's newspaper dispatches from Berlin and Paris would have exceeded the scope of this book, the editor did not prepare a bibliography. (The letters do not mention every article written; moreover, identifying those articles that were published unsigned or merely initialed would have required thorough philological work.)

Names and foreign words and expressions have been annotated in the order in which they occur in the letters; a number of these annotations were provided by Brassaï himself.

Anne Wilkes Tucker

In 1978, approaching his eightieth birthday, Brassaï agreed to publish the
letters that he had written to his parents between 1920 and 1940. Two-
thirds of them were composed before 1929 when he began to photograph,
and almost all were written before he had evolved into a famous man of
enormously diverse and recognized talents. By his death in 1984 he was one
of the twentieth century's most influential photographers, and his book *Paris
de nuit* was recognized as a classic. He had published sixteen other books and
hundreds of articles. His only film, *Tant qu'il y aura des bêtes*, won the prize
at Cannes in 1956 for the most original film. He drew, sculpted, and de-
signed sets for two plays and two ballets. He also produced designs for seven
tapestries, one of which was commissioned by the French government and
represented France in a tapestry biennial in Lausanne, Switzerland.

This correspondence with his family is relevant to our understanding
of a young man struggling to realize his considerable ambitions and to focus
his diverse talents. The letters reveal what he valued, how he organized his
thoughts, and what he accomplished as an artist and as a newspaper writer
and illustrator before he began to photograph. In his preface, the mature
Brassaï admits that his youthful boasts and the sometimes awkward phras-
ing in the letters make him wince. He wishes he could rush to the aid of his
younger self, but in defense of the untested and quite grand self-image, he
quotes Marcel Proust's advice that we shouldn't repudiate our early periods
for they are "proof that we have really lived, that it is in accordance with the
laws of life and of the mind that we have, from the common elements of
life, . . . extracted something that transcends them" (see above, p. xi). Proust
and Goethe were Brassaï's favorite authors. Both wrote novels in which

youthful heroes mature through exposure to life, and, like Brassaï, both men were gifted chroniclers of contemporary society.

The letters begin in 1920 with Brassaï's trip from his hometown, Brassóv, to Berlin. Brassaï was now a Romanian citizen because his native region, Transylvania, had been transferred from Hungary to Romania by the 1920 Treaty of Trianon. He had only recently recovered from typhus, which he had contracted while a prisoner of the Romanian army.[133] After serving in the Austro-Hungarian cavalry in 1916–1917, Brassaï had enrolled in the Budapest Academy of Fine Arts. But Hungary was moving rapidly from a democratic republic, newly free from Austria, to the Hungarian Soviet Republic, and Brassaï enlisted in the Hungarian Red Army to fight Czech, Serb, French, and Romanian forces that had united to defeat the leftist regime operating at their borders. When the Romanian army captured Budapest in August 1919, many members of the Hungarian avant-garde who, like Brassaï, had served the left fled to Berlin or Vienna rather than to Paris, because Hungary and France had been enemies in World War I. The new Hungarian government proved so repressive that even artists and other intellectuals who were not politically involved soon emigrated. Because Brassaï wished to avoid crossing through Hungary, he traveled around that country's border to reach Berlin.

The paramount and unwavering support of his parents is a frequent theme of the letters. In the early ones Brassaï seems to assume that describing life's mundane details is an essential familial intimacy. One can easily imagine an adolescent Brassaï standing in the family kitchen and describing his day to attentive parents. Away from home, he reveals what he eats, the length of his hair,[134] the state of his clothes, conflicts with landladies, the rigors of art school admissions, and even the women he courts. He wants news of his parents and his brothers, and comfortably assumes they want news of him. As he matures, these small details are omitted, but he continues to de-

scribe moments that he believes will have particular significance for his parents. For instance, he most frequently discusses friends he has made who are Hungarian rather than those of other nationalities.

As new Hungarians arrived in Berlin, and later in Paris, they naturally gravitated to their compatriots for friendship and jobs. Throughout his life, Brassaï kept a circle of Hungarian friends and a network of professional relationships with fellow Hungarians.[135] Although Brassaï was ten to fifteen years younger than the painters and sculptors of the "Eight" and the "Activists," he knew Jánis Mattis-Teutsch from Brassó and, according to the letters, had roomed with him at some point in Budapest. In Berlin, Brassaï struck up a life-long friendship with Lajos Tihanyi which in turn gave him access to László Moholy-Nagy and other prominent artists who normally might not have befriended someone so much younger. Many of these artists and writers—including Tihanyi, György Bölöni, Bertalan Pór, and Róbert Beréry—later moved to Paris; Tihanyi and Brassaï lived in the same hotel in the late twenties. (Tihany wrote Edmund Mihályi that "Paris cost thirty times less and life is a thousand times better" than in Berlin.[136])

In his preface, Brassaï notes that the letters rarely mention his friendships with the men who made Paris a cultural axis between the wars. Among those overlooked entirely are critic Maurice Raynal and artists André Breton and Man Ray. Of his many friends who were writers, he never mentions Henry Miller or Pierre Reverdy, notes meeting Henri Michaux, and omits Jacques Prévert until they escape Paris together in 1940. He names Picasso not as an acquaintance but, first, in a criticism of Picasso's classical-style paintings and, later, as the subject of an early photo essay.[137] These omissions can be attributed to a natural inclination of youth not to discuss the people and values that have evolved beyond one's parents' tutelage and daily sphere. And before World War II, Picasso, much less Brassaï's other friends, had not yet achieved international fame.

An ever-pressing subject for Brassaï is his income. In letter after letter, he itemizes the outlay of his monthly allowance and reports his earnings, or lack thereof.[138] Clearly, a condition of his parents' support was that Brassaï would supplement money from home with whatever he could earn as a correspondent. This solution would seem natural to the family because Brassaï's father had worked as a reporter in his youth and contributed occasional articles to journals throughout his life. While in Germany, Brassaï wrote for Hungarian newspapers and literary magazines. Living in Paris, he added German periodicals to his clientele. Writing freelance articles yields an irregular cash-flow, and Brassaï was often on the verge of semistarvation and of losing his accommodations because he hadn't paid the rent. He was no stranger to pawnshops. Surely some of these letters were distressing for his parents to receive. For instance, during a trip to Nice in 1926, there were days when discarded fruits were his only sustenance. Although his success increased over time in Paris, he achieved financial stability only after the publication of *Paris de nuit*.[139]

Brassaï acknowledges that a factor in his family's unfailing patronage was his father's desire to realize through his eldest son his own thwarted dreams of becoming a poet. And as if to justify his own long resistance to matrimony, Brassaï notes how marriage and children, however loving, forced his father to seek steady employment. (After World War II, Brassaï married Gilberte-Mercédès Boyer and remained married to her until his death in 1984.)

Brassaï casts aspersions on his early articles by admitting he wrote on subjects about which he knew little or nothing, and even manufactured interviews and copied others' articles to submit under his own name. He also wrote articles that others submitted under *their* names. The range of topics that he covered includes Einstein and his theory of relativity, Prussian elections, and the criminal trials of Hungarian counterfeiters working in Berlin, as well as art, music, and theater. As his photographic career flourishes,

political and scientific topics drop away, and his articles focus increasingly on culture and the arts. But throughout his career the range of his writing indicates that Brassaï was alert, practical, and industrious. In Berlin, he reports working steadily on his paintings and drawings as well as on commercial articles: the articles were necessary to support the art. In the early Parisian years, when he began to doubt the relevance of contemporary painting, including his own, the production of income takes precedence over the production of art. After he begins to photograph, he consciously separates his commercial from his artistic aspirations, although he never hesitates to sell, and then to re-sell, his photographs to any kind of publication ranging from surrealist to Roman Catholic to communist. He also continues throughout his life to work constantly. In an 1944 article in *Minicam Photography*, Maria Eisner commented that, before the war "Brassaï was so absorbed by his work that he had no spare time any more" to spend with his friends at the Café du Dôme, who began to miss his company and his brilliant conversation.[140]

Brassaï's drive further manifests itself in his many declarations about his talent. When his parents react negatively to his drawings of nudes, he predicts that they will adore the same images in ten years. "I don't care what others think of my work when I am convinced of its worth," he declared (see letter 13). He also asserted that the Berlin Charlottenburg Academy of Fine Arts, which had tested him so rigorously before admission, had little to teach him, so he stopped attending classes. "I never had any doubts about my talent," he wrote. "I was convinced that all I needed was to move out on my own and prune the influence of those years I lived with Mattis-Teutsch" (letter 11). But again, ever practical, even though cutting classes, he remained enrolled to avoid Romania's military draft.[141]

Beyond the details of his life and finances, Brassaï shared with his parents his evolving aesthetic philosophies. At age twenty-two, while still primarily a draftsman, Brassaï expresses an aesthetic mission that was to remain

constant henceforth "to express the essence of things." He continued, "What I had to do was reject expressionism itself. Nature is the foundation of every starting point, the line of progress is constant simplification, a purer and purer emphasis of the essential" (letter 10). Although Brassaï does not mention Goethe to his parents for another seven months, learning to express an object's essence through absolute objectivity is a lesson he later attributes to the great German poet.

According to Charles Rado, Brassaï's friend and picture agent, it was the objectivity of Goethe, which "combines a feeling for the essential with a profound understanding of object." Brassaï, continued Rado, quotes Goethe to the effect that "after long observation and contemplation he has been able to raise himself to the level of the object."[142] When Brassaï writes about Goethe, he frequently mentions the poet's transition from a romantic to a classical sensibility, an evolution with which Brassaï identified. Rather than reflect objects in the mirror of his own temperament (like the surrealists), Brassaï concluded that "the world is richer than I."[143] In an early issue of *Minotaure,* Brassaï cited his encounter with Goethe as the most essential moment in his life.[144]

In his last year in Berlin, Brassaï writes with increasing consciousness of his dual and dueling nature. There is Brassaï "the artist and the creator," who is guided by his intuitions and has the ability to be amazed, "which is the maximum of what a human being may attain" (letter 15). This is the Brassaï who photographs Paris at its most glittering and glistening moments, when its monuments are lighted against the night and its streets are clean, wet, and reflective. This is also Brassaï the "night walker," who chronicles a sleeping Paris as well as the erotic desires and the myriad pursuits of pleasure and entertainment by all segments of the Parisian population. Brassaï was equally amazed by Paris by day, by cactus gardens, by laundry on a windy hillside, and by preening cats. Brassaï recognized in himself an "unquenchable thirst for knowledge." This he identified as the "'thinker' or the 'phi-

losopher'" (letter 14) who speculates, analyzes, and doubts. This is Brassaï the classifier who looks for types and often pre-visualizes his pictures—who, according to Horváth, raised the newly born art of photography "to a classical status" (see above, p. 232).

Photography proved to be the medium best suited to the impulses of Brassaï's complex nature as well as his need for an income. Matching photography with his considerable writing skills enhanced his career with magazines. But he disliked the "on demand" aspect of work-for-hire as well as its dependence on fashionable topics and its superficial treatment of subjects. In late-life interviews he always drew a distinction between his serious work and his journalistic or documentary photography. Much more important, photography satisfied Brassaï's aesthetic and intellectual needs. The camera could both preserve what amazed him and stimulate his unquenchable search for understanding. For Brassaï (as for photographers since the medium's invention) the camera was a ticket to any corner of the world or class of society that he chose to investigate. And he used it to reach diverse segments of life. As he writes in his preface, "Life has awakened in me a much more passionate curiosity than the arts."

Too many artists and historians think they are well acquainted with Brassaï's photographs when actually they know only a few of the many series he formulated.[145] Some were completed in a few months and contain only a few dozen pictures. Others developed over decades and contain hundreds of negatives organized first by subcategories and then chronologically. The well-known projects are *Paris de nuit, Paris de jour, Arts, Picasso, Nus, Graffiti,* and *Plaisirs* (better known in the United States as *Paris Secret*). His photographs of the Parisian demimonde so dominate his perceived legacy that John Szarkowski wrote in his preface to Brassaï's 1968 Museum of Modern Art catalogue that Brassaï was "an angel of darkness (whose) sensibility . . . delights in the primal, the fantastic, the ambiguous, even the bizarre."[146] But Brassaï wrote to his parents that "besides the underworld and

nightlife, I am now photographing high life . . . with the same passion, because all walks of life interest me equally" (letter 81).

Actually, fashionable society plays a particularly prominent role throughout his correspondence. At the end of his report on his Aunt Margit's visit to Berlin, he values the opportunity "to have a glance at Berlin's profiteering society and see all the extravagance" (letter 9). In his preface and later in the Parisian letters, Brassaï discusses his close friendship with Madame D.-B. and the otherwise unobtainable access she afforded him to upper-middle-class and aristocratic French society. By the time he began to photograph the upper echelons, he was well schooled in its rituals and manners. Madame D.-B. refines his French and his manners to facilitate his easy movement in her social circles. Throughout the 1920s, his letters teem with countesses, marquises, and princes whom he meets in her company. Looking at the photographs later taken during gala evenings at Longchamps Racetrack or in elegant homes such as Helena Rubenstein's apartment, we realize that he is comfortable with all classes of people and they are at ease with him. Never a paparazzo, Brassaï engaged his subjects. He had no intention of dishonoring or disrupting, but sought to give fresh life to all within the scope of his remarkable eye.

"Paris" was the greatest theme that sustained his interest from his first photographs in 1929 to his last in the late sixties. In his first few letters from Paris he begins to identify topics he would later photograph in depth: views of the Tuileries and the Seine, children, cats in windows, the Parc Montsouris, and, of course, Paris at night. He was not interested, he wrote, in Paris as a museum "in the style of Florence or Rome," but in that which was alive and contemporary. In the same letter he criticizes the contemporary art he sees in galleries for having only a tenuous link to "the life of today" and for lacking human values. Photography was for Brassaï "a medium specific to our time" (see above, p. xvii) because it could embody intellectual ideas and values as well as beauty.

Brassaï also photographed aspects of Paris that remained unchanged from 1903, when he lived there briefly while his father studied French at the Sorbonne, to the 1920s, when he returned. Many of these classic scenes exist to this day: children sailing wooden boats in reflecting pools, sweepers cleaning gutters with arching brooms, chestnut trees blooming over the boulevards, and late-night revelers winding down in the cafés.

The mistake with prior evaluations of Brassaï have been to regard him as a chronicler in the strictest sense. That Brassaï was a documentary photographer is only part of the truth. It misses both the calculation of most of his work and his belief in photography's metaphoric capacity. His shots were calculated both in their being pre-planned and staged, and in certain actions being anticipated, so that Brassaï was set to capture them. Anticipating a picture came from knowing a potential subject very well, whether it was the Pont Neuf, Paris' oldest bridge, or Picasso. Henry Miller tells the story of Brassaï's photographing Picasso and the sitter's surprise that he exposed only one negative.[147] Lawrence Durrell relates a story of similar economy.[148] But knowing both subjects well, Brassaï could have decided which typical pose and expression he would await before taking his picture. As he told Nancy Newhall in 1952, "I invent nothing, I imagine everything," which is a paraphrase of how Proust's biographer, George D. Painter, described Proust's retelling of his life in *Remembrance of Things Past.*[149]

Toward the end of this book there are long periods between letters, sometimes months, and once, a year. We cannot know whether letters have been omitted or whether Brassaï actually let such lapses occur. Andor Horváth's editorial note (see above) explains that more letters were serialized in the Hungarian newspaper *A Hét,* than were included in the book, but we don't know where the missing entries fell in the sequence. Occasionally Brassaï will begin a letter with an apology that he hasn't written because . . . he is busy, he doesn't want to write when his fortunes are down, etc., etc. It is natural that, in time, communicating with home would become less urgent.

By the end of the thirties, he has been away for almost two decades and considers Paris his home to the extent that he writes exclusively in French, even in letters home. Most of his Hungarian friends have died or emigrated to America. And, most important in terms of the story being told here, he is no longer struggling to find the right path to artistic expression or to financial security. While his life is not without hardship, our hero's education is complete. He is a man, aged forty, with well-honed talents and an international reputation. The portrait of the young artist is complete.

Acknowledgments

My essay for this publication has been aided first and foremost by Madame Gilberte Brassaï. Others to whom I am grateful include the trustees and staff of M.F.A.H.; David Travis, Art Institute of Chicago; Maria Morris Hamburg, Metropolitan Museum of Art; Stuart Alexander, Paris; Andor Horváth, Cluj, Romania; Enikö Róko, Budapest, Hungary; Mr. and Mrs. Kálmán Halász and Eva Lendvay, Brassó, Romania; and the staffs at Petöfi Irodalmi Múzeum (Literature Museum), Budapest; Magyar Nemzeti Galéia (Hungarian National Gallery), Budapest; and Magyar Fotográfiai Múzeum, Kecskemét, Hungary. Research was conducted at the Getty Institute for History and the Humanities with a grant from the Institute.

NOTES

Brassaï's own notes are identified; other notes are those of Andor Horváth, editor of the original Hungarian text, and the translators and editors of the present edition.

1. Marcel Proust, *Swann's Way*, vol. 1 of *Remembrance of Things Past*, trans. C. K. Scott Moncrieff and Terence Kilmartin (New York: Random House, 1981), 922–23.

2. Brassaï, *Histoire de Marie*, introduction by Henry Miller (Paris: Éditions du Point du Jour, 1949), 7–8.

3. (Brassaï's note) Of all the articles written merely in order to eat and mostly without any interest, one written about the Teutonic knights is an exception. As a child I spent several vacations in the small village of Marienburg (Foldvar in Hungarian), near Brassó, where one of my uncles had a pharmacy. *Fold-var*, "castle of earth": the name is derived from the ruins of a fortress built of red bricks. This fortress intrigued me as much as the herds of half-wild buffalo that passed through the village every night. As an adult I learned the history of this castle and thus the history of the Teutonic order, founded in Jerusalem in the thirteenth century, during the Crusades. Originally a charitable order, it became a military one to protect Christianity wherever it was in danger. Thus the German knights were invited to Transylvania by King Endre II of Hungary to defend the land nestled among the Carpathian Mountains against invasions of the "barbarians." The order, a vassal of the king of Hungary, could neither mint money nor build any castles except brick ones. But it had an authoritarian and dominating leader, Hermann von Salza — a kind of Hitler. After conquering all of Wallachia in a short time and settling numerous German colonists in Transylvania, he wanted to lay the foundations of a German state. One fine day he offered all the conquered territories to the pope as a liege, in spite of his contract with Hungary. He must have thought, not without reason, that Endre II would be too weak to react. But the king saw the danger, and by uniting all the armed forces of the country, drove out the Teutonic knights. The story repeated itself in Poland, where Hermann von Salza was invited to fight against the Slavic incursions. The knights then built their second Marienburg, one of the largest and most magnificent castles in Germany. Thus began the systematic

extinction of the Prussians—a name that originally belonged to a Slavic people. After a century and a half, the genocide was complete. The German colonists gradually established themselves in East Prussia, Estonia, Courland, and Pomerania. The Prussians were wiped out, surviving in name only, a name now borne by the German conquerors. Poland and Lithuania, constantly threatened by the fate that had befallen the Prussians, did not break the power of the Teutonic knights until 1410, the year of the battle at Tannenberg. The defeat of the knights marked the end of the *Drang nach Osten,* the German colonization of the Slavic countries.

4. *Histoire de Marie,* 7–8.

5. Léda (Mrs. Adél Brüll) was a lover and patron of Endre Ady (1877–1919), one of Hungary's greatest poets. Ady sojourned in Paris with her for two decades before Brassaï arrived in the city. Ady wrote many poems to Léda.

6. Brassaï, *The Secret Paris of the 30's,* trans. Richard Miller (London: Thames and Hudson; New York: Pantheon Books, 1976); originally published as *Le Paris secret des années 30* (Paris: Éditions Gallimard, 1976).

7. Henry Miller, *Tropic of Cancer* (New York: Grove Press, 1961), 189–90.

8. Brassaï, *Picasso and Company,* trans. Francis Price (Garden City, NY: Doubleday, 1966), 47; originally published as *Conversations avec Picasso* (Paris: Éditions Gallimard, 1964), 60.

9. Ibid., 131–32.

10. A. D. Coleman, "Brassaï Uncovers the Hidden Life," *New York Times,* 26 September 1971.

11. Brassaï traveled from Brassó via the Romanian-Czechoslovakian border. (Between the two world wars these countries shared a common border.) This meant a huge detour, in order to avoid crossing through Hungary. From October 1916 to December 1917, Gyula Halász did his military service at Nagyszeben-Hermanstadt-Sibiu in the Hungarian cavalry. December 17, 1917, marked the Russian-German armistice and the fall of the Austro-Hungarian Empire. In 1918, Brassaï went to Budapest and enrolled in the Academy of Fine Arts. In the autumn of 1919 he joined the Hungarian Red Army and served as a telephone operator at general headquarters until he was taken prisoner by the Romanian army.

12. (Brassaï's note) "The ladies": Grete Hoffstaetter was the widow of a German officer who died in World War I. She traveled to Germany to be eligible for

a German pension. She was accompanied by her son Burschi, and Olga Weber, a young girl also from Brassó.

13. Goulard water is an anti-inflammatory solution containing lead acetate, alcohol, and water; it is used in poultices.

14. *Kreisausschuss:* local municipality.

15. Bodenbach is a town on the Czech-German border.

16. Everyone exchanged presents.

17. János Mattis-Teutsch (1884–1960) was a painter, sculptor, and draughtsman. Also born in Brassó, Mattis-Teutsch lived in Budapest from 1912 to 1919 and then returned to Brassó. Brassaï's relationship with him and Mattis-Teutsch's impact upon the young Brassaï are often mentioned in the subsequent letters.

18. *Napkelet* (Sunrise): a Hungarian literary journal published in Romania from 1920 to 1922 and edited by Árpád Paál, Imre Kádár, Jen Szentimrei, and Ern Ligeti.

19. *Keleti Újság* (Eastern Journal): a political daily, published in Kolozsvár (Cluj) from 1918 to 1944.

20. *Brassói Lapok* (Brassó Papers): a political daily published from 1895 to 1940. It was edited by Miklós Móricz, the younger brother of the writer Zsigmond Móricz, from 1923 to 1928. Bernát Kahána bought the paper in 1928; it was then edited by Bertalan Füzi and later by Sándor Kacsó.

21. Main administrative and cultural center of Transylvania.

22. "Kánka" is Kálmán Halász, one of Brassaï's younger brothers; he was studying in Budapest. "At that time mail delivery between Hungary and Romania was shut down. I sent messages via our parents" (Brassaï).

23. Brassaï raised the money he needed for traveling in part from the revenues of his recital.

24. *Der Sturm* was a journal and gallery in Berlin that promoted expressionism. It was founded by H. Warden in 1910. The exhibition took place in July and August. At this collective debut, Mattis-Teutsch exhibited with artists such as Klee, Archipenko, and Chagall.

25. Leading liberal daily in Budapest between the wars.

26. For a short time Hungarian-language media were banned in Transylvania after Hungary lost the territory to Romania in World War I.

27. After World War I the Allies demanded 132 billion gold marks in reparations from Germany. To secure this payment, the London conference decided in May 1921 to occupy the entire Ruhr region of Germany.

28. Lajos Tihanyi (1885–1938) was a painter and founding member of "The Eight," an internationally recognized group of Hungarian avant-garde painters. Originally called "The Seekers" (1909–11), they exhibited as The Eight from 1911 to 1913. Members included Róbert Beréry, Béla Czóbel, Dezsö Czigány, Károly Kernstok, Odön Márffy, Dezsö Orbán, Bartalan Pór, and Tihanyi. Tihanyi later participated in the movement known as "activism." His painting, initially anchored in Cézanne's tenets and in expressionism, came to incorporate elements of cubism as well. His main works are his portraits (*Lajos Fülep,* 1915; *Lajos Kassák,* 1918; *Self-portrait,* 1920). Tihanyi was one of Brassaï's closest friends. After the Hungarian Revolution he lived in Vienna (1919–20), Berlin (1921–24), and Paris (1924–38).

29. György Bölöni (1882–1959), writer, journalist. He met and made friends with Ady in Paris. He emigrated after the fall of the communist regime in 1919. After living in Vienna, Bucharest, and Berlin, he settled in Paris in 1923 and joined the circle of Mihály Károlyi. He wrote his book on Endre Ady, *The True Ady,* in Paris. He edited the *Párizsi Hírlap* (Paris Paper). After World War II he returned to Hungary.

30. (Brassaï's note) In 1917 I wrote a draft of a ballet. I took it to Budapest to Kassák. With his recommendation I visited Bartók. Bartók was very friendly and promised to read the draft. Now I believe that it was poor, but it allowed me to meet Bartók, that wonderful person, whom I had a chance to see several more times later in Paris.

31. Gyula Halász's essay "Critique on Berlin Theaters" was published in the 1921/14 and 16 issues of the *Napkelet* (Sunrise).

32. This letter was addressed to Kálmán Halász.

33. Róbert Berény (1887–1953), noted Hungarian painter and founding member of The Eight who lived in Berlin from 1919 to 1926.

34. Sections of Brassó.

35. Piotr Nikolaievich Wrangel (1878–1928), a Russian general.

36. *Rohrpost:* "pneumatic dispatch."

37. The original German term for "profiteering society" referred to entrepreneurs who became rich in a very short time after World War I.

38. *nochniedagewesen:* "having never existed before."

39. Possibly to avoid military service in the Romanian army.

40. "Ignotus" was the pen name of Hugo Veigelsberg (1869 – 1949), a writer, critic, journalist and the editor-in-chief of the *Nyugat* (West), Hungary's foremost literary journal from the beginning of the century through the late 1930s.

41. Sándor Márai (1900 – 1989), one of the most influential Hungarian writers of the interwar period. Between 1919 and 1923 he lived in Germany; he later moved to Paris. In 1948 he emigrated to Switzerland, and in 1950 he settled in the United States. In 1989 he committed suicide in San Diego.

42. Károly Kernstok (1873 – 1940), painter, the leader of The Eight, and a pioneer of modernism and Hungarian fine art. He participated in the revolution of 1918 – 19 (he was a government commissioner of culture and education, among other posts). He lived in exile in Berlin from 1919 to 1926.

43. Béla Czóbel (1883 – 1976), prominent Hungarian painter and a founding member of The Eight. He lived in Berlin between 1919 and 1925, then moved to Paris. Beginning in the 1940s, he worked alternately in France and Hungary.

44. Illés Kaczér (1887 – 1980), journalist and writer. He was a successful playwright in Kolozsvár in the 1920s. In 1938 he moved to London, where he became a scriptwriter and dramaturgist for Alexander Korda's film company. Later he moved to Israel.

45. Béla Révész (1876 – 1944), writer and journalist, a forerunner of the expressionist style of socialist prose.

46. Alexander Archipenko (1887 – 1964), American sculptor of Ukrainian origin, a pioneer of modern sculpture.

47. Lajos Kassák (1887 – 1967), leading Hungarian avant-garde poet and painter. A major figure in international modernism, he published the magazines *A Tet* (The Deed) from 1915 to 1916, and *Ma* (Today) from 1916 to 1920 in Budapest (where he established Ma Gallery in 1917) and from 1920 to 1925 in Vienna. Both publications promoted the work of Hungarian artists within the context of international art movements. With László Moholy-Nagy, Kassák published the influential book *Buch neuer Künstler* (Book of New Artists) in 1922.

48. Mihály Károly (1875 – 1955), Hungarian statesman, prime minister from 1918 to 1919, and later president. He emigrated to Paris, where he lived until the

end of the 1920s. He returned to Hungary in 1946 and emigrated again in 1949. He wrote several volumes of memoirs.

49. Józsi Jeno Tersánszky (1888 – 1969), an outstanding figure of twentieth-century Hungarian prose. His *Marci Kakuk* is a modern picaresque novel.

50. Oskar Kokoschka (1886 – 1979) was not German but Austrian — a painter, graphic artist, and playwright and a significant exponent of expressionism. He lectured at the Dresden Academy between 1920 and 1924.

51. Bernát Alexander (1850 – 1927), aesthete, philosopher, and publicist. Of his literary efforts, the Shakespeare essays are the most significant, in particular his essay on *Hamlet*. See Bernát Alexander, *Shakespeare* (Budapest: Franklin-Tarsulat, 1920). He lived in exile between 1920 and 1923.

52. (Brassaï's note) A lot of artists and writers, Tristan Tzara among them, used to stay at the Hôtel des Écoles. Henry Miller stayed there in 1928 when he first came to Paris with his wife, June.

53. (Brassaï's note) Ivan Puni was a painter of Russian origin. I met him and his wife in Berlin, just as I did Larionov and his wife, Goncharova, and Kandinsky and his wife, Nina. We often used to go to concerts together in Berlin.

54. *Kassai Újság* (Kassa Paper), a Hungarian-language newspaper in Kassa (Koöice, Slovakia).

55. *Mi-carême:* mid-Lent Thursday, a day of entertainment when parades are traditionally held.

56. Endre Ady (1877 – 1919), major Hungarian poet.

57. Friedrich Hebbel (1813 – 63), one of the greatest German dramatists. For diary entry, consult *Sämtliche Werke,* ed. R. M. Werner, 24 vols., 3d ed. (1901 – 7).

58. An allusion to a well-known drinking song by the great Hungarian poet Sándor Petöfi (1823 – 49).

59. *Bácskai Napló* (Bácska Journal), a Hungarian-language newspaper published in the region that became part of Yugoslavia after World War I.

60. Literally, "a little drink" — a term of endearment.

61. Cecil Rhodes (1853 – 1902), English businessman, one of the front-line fighters in the colonization of South Africa and the expansion of the British Empire.

62. Hugo Stinnes (1870 – 1924), German industrial baron, one of the leaders of the National Party.

63. Raymond Poincaré (1860 – 1934), French politician, president (1913 – 20), and prime minister (1922 – 24; 1926 – 29); in 1923 he ordered that the Ruhr region be occupied in order to force the Germans to honor the treaty of Versailles.

64. Alexandre Millerand (1859 – 1943), French politician and president (1920 – 24); he played an important role at the signing of the peace treaty of Trianon.

65. Klingsor was a German publishing house that operated in Romania between 1924 and 1939. It sponsored an art salon and operated a concert bureau as well. Between 1924 and 1939 it published the literary journal *Klingsor*.

66. Bock: beer brewer of Alsace.

67. For "English lady," Brassaï uses the word "angolna" (eel) — an irreverent pun.

68. Alexandru Marghiloman (1854 – 1925), Romanian politician. A leading figure of the conservative party, he served several terms as minister, was elected prime minister in 1918, and was one of the signers of the peace treaty with the Germans in 1918.

69. Silvio Floresco — born Scipione Adam Anastasiu — (1875 – 1945), noted Romanian violinist. He studied with Robert Klenck in Bucharest, Eugène Ysaÿe in Brussels, Gustav Holländer in Berlin, and Otakar Sevcik in Prague. In addition to giving concerts he taught in Heidelberg and Vienna before World War I. He led the violin master class department at the Bucharest conservatory until 1939.

70. Miguel de Unamuno (1864 – 1936), an outstanding figure of the Spanish essayist generation at the beginning of the century.

71. *mont de piété:* ("pawnshop"); literally "mountain of mercy."

72. "To Gyula Halász, because he is one of those who know how to hear and see, and whose future will surely multiply the spiritual echo of the words he has already been able to say — this souvenir from Silvio Floresco."

73. Count Mihály Károlyi was the first prime minister of Hungary after the country won independence from Austria in 1918. He lost his power to the Communists in the spring of 1919 and went into exile.

74. (Brassaï's note) Károlyi secretly confessed to me that sometimes he draws, too. I asked him to draw a self-portrait. Indeed, he drew it and handed it over to me a few days later. I saved it but it is buried in the bottom of one of the cases in my atelier.

75. Tibor Harsányi (1897–1954), Hungarian composer and pianist. He settled in Paris in 1924.

76. Humorous allusion to a famous poem by Endre Ady: "I would love it if they loved me, and if I belonged to someone" (Szeretném, hogyha szeretnének, slennék valakié).

77. Arzén Cserépy (1881–1946), Hungarian film director. He moved to Berlin during the 1910s; he first wrote scripts, then later directed and founded his own film company (Cserépy Film).

78. Ödön Mihályi (1899–1929), Hungarian writer from Czechoslovakia. Initially he had close links to Kassák's circle, and later he became a member of the *Sarló* (sickle) movement.

79. Endre Nagy (1877–1938), writer, journalist, comedian, founder of Hungarian literary cabaret.

80. *à la garçonne:* a type of boyish hairstyle.

81. Maurice Barrès (1862–1923), French writer and journalist. His right-wing sentiments centered first on the cult of the self and later on French nationalism.

82. (Brassaï's note) Henri Michaux [1889–1984] is regarded as one of the most outstanding poets, if not *the* most outstanding. He is also significant as a painter. The Beaubourg-Pompidou Museum exhibited a selection of his oeuvre.

83. Bertalan Pór (1880–1964), Hungarian painter, founding member of The Eight (see note 28 above). He was a constructivist. He lived in exile from 1918 to 1948.

84. Albert Gleizes (1881–1953), French painter and theorist, one of the most significant exponents of cubism.

85. (Brassaï's note) My younger brother, Endre Halász [Bandi], was killed in the Crimea during World War II. He was fourteen years younger than I.

86. Miksa Feny, literary critic associated with the prominent Budapest literary journal *Nyugat* (Occident).

87. One of the most prominent theaters in Budapest.

88. "Life is courage."

89. "Color of hope."

90. *fines à l'eau:* "cognac with sparkling water."

256

91. In English in the original.

92. "Devil! you are a devil!"

93. "Open the door, please!"

94. (Brassaï's note) "Adorable 'junk-aid,' may the blessing of the heaven of the white mountain accompany you! On Sunday, together with my beloved daughter, I am going to search my trunks. Come around four o'clock." When Mme D.-B. moved out, she had her boxes and trunks moved to the atelier in which she stored her silverware, china, clothes, white goods. We called these trunks and boxes, piled up on top of one another, the "white mountain," since they were covered with a white blanket. From time to time, when she was looking for something she arranged for a "dig," to which she invited friends. Once I signed a reply to one of her invitations as "aide-fourbi," "junk-aid." Since then the name Fourbi has stuck with me — members of the family still call me this.

95. The private painting and sculpture exhibition took place in the Galerie Visconti between April 15 and 30.

96. "The article and the two photographs on the exhibition were accepted."

97. "The program will take place at Jacqueline's apartment on Sunday. If you come, we will have a dinner later."

98. (Brassaï's note) Among the letters written by my friend Gyula Illyés to Tihanyi I found a postcard in which he mentions that he cannot make the appointment because he has no shoes. (I handed over this letter to Illyés.)

99. *tout Paris mondain:* "the entire Paris society."

100. "Gyula Halász, the great Hungarian painter."

101. *femme du monde:* "woman of the world."

102. "Tu es l'essence même":

> *You are the very essence of what I love*
> *the be-all and end-all of my love,*
> *the wild and sturdy plant*
> *around which, like a convolvulus,*
> *my desire is entwined . . .*
>
> *There I have "espoused" the future form that*
> *God had reserved for you in His wisdom,*

and there you have known that my mortal form
would be for your eyes a source of delight . . .

Oh, there we have really
"known" each other and now (no matter when
and where) we only had
to RE-COGNIZE each other.

103. "Mr. Halász, please leave your room if you cannot pay at least 200 francs. L. Charanel, *hotel proprietor.*"

104. *fanfaronnade:* "bragging."

105. The civil revolution of 1918, led by Károlyi, abolished the Hapsburg rule over Hungary. Károlyi was later forced to leave the country.

106. "I spent much of my time playing chess at the Café de la Régence, opposite the Comédie Française. I had a passion for the game and could spend my nights at it. I played with all nationalities and all classes and it was revealing to notice that each nationality had its own approach: I had no need to ask them from which country they came, I could recognize it by their game.

"Enclosed behind an iron railing the marble table is preserved on which Napoleon used to indulge in his favourite pastime. It was here, too, that Trotsky sat playing his King gambit, for which he was so well known in chess circles. For me this game was an escape; through it I could forget my cares." Mihály Károlyi, *Memoirs of Michael Karolyi: Faith without Illusion,* trans. Catherine Karolyi (New York: E. P. Dutton, 1956), 227.

107. Queen Zita (1892–1989), Zita von Bourbon-Parma, princess of Parma. As the wife of Charles IV, she was the Hapsburg empress of Austria and the queen of Hungary.

108. "For July 14, triumph!"

109. (Brassaï's note) This little fishing port is situated near the bay of Finistère, between the capes of Raz and Penmarch.

110. Joseph Caillaux (1863–1944), French politician and prime minister. Convicted of treason, his sentence was later revoked.

111. K. G. Rakowski (1873–1941), Soviet politician, diplomat, Soviet ambassador to the United Kingdom and later to France. He is mentioned in Mihály

Károlyi's memoirs: "He was the old type of intellectual Bolshevik with high moral standards and integrity, deeply convinced of the truth of Communism, for which no sacrifice would be too much. He had lived many years in Paris as a gynaecologist, and belonged to the so called 'Westerners,' in opposition to the Asiatic group of Stalinists. Highly cultivated, he was well acquainted with Western thought and conditions, subtle and sharp witted, with much humanity, and a sense of humour: in all a delightful companion. His loyalty to his principles and to his friend Trotsky was his undoing." Károlyi, *Memoirs*, 198.

112. Tristan Bernard (1866–1947), French playwright.

113. Brassaï means the place Saint-Sulpice, playfully distorting the name (*supplice:* "torture").

114. (Brassaï's note) Giovanni Nicolo Servandoni, an architect from Florence, one of the designers of the Saint-Sulpice church, an excellent representative of rococo style.

115. (Brassaï's note) The Glénan Islands are a small group of islands close to the coast of Finistère.

116. André Kertész (1894–1985), internationally renowned photographer. He advised the beginner Brassaï on technical matters in regard to photography.

117. It is customary among Hungarians to celebrate one's name day—the church feast day of the saint after whom one is named—just like one's birthday.

118. "The First Snapshots in the World."

119. (Brassaï's note) Lajos Tihanyi was the son of the owner of the Balaton café. The café was managed by his lawyer brother.

120. Lucien Vogel is mentioned in Mihály Károlyi's memoirs: "In 1931 Lucien Vogel, Parisian editor of *Vu* as well as of various fashion papers, asked me to join his group of writers on a visit to Soviet Russia and prepare a special number for his magazine." Károlyi, *Memoirs*, 249.

121. Alexander (Sándor) Korda (1893–1956), Hungarian-born English director and producer. He emigrated after 1919. After sojourns in Germany and Hollywood, he founded the London Film Company in 1932. He was knighted that same year.

122. "A man dies in the street."

123. (Brassaï's note) I couldn't deliver the material for the exhibition because of my contract with Korda. This was a serious mistake. My name could have become

known in America as early as 1932. (So I wasn't advanced the 3,000 francs for the pictures either.)

124. "The Great Parisian Photoreporter: A Visit to Brassaï's Workshop."

125. Lajos Biró (1880 – 1948), noted Hungarian novelist.

126. (Brassaï's note) The shooting of the first film (*Windstorm*) was cancelled at the last minute. *Dame de chez Maxim's* was put on the agenda, but only at the beginning of November.

127. Mattis-Teutsch, for example, who made a strong impression on the young Gyula Halász, not only through his art but also with his theoretical manifesto, argued that postimpressionist art "frees the activity of the Ego to the extreme." See Zoltán Banner, *Mattis-Teutsch János* (Kriterion, 1972), 10. Arnold Hauser, however, describing Picasso's life's work, states that "Picasso's eclecticism signifies the deliberate destruction of the unity of the personality; his imitations are protests against the cult of originality; his deformation of reality, which is always clothing itself in new forms, in order the more forcibly to demonstrate their arbitrariness, is intended, above all, to confirm the thesis that 'nature and art are two entirely dissimilar phenomena.' Picasso turns himself into a conjurer, a juggler, a parodist, out of opposition to the romantic with his 'inner voice,' his 'take it or leave it,' his self-esteem and self-worship. And he disavows not only romanticism, but even the Renaissance, which, with its concept of genius and its idea of the unity of work and style, anticipates romanticism to some extent. He represents a complete break with individualism and subjectivism, the absolute denial of art as the expression of an unmistakable personality." Arnold Hauser, *The Social History of Art and Literature* (New York: Alfred A. Knopf, 1951), 934 – 35.

128. Gyula Illyés (1902 – 1983), prominent Hungarian poet.

129. Hungarian edition: *Beszélgetés Picassóval* (Corvina, 1968).

130. "Post-impressionist art is the first to renounce all illusion of reality on principle and to express its outlook on life by the deliberate deformation of natural objects. Cubism, constructivism, futurism, expressionism, dadaism and surrealism turn away with equal determination from nature-bound and reality-affirming impressionism. . . . Post-impressionist art can no longer be called in any sense a reproduction of nature; its relationship to nature is one of violation. We can speak at most of a kind of magic naturalism, of the production of objects which exist along-

side reality, but do not wish to take its place. Confronted with the works of Braque, Chagall, Rouault, Picasso, Henri Rousseau, Salvador Dali, we always feel that, for all their differences, we are in a second world, a super-world which, however many features of ordinary reality it may still display, represents a form of existence surpassing and incompatible with this reality." Hauser, *The Social History of Art and Literature,* 930 – 31.

131. Henry Miller, "The Eye of Paris," in *Wisdom of the Heart* (Norfolk, Conn.: New Directions, 1941), 173 – 74.

132. Gyula Halász Sr., *On the Threshold of the One-Hundredth Year* (Bucharest: Irodalmi Kiadó [Literary Press], 1967).

133. This fact was confirmed both by Brassaï's nephew Kálmán Halász and by an obituary published in Hungary. The clipping from an unidentified newspaper is in the archive of the Magyar Fotográfiai Múzeum, Kecskemét, Hungary.

134. Brassaï's wavy, shoulder-length hair was so distinctive that when he cut it in 1924, Lajos Tihanyi noted the event in a letter to Edmund Mihályi, concluding that now "he looks like a journalist." Letter in Tihanyi Archive, Magyar Memzeti Galéria, Budapest.

135. For instance, his picture agent, Charles Rado, was Hungarian. So was an important newspaper and magazine editor, Stephan Lorant.

136. Letter in Tihanyi Archive, Magyar Nemzeti Galéria, Budapest.

137. In letter 20 he criticizes Picasso's latest, "classical" works. Similarly, Tihanyi wrote to Mihàlyi in May 1924 that he thought Picasso's exhibition of neo-classical paintings was very bad. In letter 77 Brassaï mentions his photographs of Picasso being published in the first issue of *Mınotaure.*

138. He frequently thanks his parents for underwriting his life in Berlin, and later, in Paris. As late as 1931 he still needs occasional checks from home, and that summer when his parents visited Paris, they purchased the last few pieces of photographic equipment that he needed to function in his new career.

139. Eventually, his photographs and articles were published worldwide. From 1937 to 1962 he worked steadily for *Harper's Bazaar,* reporting to the legendary editor-in-chief Carmel Snow and her equally famous art director Alexey Brodovitch. Among the other magazines to which Brassaï contributed frequently were *Le Minotaure, Verve, Vu, Picture Post, Lilliput, Coronet, Labyrinthe, Réalités,* and *Plai-*

sirs de France. During World War II, Brassaï was again almost penniless because he would not photograph for the Germans who occupied Paris and therefore was not allowed to publish his work.

140. Maria Giovanna Eisner, "Brassaï," *Minicam Photography,* April 1944, 74.

141. Since he had already served in the Austrian-Hapsburg army when Transylvania was part of Hungary, he must have become eligible for the Romanian army when Transylvania was annexed by Romania in 1920.

142. Lecture by Rado to Photo League, New York City, 1948. Copy in Anne Tucker's Photo League files and in the Brassaï Archives, Paris.

143. "Brassaï Talking about Photography: An Interview with Tony Ray-Jones," *Creative Camera,* April 1970, 120.

144. He first mentions Goethe in letter 15, 24 March 1922. In *Minotaure,* nos. 3–4: 105, he writes: "Fortuitous or necessary, who knows? — my encounter with Goethe was, in any case, fatal for me. The serenity of his submission remained the consistent emotion of my life, and I acquired a faith so much the larger for having no determined object."

145. Selected single images from the other series have been published.

146. John Szarkowski, *Brassaï* (New York: Museum of Modern Art, 1968), 7.

147. Henry Miller, preface, in Brassaï, *Picasso and Company,* xi.

148. *Brassaï,* Museum of Modern Art, 10.

149. Nancy Newhall, "Brassaï," *Untitled,* 1976, no. 10: 14. George D. Painter, *Marcel Proust: A Biography,* vol. 1 (New York: Viking Books, 1959), xiii. Painter's words were: "though he invented nothing, he altered everything."

*Out of respect for Mme D.-B., Brassaï always maintained strict confidence as to her identity.